ARCHITECTURE AND ORNAMENT

ARCHITECTURE AND ORNAMENT

An Illustrated Dictionary

by MARGARET MALISZEWSKI-PICKART

McFarland & Company, Inc., Publishers
Jefferson, North Carolina, and London

Front cover: The American Museum of Natural History in New York
City (photograph by the author)

British Library Cataloguing-in-Publication data are available

Library of Congress Cataloguing-in-Publication Data

Maliszewski-Pickart, Margaret, 1963–
 Architecture and ornament : an illustrated dictionary / Margaret
Maliszewski-Pickart.
 p. cm.
 Includes bibliographical references.
 ISBN 0-7864-0383-7 (case binding : 50# alkaline paper) ∞
 1. Architecture — Details — Dictionaries. I. Title.
NA2840.M36 1998
721'.03 — dc21 97-33112
 CIP

721.03
MAL

Manufactured in the United States of America

McFarland & Company, Inc., Publishers
 Box 611, Jefferson, North Carolina 28640

To my mother and father—
two fellow building enthusiasts

TABLE OF CONTENTS

Acknowledgments viii

Illustration Credits ix

Preface 1

How to Use This Book 3

THE ILLUSTRATIONS
 Windows and Doors 6
 Walls 44
 Roofs 69
 Columns 79
 Stairs 102
 Ornament and Moldings 108
 Arches, Vaults and Domes 126

THE DICTIONARY 139

Appendix: Describing Architecture 183

Selected Bibliography 197

ACKNOWLEDGMENTS

Without the invaluable contributions of numerous individuals, this work would not have been accomplished. Thanks go to the illustrators whose work has taught me much about architecture: Daniel Robinson, Chris Pickart, Nicholas M. Mazzella, Gregory S. Schaumburg, John V. Maliszewski, Annabel Farrales, and David Sinclair Bleicher. Thanks also go to Kathy Howe for the use of her photographs, to Betsy Bradley for reviewing an early draft of the manuscript, and to Annabel Farrales and Regine Charles-Bowser for their continued moral support. Special thanks go to the numerous friends and associates who contributed suggestions for titles for this work. Finally, I thank my mother, Irene Maliszewski, whose help proved indispensable throughout this project, and my husband, Chris, for his boundless interest in architecture and ornament.

ILLUSTRATION CREDITS

ABBREVIATIONS

AF (drawn by Annabel Farrales)

AGS (Ramsey, Charles G., and Harold R. Sleeper. *Architectural Graphic Standards.*, 6th ed. New York: John Wiley & Sons, 1970)

AS (Sturgis, Russell. *Architecture Sourcebook.* New York: Van Nostrand Reinhold, 1984)

CP (drawn by Chris Pickart)

DB (drawn by David Sinclair Bleicher)

DR (drawn by Daniel Robinson)

FGP (Tunick, Susan. *Field Guide to Apartment Building Architecture.* New York: Friends of Terra Cotta/New York State, 1986)

GS (drawn by Gregory S. Schaumburg)

JM (drawn by John V. Maliszewski)

KH (photo by Kathy Howe)

MP (photo by Margaret Maliszewski-Pickart)

NM (drawn by Nicholas M. Mazzella)

PE (Haneman, John Theodore. *Pictorial Encyclopedia of Historic Architectural Plans, Details and Elements.* New York: Dover, 1984)

RF (Spence, William P. *Residential Framing.* New York: Sterling Publishing Co., 1993)

Windows and Doors: 1–5 (DR); 6 (AS: *Dormer Window: House of Jacques Coeur, Bourges; 1443*, page 141); 7 (DR, based in part on AS: *Window, Fig. 24: Rose window, west front of church, Montreal [Yonne], Burgundy; c. 1250*, page 393); 8 (DR, with additions by CP); 9 (DR); 10 (AS: *Window, Fig. 5: Witney Church, Oxfordshire*, page 389; *Window, Fig. 17: Denford Church, Northamptonshire; c. 1350*, page 391); 11–26 (MP); 27–29 (DR); 30–37 (MP); 38 (AS: *Brackets carrying porch-roof; Arnold House, Charlestown, Mass.*, page 65).

Walls: 39 (GS); 40 (CP, adapted in part from AGS, page 148); 41–44 (GS, adapted in part from AGS, pages 148, 157, 171); 45 (AS: *Rustication: Base of Palazzo Strozzi, Florence; 15th Century*, page 306; *Rustication: Palazzo Widman, Venice, Italy; Close of 16th century*, page 306); 46–50 (MP); 51 (NM with additions by CP); 52 (NM); 53 (NM, adapted from RF, page 78); 54 (NM, adapted from RF, page 80); 55 (CP); 56 (MP); 57 (CP); 58 (GS, with additions by CP); 59 (AS: *Anchor: 14th Century; Wrought-iron fleur-de-lis for head*, page 17; *Kneeler*, page 210; and NM, adapted in part from AGS, pages 90 and 255); 60 (NM, adapted from FGP); 61 (CP); 62 (AS: *Flying Buttress: Strasburg Cathedral; North side of nave*, page 73).

Roofs: 63 (CP); 64 (CP and GS); 65 (GS AND CP); 66 (CP); 67 (NM, adapted in part from AGS, pages 249 and 298; and CP); 68 (NM, adapted in part from AGS, pages 295 and 308; RF, page 184); 69 (DB); 70 (NM with additions by CP, based in part on AS: *Broletto at Como, Lombardy*, page 69); 71 (AS: *Double Church, Schwarzrheindorf*, page 143).

Columns: 72 (AF); 73 (AF and CP, adapted in part from AS: *Spur: English Gothic, earliest type; S. Cross, Winchester*, page 326); 74 (AS: *Entablatures of six classic orders*, page 149); 75 (CP and NM, based in part on AS: *Foliated capital, Canterbury Cathedral, c. 1177,*

page 155; *Roman Imperial Architecture: Corinthian capital with imagery preserved in the Lateran Museum, Rome,* page 296; *Capital: Norman cushion capital, Cassington, Oxfordshire,* page 82; *Capital: Lotus bud capital from Temple at Luxor,* page 80; *Interlace: Interlaced ornament, Canterbury Cathedral crypt,* page 200; *Crockets on capital, Cathedral of Semur [Côte-d'Or],* page 129); 76 (AS: *Order: Grecian Doric; That of the Parthenon: Having the entablature much less high and the echinus much less spreading, in proportion, than those at Paestum,* page 249); 77 (MP); 78 (AS: *Grecian Architecture: Angle of an Ionic building; One corner capital and two common Ionic capitals,* page 183); 79 (MP); 80 (CP, based in part on AS: *Nave arcade, Great Malvern Church, Worcestershire; 12th century,* page 27; *Pier: Clustered pier; old, Northamptonshire, c. 1450,* page 265; *Pier: Clustered pier of latest type, with one capital for the whole, Stogumber, Church of S. Mary, Somerset; c. 1500,* page 25); 81 (CP); 82 (CP); 83 (MP); 84 (CP); 85 (CP); 86 (CP); 87 (CP, adapted in part from AS: *Surface arcade, stone church, Kent,* page 27; *Intersecting arcade: Christ Church, Oxford; close of 12th century,* page 25); 88–89 (NM); 90–93 (MP).

Stairs: 94 (NM); 95 (NM and CP, based in part on a drawing by DR); 96 (CP); 97 (NM, with additions by CP); 98 (AS: *Staircase at Perigueux [Dordogne]: Neoclassic of 17th century, with local peculiarities of detail,* page 328).

Ornament and Moldings: 99 (JM); 100–101 (DR); 102–111 (MP); 112–114 (DR); 115 (NM); 116 (GS); 117–119 (MP).

Arches, Vaults and Domes: 120 (CP); 121–122 (NM, adapted in part from PE, plate 2); 123 (NM); 124 (CP); 125–126 (MP); 127 (NM, adapted from AS, pages 369–371); 128 (NM and CP, adapted from AS, pages 369–371 and 382); 129 (NM, adapted from AS: *Vaults: Fig. 44 (plan),* page 374; *Boss: St. Alban's Abbey Church, Hertfordshire,* page 64; *Rib, Fig. 2: Vaulting of 1260 with many ribs used for ornament alone, as those at the ridge of the vault and all the others not found in Fig. 1: Westminster Abbey,* page 287); 130 (AS: *Gothic Architecture: Figs. 7 and 8, Relation of rib to shell of vault,* page 181; *Squinch: Salisbury Cathedral, c. 1300,* page 326; *Romanesque Architecture: A domed church; S. front at Perigueux [Dordogne]; 13th century,* page 291); 131 (NM, adapted from PE, plate 18).

Describing Architecture: 132–134 (DR); 135 (DR, adapted from KH); 136 (DR); 137–139 (DR, adapted from MP); 140 (DR).

PREFACE

This book was created to allow the architect, historian, preservationist, student, and enthusiast of architecture and history to easily identify and learn the names of specific architectural terms. This book can be used as a field guide, as a tool to assist in formulating accurate architectural descriptions, or simply for general knowledge. It avoids the basic problem of traditional dictionaries — having to know the name of a term before being able to look it up — by allowing the reader first to visually identify a particular building element in a series of illustrations. Once the visual identification is made, the name of the term is given. This allows the definition to be easily found in the dictionary.

The numerous illustrations compiled here cover a wide range of styles and time periods, and provide an overview of architectural ornament and detailing. This broad range of architectural illustrations allows *Architecture and Ornament* to function not only as a traditional architectural dictionary but also as a design source or as an overview of architectural ornament and detailing.

HOW TO USE THIS BOOK

This dictionary can be used in several ways. The illustrations are arranged by building part (windows and doors, walls, roofs, etc.). If there is a building element that you would like to identify by name, scan the annotated illustrations in the chapter that corresponds to the element in question. For example, if the element you need to identify is part of a window, look through the chapter on windows and doors. At least one of the illustrations in the chapter should include the element you need to identify. (In many cases, a particular element appears several times in one chapter, as well as in other chapters.) Each element in the illustration is identified by name. After locating the name of the element you are interested in, turn to the dictionary in the second part of the book to read its definition. Figure numbers for illustrations of each element are found in brackets at the end of each definition: [30, 43].

The definitions included in the dictionary part of this book encompass most of the elements encountered in American architecture and in general architectural history courses of study. The most commonly used definition is given first, with secondary meanings following. Elements known by more than one name are defined under the most common name, with all secondary names cross-referenced to that definition. Similar and related terms are identified with the following notation: (*see also:*). Types and variations of terms are listed with this notation: (*for types see:*).

An important part of this book is the appendix on describing architecture, which provides a standardized format for describing buildings and includes examples of completed building descriptions. The checklist and sample descriptions, used in combination with the annotated illustrations and cross-referenced definitions, provide a complete resource for identifying and describing architecture.

THE ILLUSTRATIONS

WINDOWS
AND
DOORS

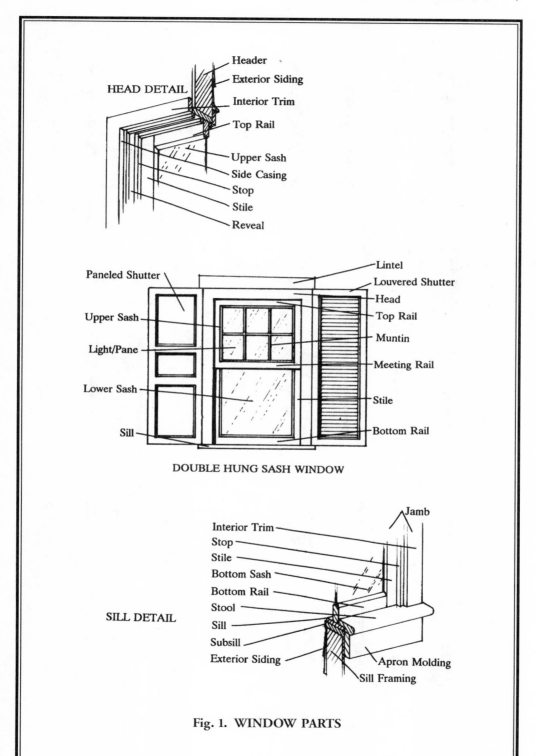

HEAD DETAIL

- Header
- Exterior Siding
- Interior Trim
- Top Rail
- Upper Sash
- Side Casing
- Stop
- Stile
- Reveal

Paneled Shutter

Upper Sash

Light/Pane

Lower Sash

Sill

- Lintel
- Louvered Shutter
- Head
- Top Rail
- Muntin
- Meeting Rail
- Stile
- Bottom Rail

DOUBLE HUNG SASH WINDOW

SILL DETAIL

Jamb

- Interior Trim
- Stop
- Stile
- Bottom Sash
- Bottom Rail
- Stool
- Sill
- Subsill
- Exterior Siding
- Apron Molding
- Sill Framing

Fig. 1. WINDOW PARTS

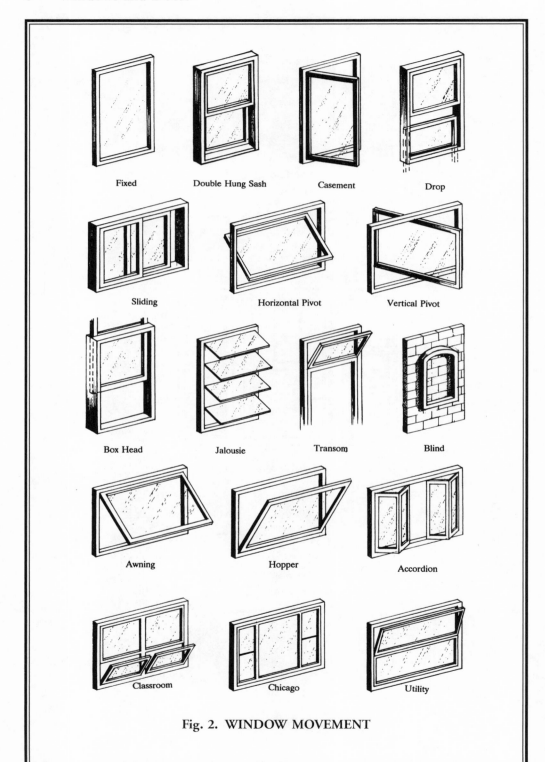

Fixed

Double Hung Sash

Casement

Drop

Sliding

Horizontal Pivot

Vertical Pivot

Box Head

Jalousie

Transom

Blind

Awning

Hopper

Accordion

Classroom

Chicago

Utility

Fig. 2. WINDOW MOVEMENT

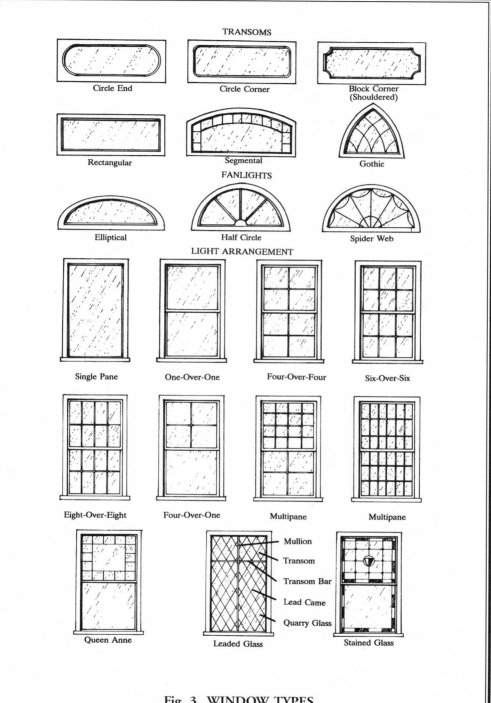

Fig. 3. WINDOW TYPES

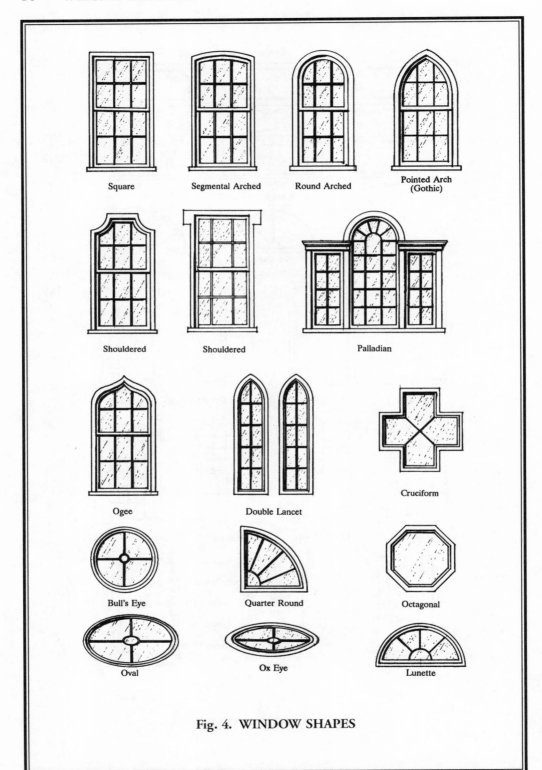

Square Segmental Arched Round Arched Pointed Arch (Gothic)

Shouldered Shouldered Palladian

Ogee Double Lancet Cruciform

Bull's Eye Quarter Round Octagonal

Oval Ox Eye Lunette

Fig. 4. WINDOW SHAPES

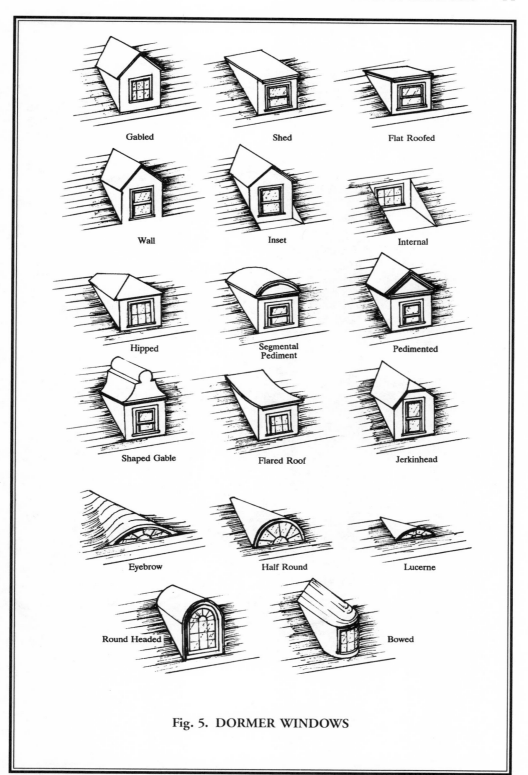

Gabled

Shed

Flat Roofed

Wall

Inset

Internal

Hipped

Segmental
Pediment

Pedimented

Shaped Gable

Flared Roof

Jerkinhead

Eyebrow

Half Round

Lucerne

Round Headed

Bowed

Fig. 5. DORMER WINDOWS

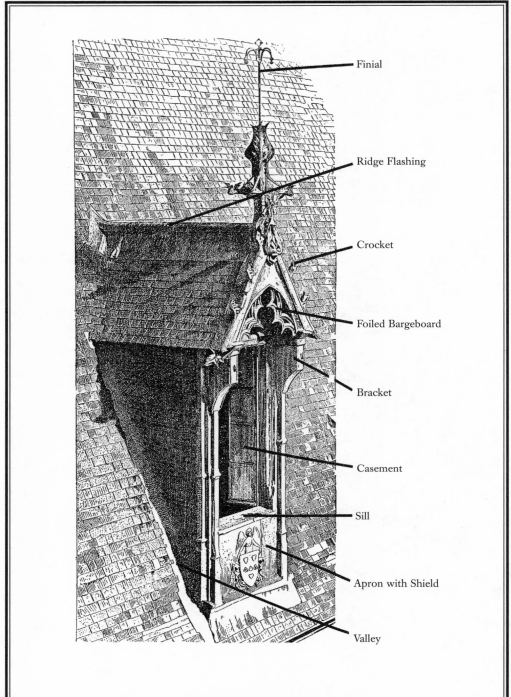

Finial

Ridge Flashing

Crocket

Foiled Bargeboard

Bracket

Casement

Sill

Apron with Shield

Valley

Fig. 6. GABLED DORMER

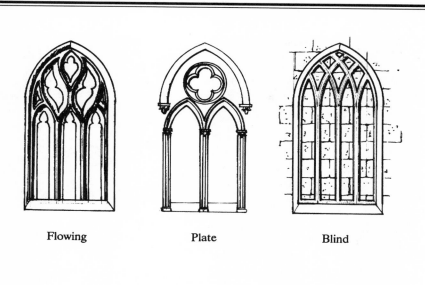

Flowing Plate Blind

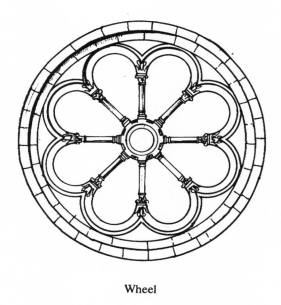

Wheel

Fig. 7. WINDOW TRACERY

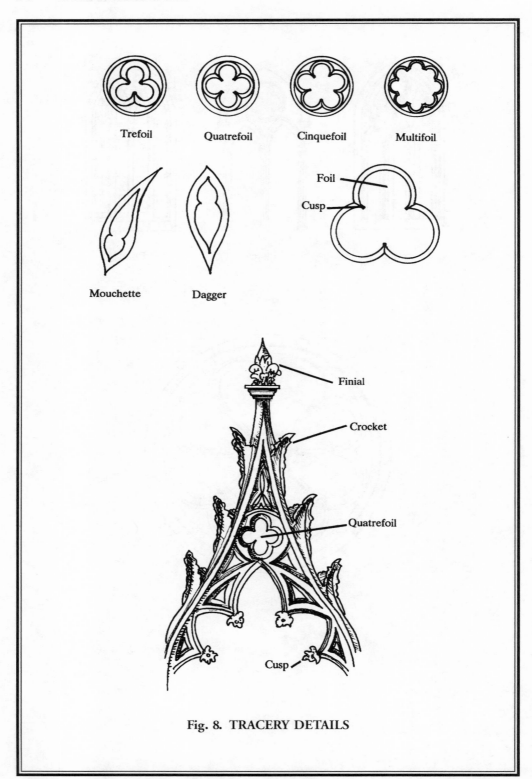

Trefoil Quatrefoil Cinquefoil Multifoil

Mouchette Dagger

Foil

Cusp

Finial

Crocket

Quatrefoil

Cusp

Fig. 8. TRACERY DETAILS

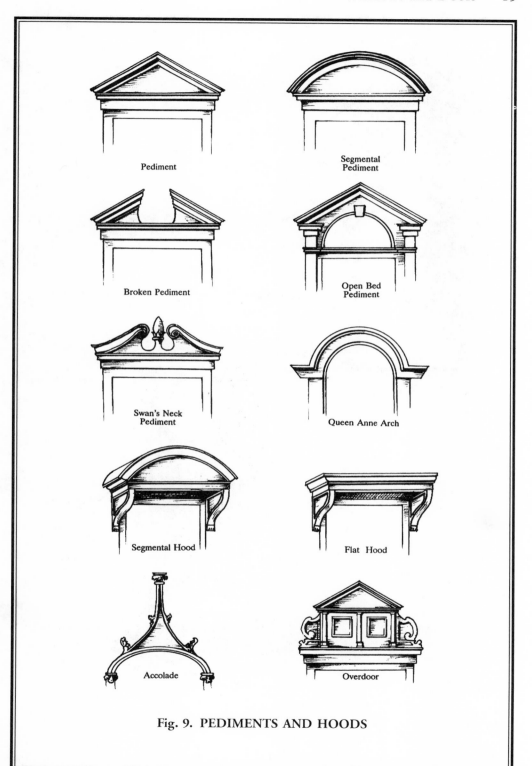

Pediment

Segmental
Pediment

Broken Pediment

Open Bed
Pediment

Swan's Neck
Pediment

Queen Anne Arch

Segmental Hood

Flat Hood

Accolade

Overdoor

Fig. 9. PEDIMENTS AND HOODS

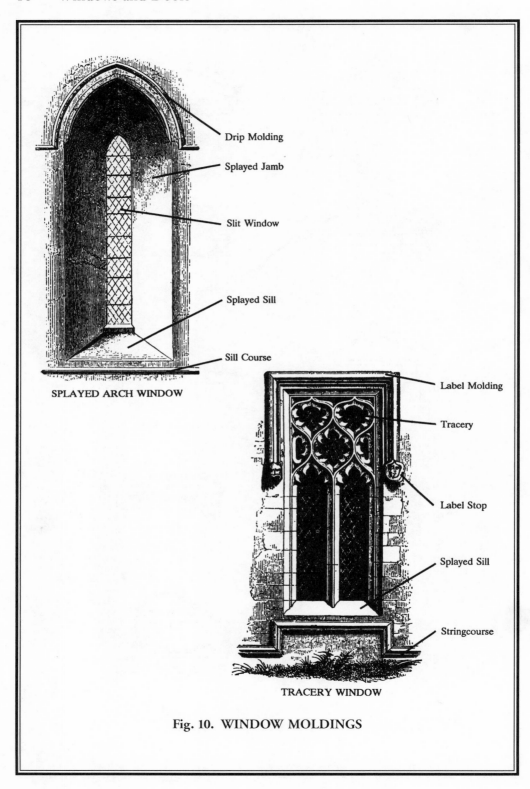

Drip Molding

Splayed Jamb

Slit Window

Splayed Sill

Sill Course

SPLAYED ARCH WINDOW

Label Molding

Tracery

Label Stop

Splayed Sill

Stringcourse

TRACERY WINDOW

Fig. 10. WINDOW MOLDINGS

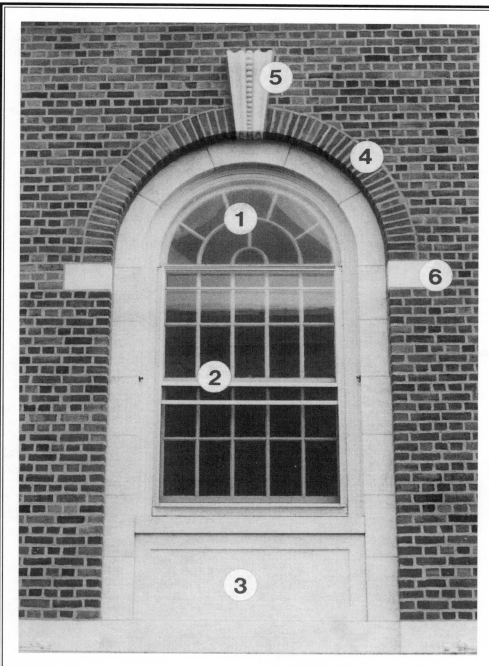

Fig. 11. ROUND ARCHED WINDOW
[1]Transom [2]Double-Hung Sash [3]Sunk Panel
[4]Voussoirs [5]Keystone with Pearl Molding [6]Impost

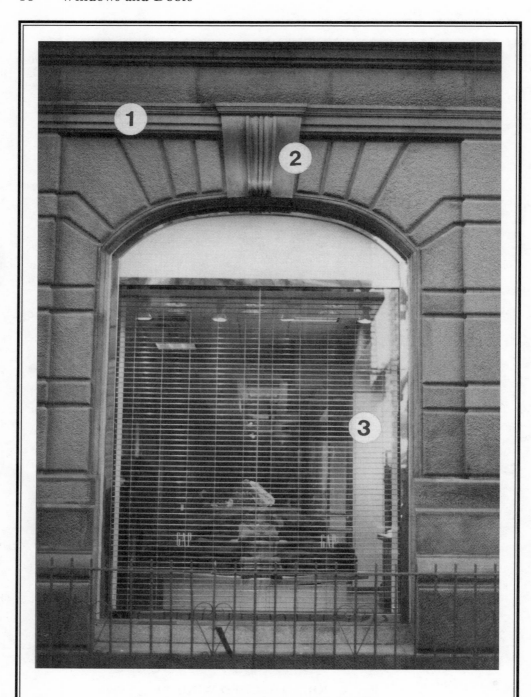

Fig. 12. ELLIPTICAL ARCHED WINDOW
[1]Cornice [2]Volute Keystone [3]Security Gate

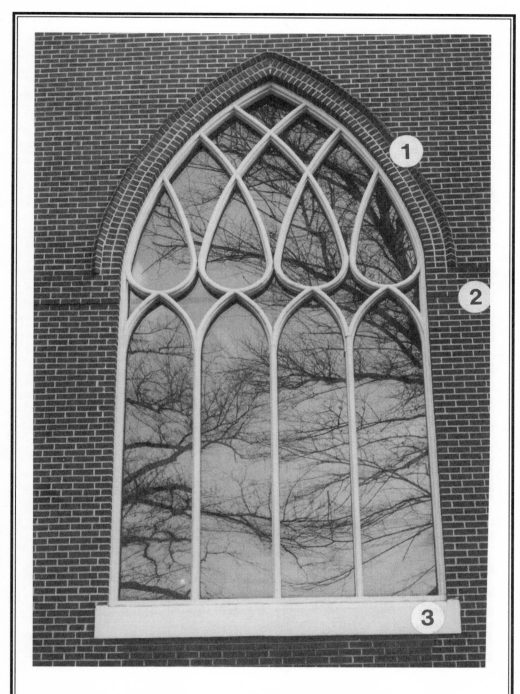

Fig. 13. POINTED ARCH TRACERY WINDOW
[1]Molded Brick Arch [2]Brick Stringcourse [3]Sill

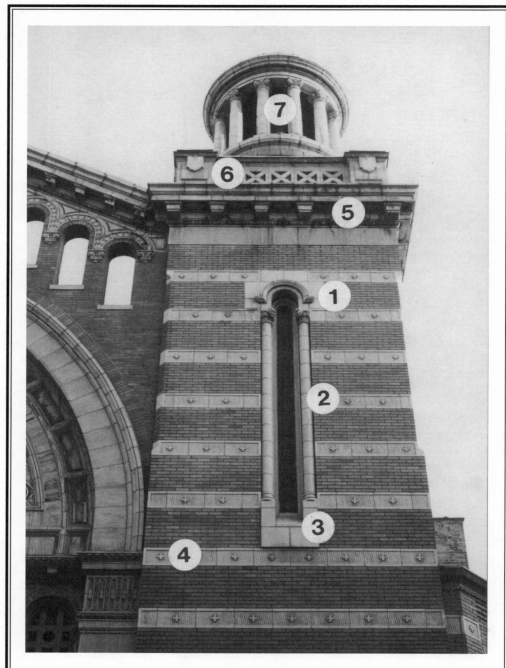

Fig. 14. TOWER WITH SLIT WINDOW
[1]Stilted Arch [2]Jamb Shaft [3]Splayed Sill [4]Striated Masonry
[5]Block Modillion [6]Balustrade [7]Rotunda

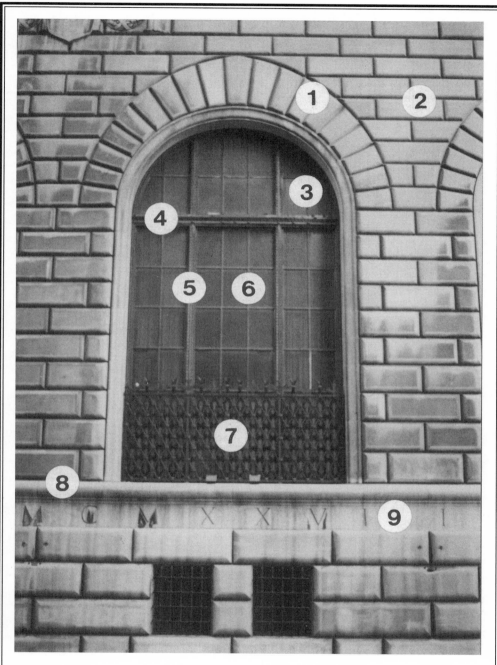

Fig. 15. VENETIAN ARCHED WINDOW
[1]Venetian Arch [2]Rusticated Masonry [3]Multipane Transom [4]Transom Bar [5]Mullion
[6]Muntin [7]Decorative Window Grille [8]Sill Course [9]Band Course

Fig. 16. ROUND ARCHED WINDOW
[1]Brick Keystone [2]Brick Arch [3]Impost [4]Multipane Transom [5]Eight-Over-Eight
Double-Hung Sash Window [6]Plain Stone Sill [7]Broken Coursed, Rock-Faced Stone

Fig. 17. ROUND ARCHED WINDOW
[1]Drip Molding [2]Egg and Dart Molding [3]Fluted Band [4]Transom
[5]Decorative Window Grille [6]Sill Course [7]Apron with Putti and Rinceau

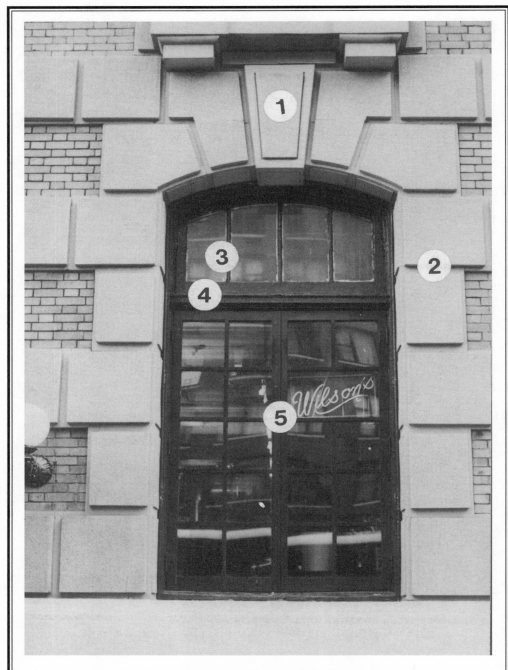

Fig. 18. SEGMENTALLY ARCHED WINDOW
[1]Paneled Keystone [2]Rusticated Surround [3]Segmental Transom
[4]Transom Bar [5]Multipane Casements

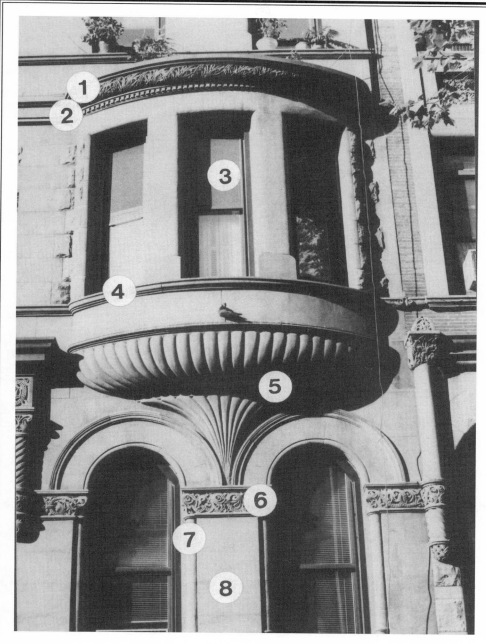

Fig. 19. BOWED ORIEL WINDOW
[1]Molding of Entwined Foliage [2]Dentil Molding
[3]One-Over-One Double-Hung Window [4]Sill Course [5]Gadrooned Support
[6]Rinceau [7]Jamb Shaft [8]Paired Round Arched Windows

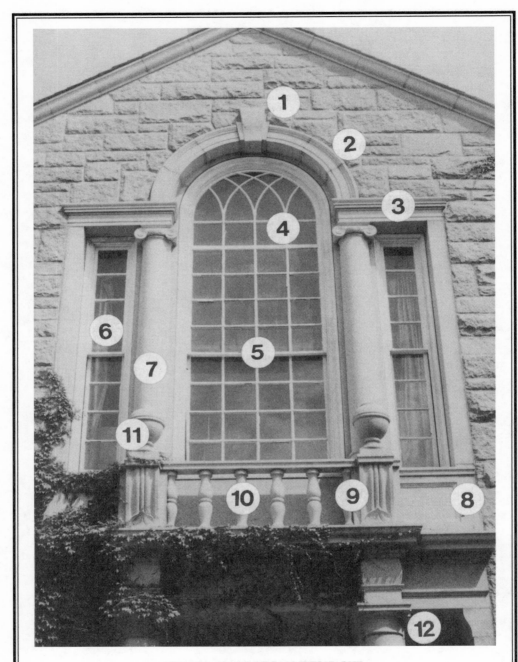

Fig. 20. PALLADIAN WINDOW
[1]Double Keystone [2]Round Arched Surround [3]Flat Lintel [4]Transom
[5]Multipane Double-Hung Sash [6]Double-Hung Sidelights [7]Engaged Ionic
Columns [8]Sunk Panel [9]Balconette [10]Baluster [11]Urn [12]Doric Column

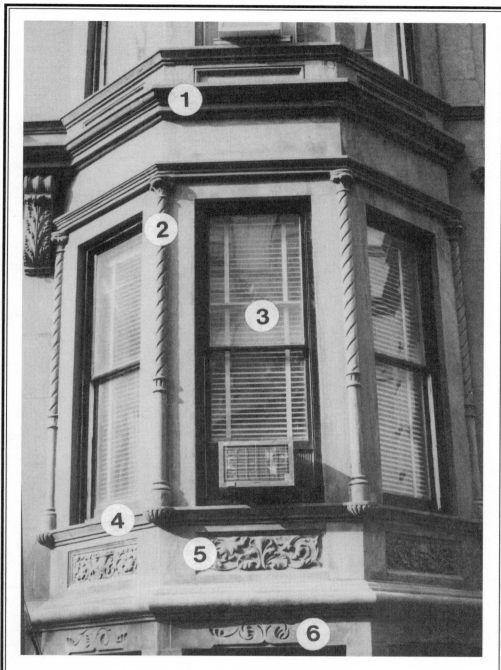

Fig. 21. BAY WINDOW
[1]Cornice [2]Spiral Colonette [3]One-Over-One Double-Hung Window
[4]Continuous Sill [5]Apron with Arabesque Ornament [6]Incised Ornament

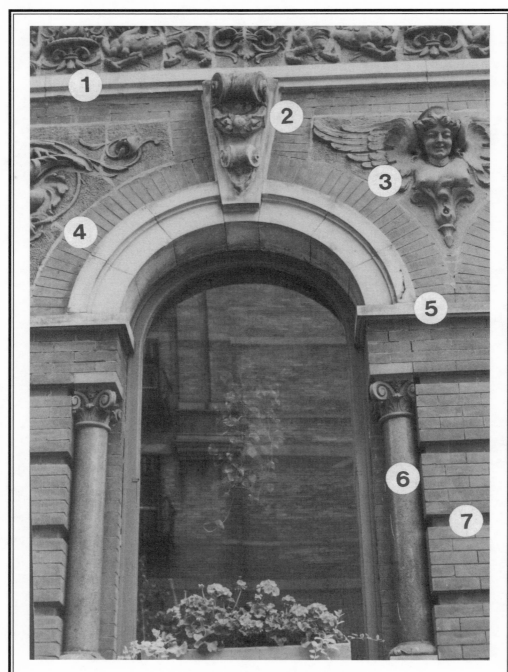

Fig. 22. ROUND ARCHED WINDOW
[1]Stringcourse [2]Oversize Keystone with Volute and Garland [3]Cherub
[4]Brick Voussoirs [5]Impost [6]Jamb Shaft [7]Rusticated Brickwork

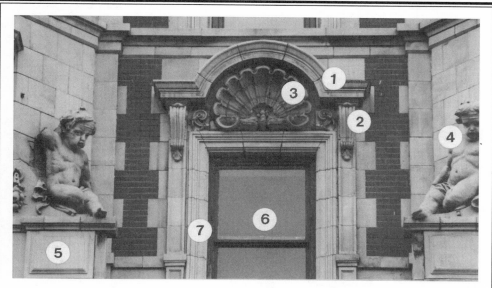

Fig. 23. ORNAMENTED WINDOW SURROUND
[1]Queen Anne Hood [2]Ancon [3]Scallop Ornament [4]Putti
[5]Pedestal with Raised Panel [6]Double-Hung Window [7]Molded Architrave

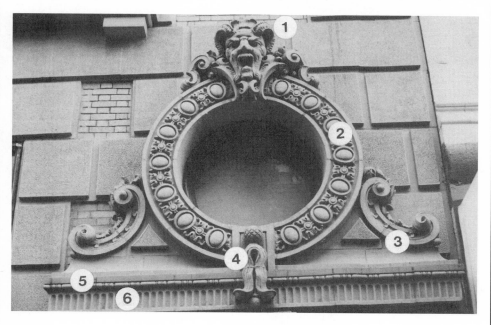

Fig. 24. BULL'S EYE WINDOW
[1]Mask [2]Egg and Leaf Molding [3]Scroll Ornament [4]Bell Flower
[5]Bead and Reel Molding [6]Fluted Molding

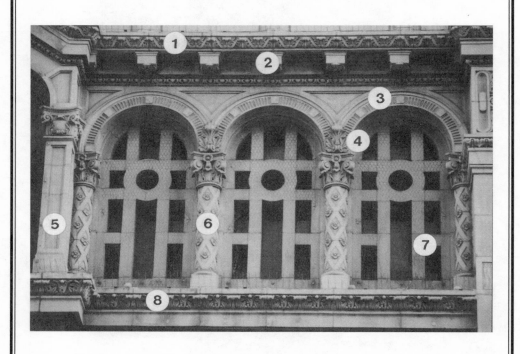

Fig. 25. GROUPED, ROUND ARCHED WINDOWS
[1]Acanthus Molding [2]Modillion [3]Fluted Molding [4]Anthemion [5]Paneled Pilaster
[6]Column with Rosettes and Latticework [7]Grille [8]Acanthus and Bell Flower Molding

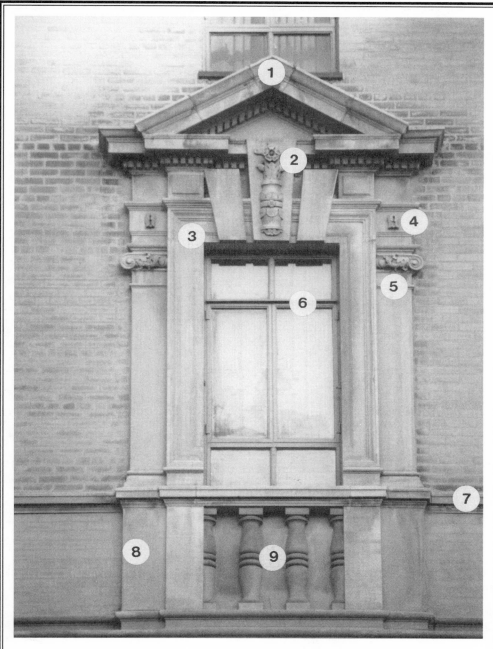

Fig. 26. PEDIMENTED WINDOW SURROUND
[1]Open Bed Pediment [2]Ornamented Keystone [3]Molded Architrave
[4]Bell Flower [5]Ionic Pilaster [6]Casement Window with Transom
[7]Sill Course [8]Pedestal [9]Blind Balustrade

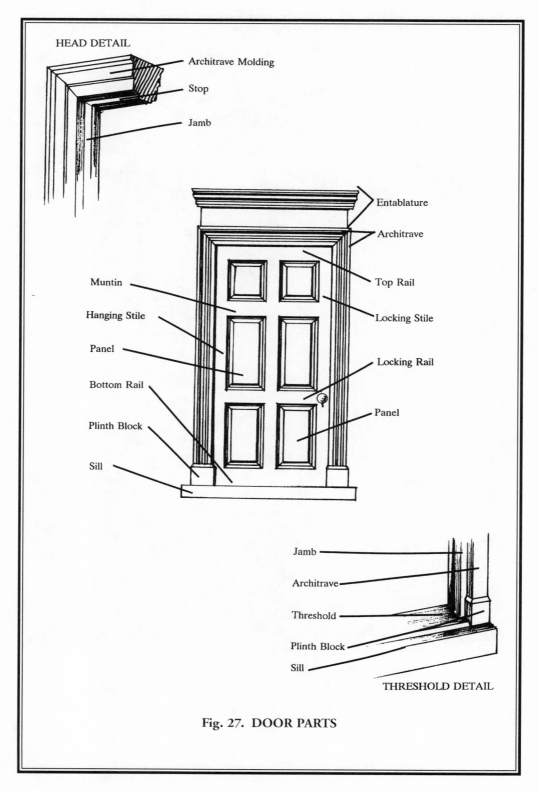

Fig. 27. DOOR PARTS

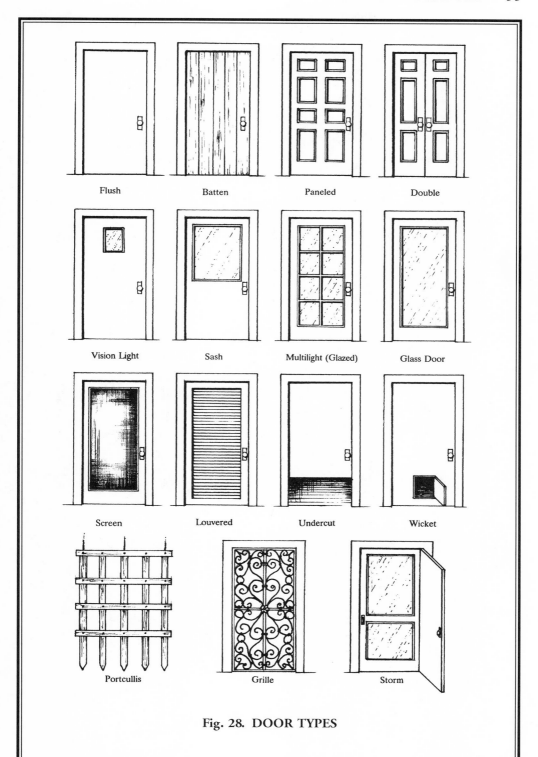

Flush Batten Paneled Double

Vision Light Sash Multilight (Glazed) Glass Door

Screen Louvered Undercut Wicket

Portcullis Grille Storm

Fig. 28. DOOR TYPES

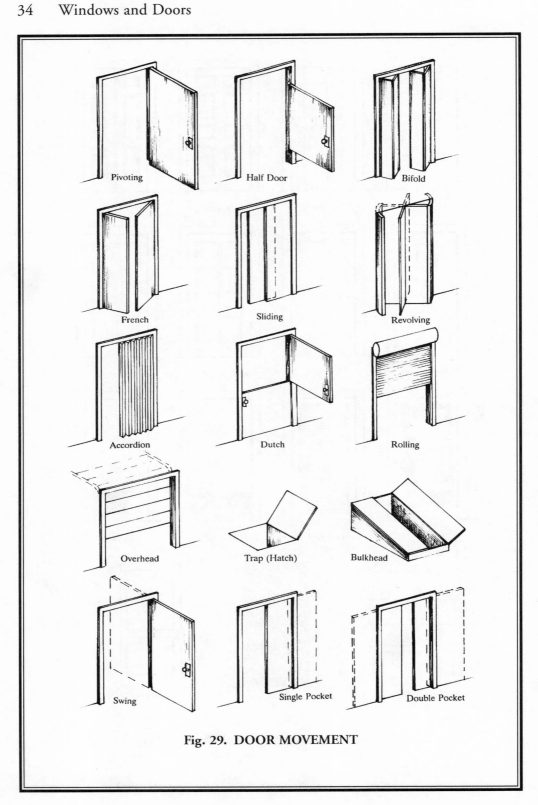

Fig. 29. DOOR MOVEMENT

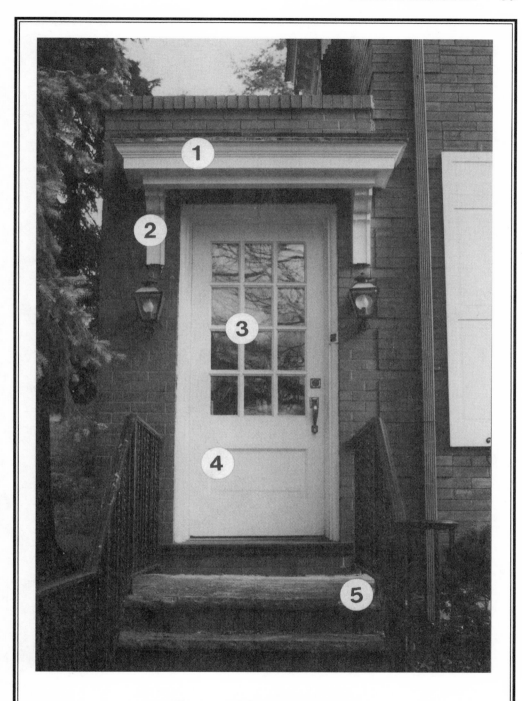

Fig. 30. DOOR WITH HOOD
[1]Molded Hood [2]Bracket [3]Multilight Door [4]Panel [5]Stoop

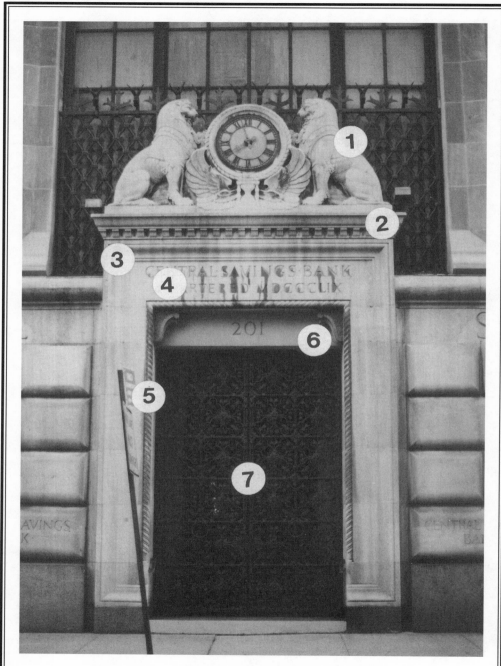

Fig. 31. ORNAMENTED DOOR SURROUND
[1]Affronted Lions and Eagles [2]Cornice with Dentil Molding [3]Molded Architrave
[4]Inscription [5]Rope Molding [6]Volutes [7]Ornamental Grille

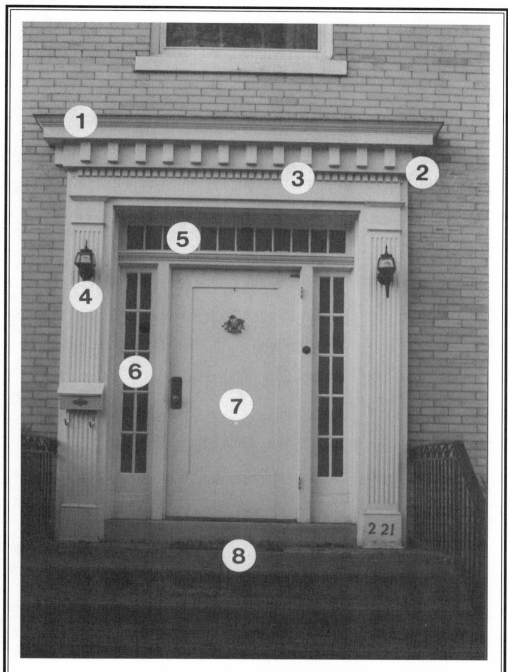

Fig. 32. CLASSICAL DOOR SURROUND
[1]Cornice [2]Entablature [3]Dentils [4]Fluted Pilasters [5]Multipane Transom
[6]Multipane Sidelights [7]Paneled Door [8]Stoop

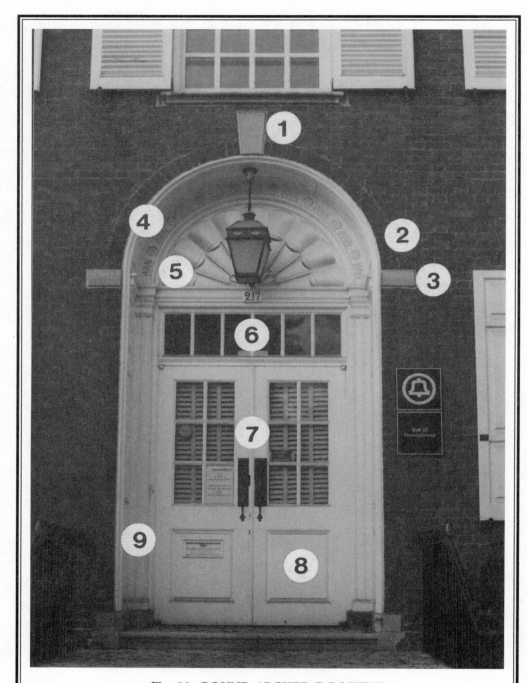

Fig. 33. ROUND ARCHED DOORWAY
[1]Keystone [2]Brick Surround [3]Impost [4]Paneled Soffit [5]Solid Molded Fanlight
[6]Multipane Transom [7]Paired Multilight Doors [8]Raised Panel [9]Attenuated Pilaster

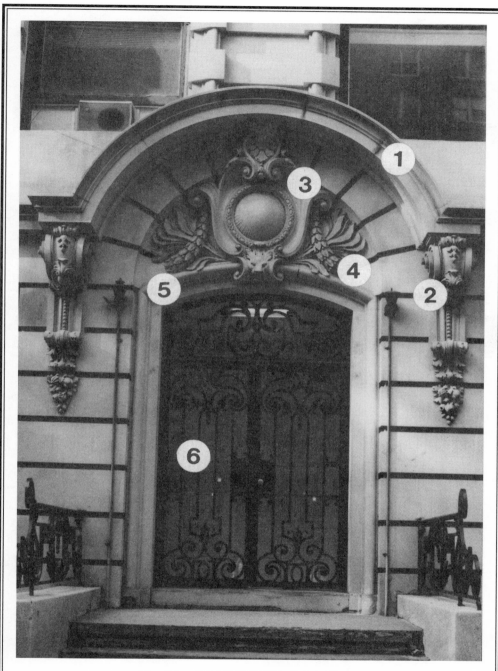

Fig. 34. ORNAMENTED DOORWAY
[1]Oversized Queen Anne Pediment [2]Oversized Console
[3]Oversized Cartouche [4]Festoon [5]Segmental Arch [6]Ornamental Grille

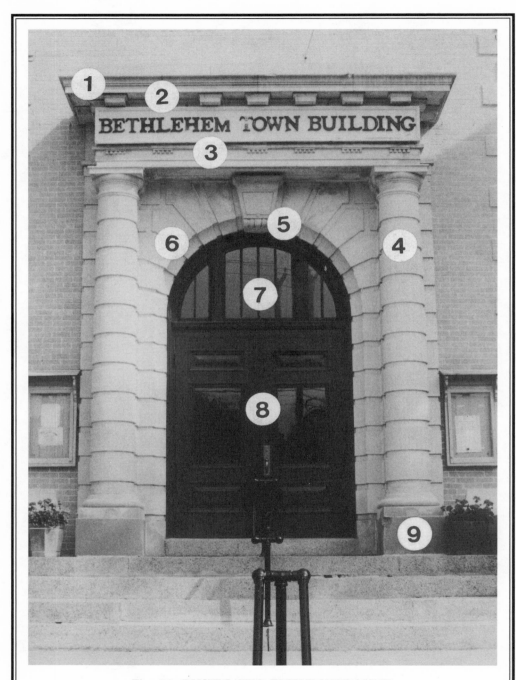

Fig. 35. RUSTICATED ENTRY SURROUND
[1]Cornice [2]Modillions [3]Taenia with Guttae [4]Banded Columns
[5]Paneled Keystone [6]Voussoirs [7]Tripartite Transom [8]Paired Doors [9]Pedestal

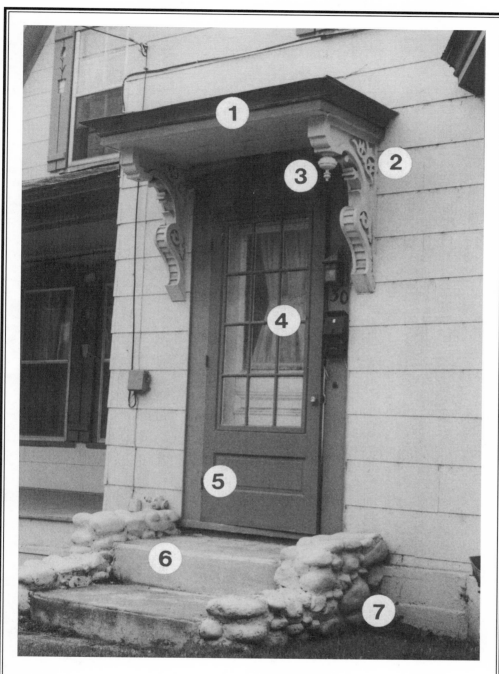

Fig. 36. DOOR WITH HOOD
[1]Simple Hood [2]Elaborate Console with Scrollwork [3]Pendant Ornament
[4]Multilight Door [5]Raised Panel [6]Stoop [7]Stone Cheek Wall

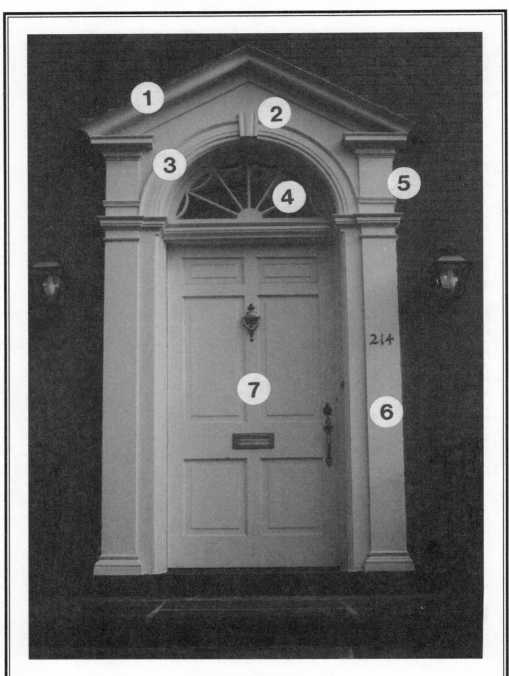

Fig. 37. PEDIMENTED DOORWAY
[1]Open Bed Pediment [2]Molded Keystone [3]Molded Round Arch
[4]Spider Web Fanlight [5]Entablature [6]Doric Pilaster [7]Paneled Door

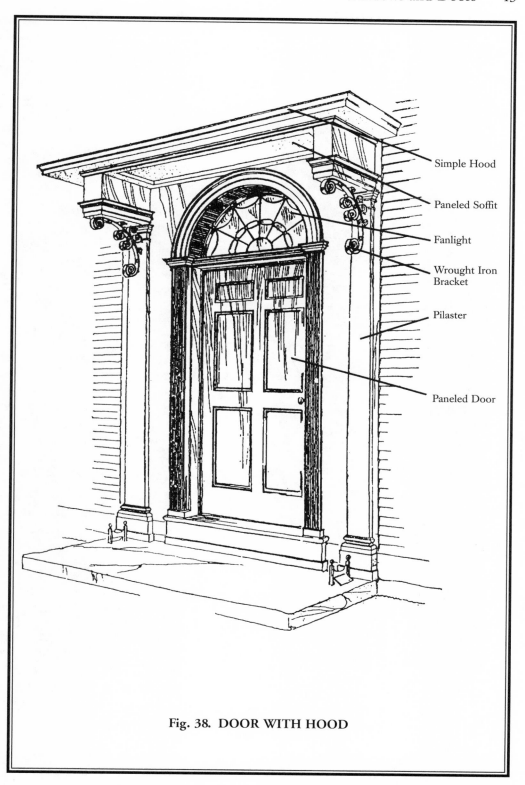

Simple Hood

Paneled Soffit

Fanlight

Wrought Iron
Bracket

Pilaster

Paneled Door

Fig. 38. DOOR WITH HOOD

WALLS

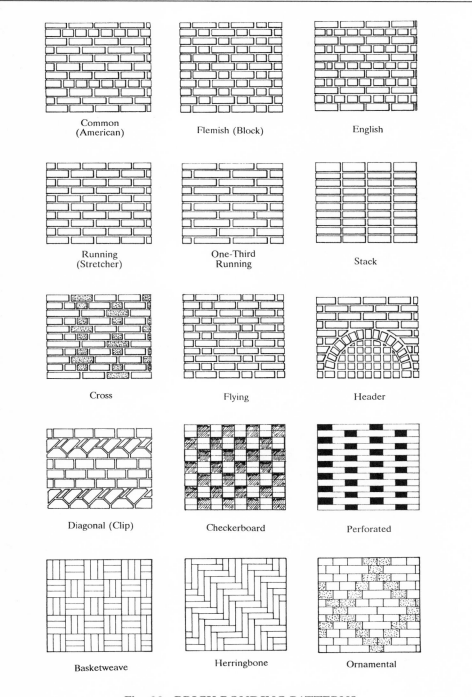

Fig. 39. BRICK BONDING PATTERNS

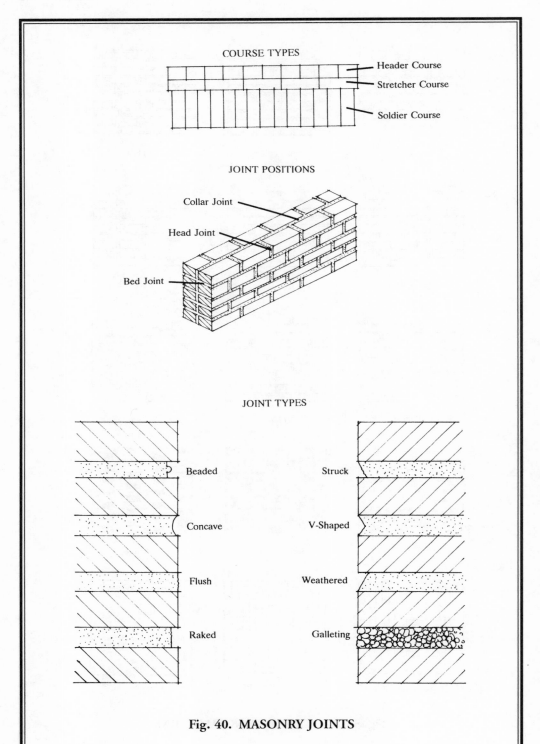

COURSE TYPES

Header Course
Stretcher Course
Soldier Course

JOINT POSITIONS

Collar Joint
Head Joint
Bed Joint

JOINT TYPES

Beaded
Concave
Flush
Raked

Struck
V-Shaped
Weathered
Galleting

Fig. 40. MASONRY JOINTS

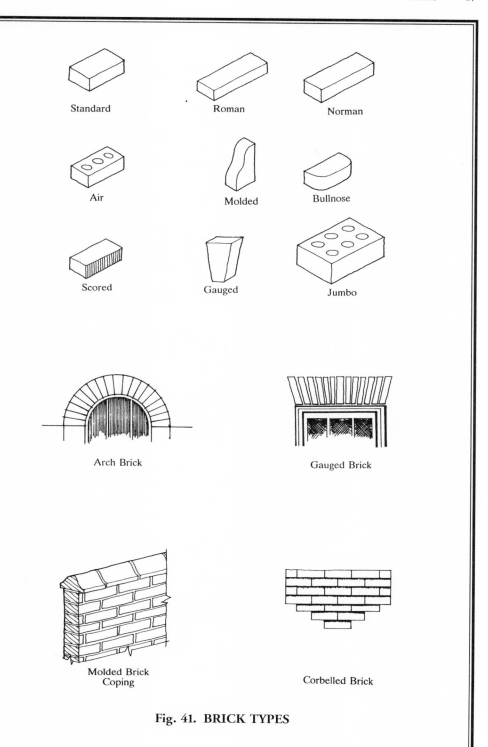

Fig. 41. BRICK TYPES

SPECIAL SIZES

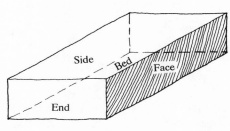

Three-Quarter Queen Closer King Closer Quarter Closer Half Brick

PARTS

Side Bed Face

End

POSITIONS

Sailor Soldier Stretcher Shiner Header Rowlock

Fig. 42. BRICK DETAILS

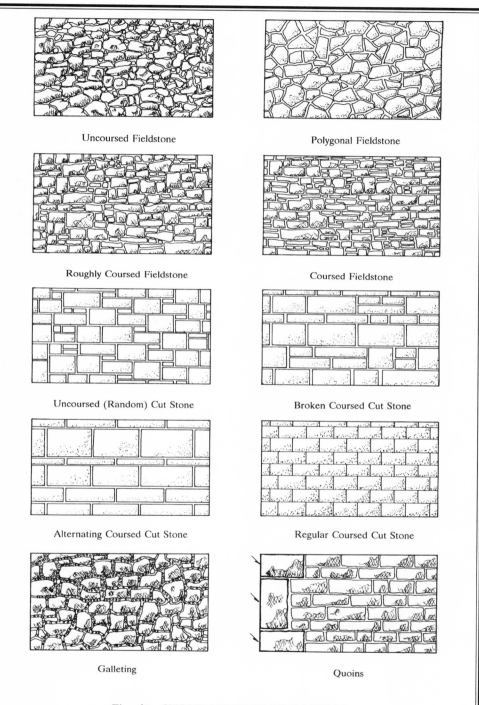

Uncoursed Fieldstone

Polygonal Fieldstone

Roughly Coursed Fieldstone

Coursed Fieldstone

Uncoursed (Random) Cut Stone

Broken Coursed Cut Stone

Alternating Coursed Cut Stone

Regular Coursed Cut Stone

Galleting

Quoins

Fig. 43. STONE BONDING PATTERNS

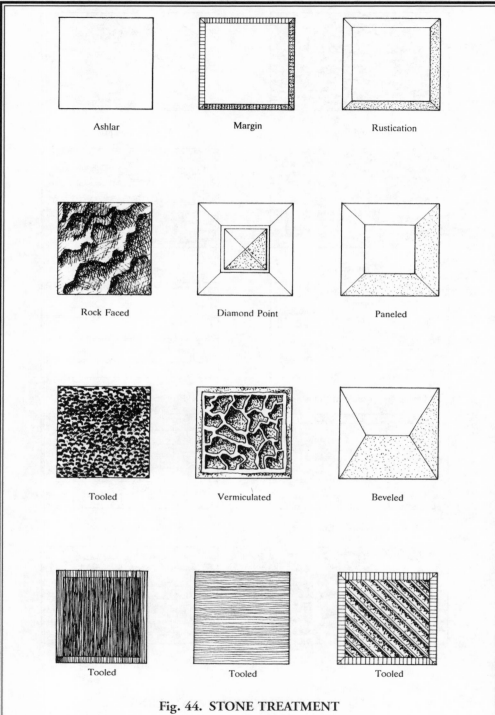

Ashlar Margin Rustication

Rock Faced Diamond Point Paneled

Tooled Vermiculated Beveled

Tooled Tooled Tooled

Fig. 44. STONE TREATMENT

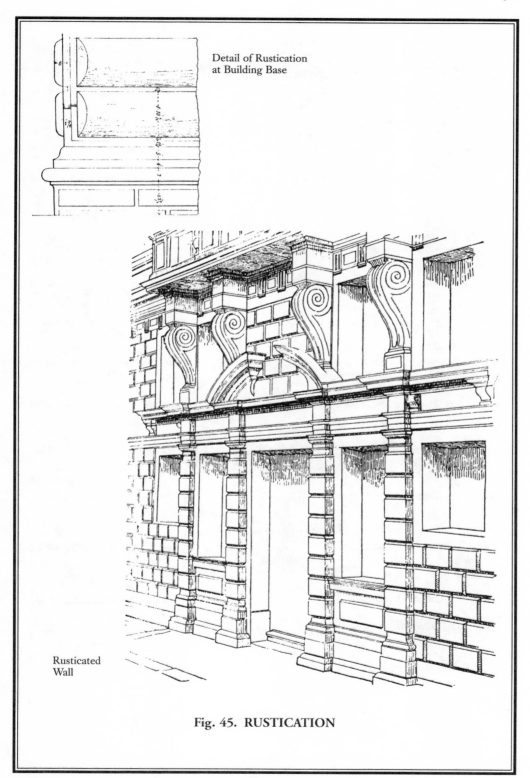

Detail of Rustication
at Building Base

Rusticated
Wall

Fig. 45. RUSTICATION

Fig. 46. WALL OF RUSTICATED STONEWORK

Fig. 47. TOOLED MASONRY

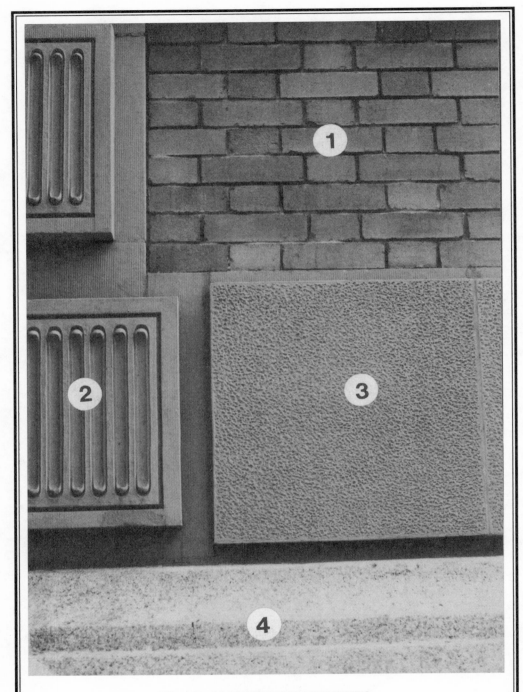

Fig. 48. MASONRY TREATMENTS
[1]Flemish Bond Brickwork [2]Fluted Panel [3]Tooled Masonry [4]Molded Stonework

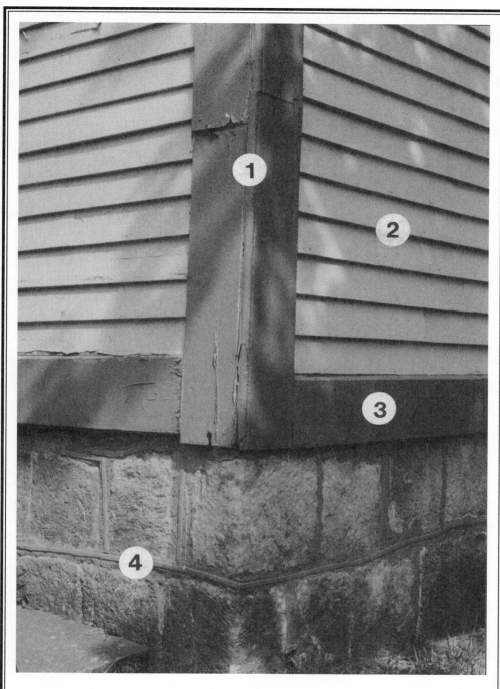

Fig. 49. CORNER DETAIL
[1]Corner Board [2]Clapboards [3]Sill [4]Stone Foundation

Fig. 50. MASONRY TREATMENTS
[1]Regular Coursed Ashlar [2]Coursed, Rock-Faced Stone

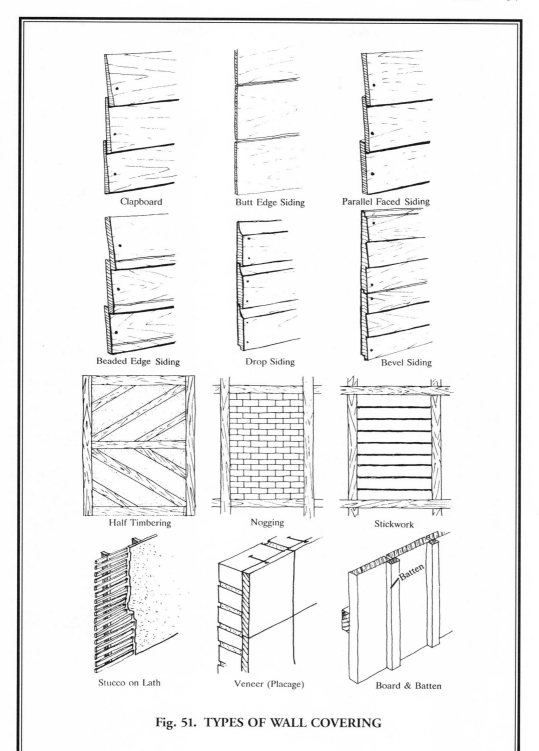

Clapboard

Butt Edge Siding

Parallel Faced Siding

Beaded Edge Siding

Drop Siding

Bevel Siding

Half Timbering

Nogging

Stickwork

Stucco on Lath

Veneer (Placage)

Batten

Board & Batten

Fig. 51. TYPES OF WALL COVERING

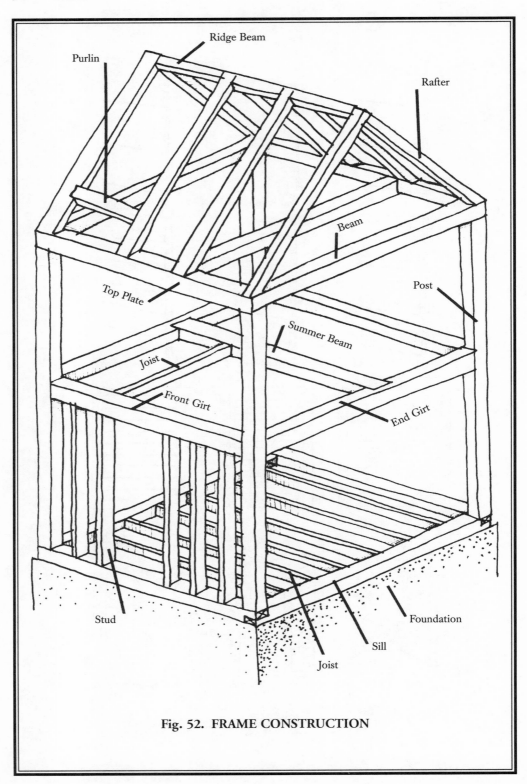

Fig. 52. FRAME CONSTRUCTION

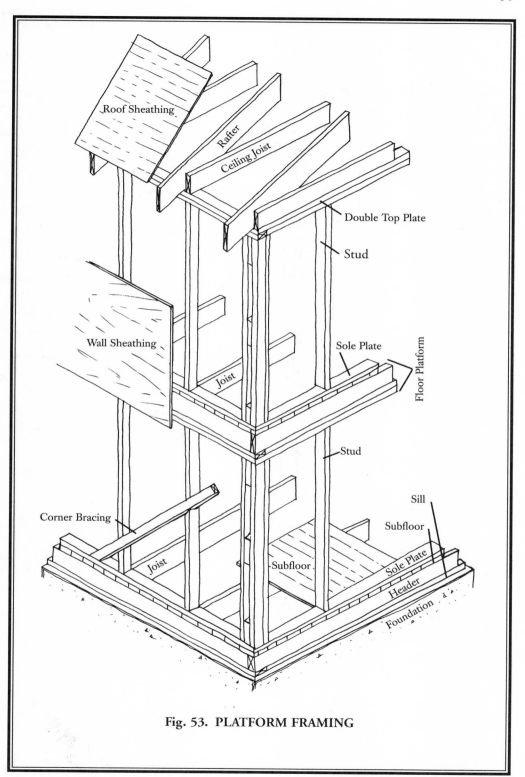

Roof Sheathing

Rafter

Ceiling Joist

Double Top Plate

Stud

Wall Sheathing

Joist

Sole Plate

Floor Platform

Stud

Corner Bracing

Joist

Subfloor

Sill

Subfloor

Sole Plate

Header

Foundation

Fig. 53. PLATFORM FRAMING

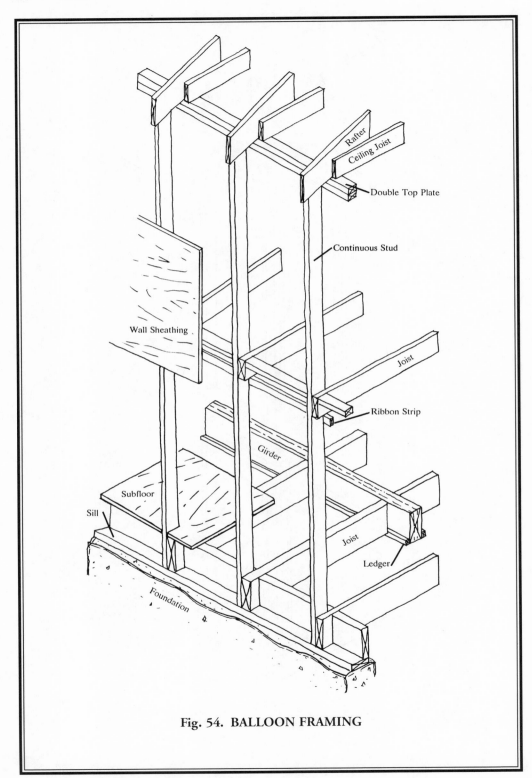

Fig. 54. BALLOON FRAMING

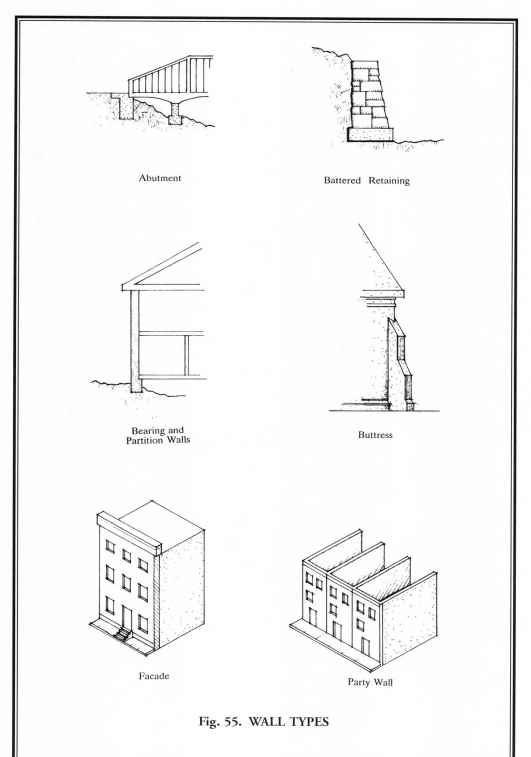

Abutment

Battered Retaining

Bearing and
Partition Walls

Buttress

Facade

Party Wall

Fig. 55. WALL TYPES

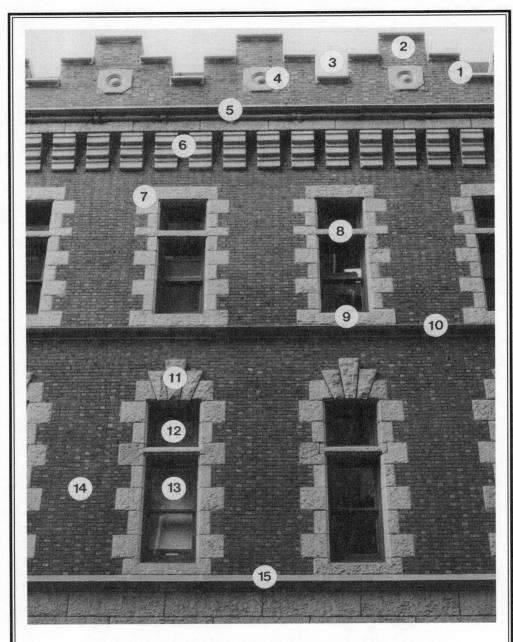

Fig. 56. WALL WITH ORNAMENTAL FORTIFICATIONS
[1]Battlement [2]Merlon [3]Crenel [4]Shield with Central Roundel [5]Stringcourse
[6]Corbel Table [7]Quoined Surround [8]Transom Bar [9]Sill [10]Sill Course
[11]Keystone [12]Transom [13]One-Over-One Double-Hung Sash
[14]Flemish Bond Brickwork [15]Sill Course

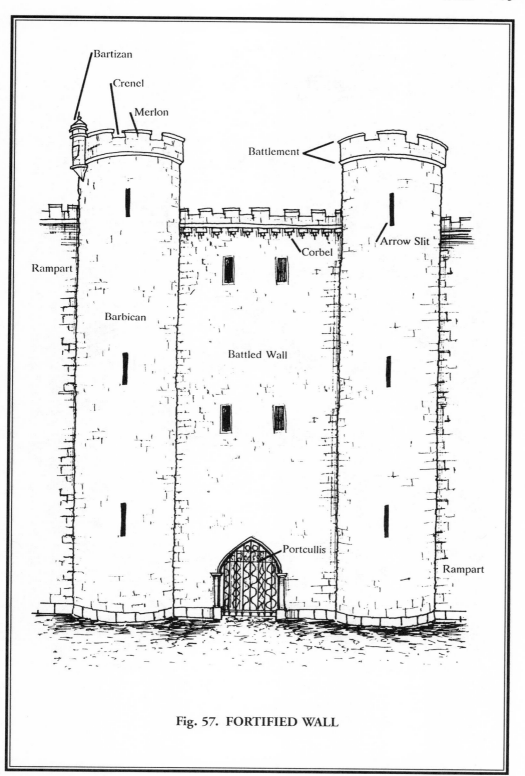

Fig. 57. FORTIFIED WALL

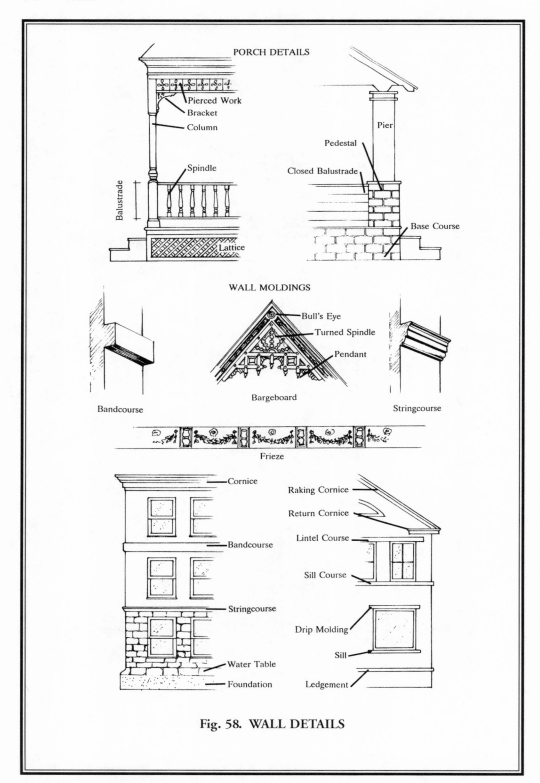

PORCH DETAILS

Pierced Work
Bracket
Column
Spindle
Balustrade
Lattice

Pier
Pedestal
Closed Balustrade
Base Course

WALL MOLDINGS

Bull's Eye
Turned Spindle
Pendant

Bandcourse

Bargeboard

Stringcourse

Frieze

Cornice
Bandcourse
Stringcourse
Water Table
Foundation

Raking Cornice
Return Cornice
Lintel Course
Sill Course
Drip Molding
Sill
Ledgement

Fig. 58. WALL DETAILS

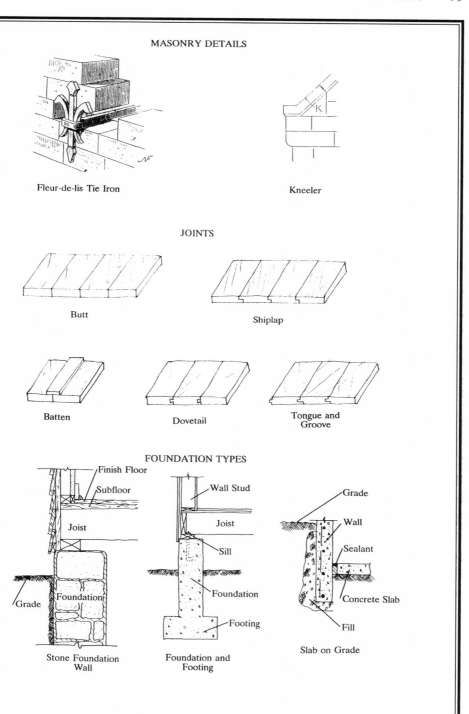

MASONRY DETAILS

Fleur-de-lis Tie Iron

Kneeler

JOINTS

Butt

Shiplap

Batten

Dovetail

Tongue and Groove

FOUNDATION TYPES

Finish Floor
Subfloor
Joist
Grade
Foundation
Stone Foundation Wall

Wall Stud
Joist
Sill
Foundation
Footing
Foundation and Footing

Grade
Wall
Sealant
Concrete Slab
Fill
Slab on Grade

Fig. 59. WALL AND FOUNDATION DETAILS

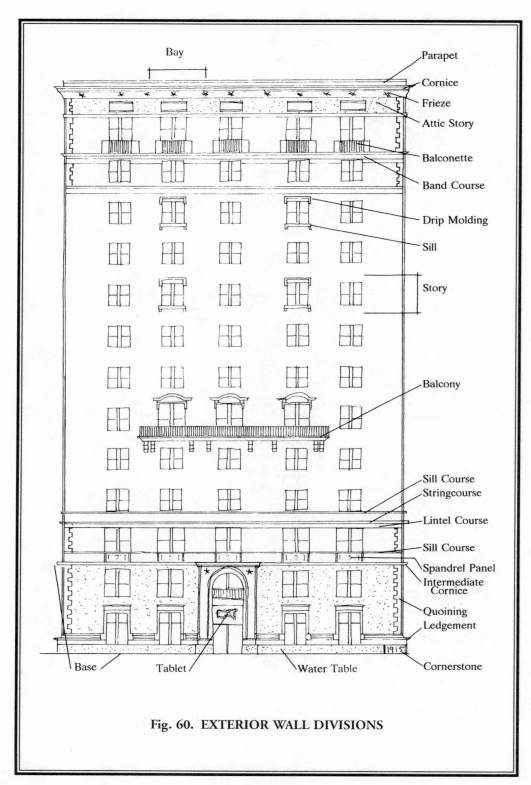

Fig. 60. EXTERIOR WALL DIVISIONS

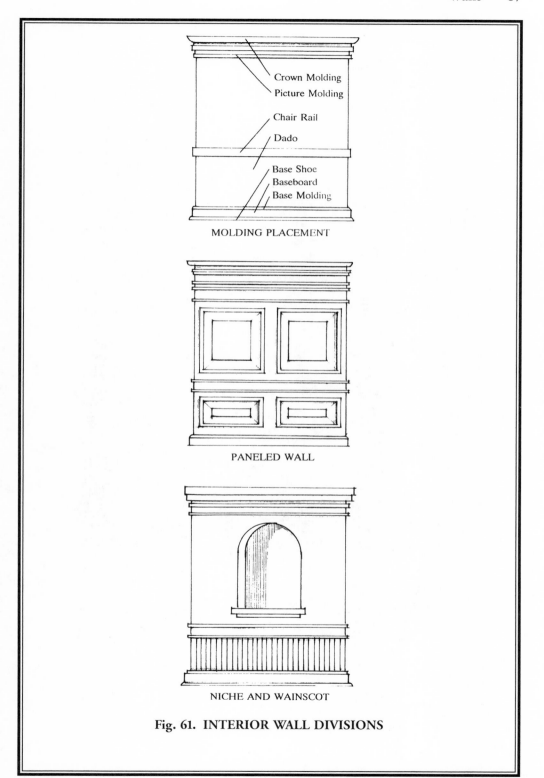

Crown Molding
Picture Molding

Chair Rail

Dado

Base Shoe
Baseboard
Base Molding

MOLDING PLACEMENT

PANELED WALL

NICHE AND WAINSCOT

Fig. 61. INTERIOR WALL DIVISIONS

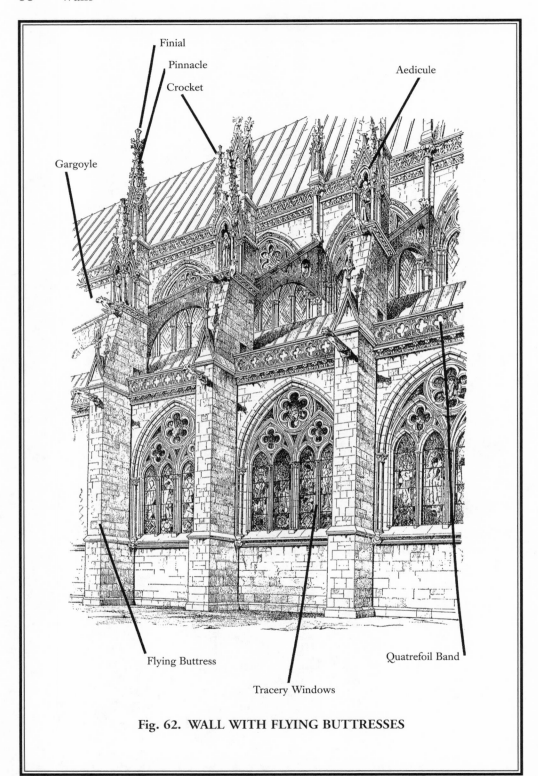

Finial

Pinnacle

Crocket

Aedicule

Gargoyle

Flying Buttress

Tracery Windows

Quatrefoil Band

Fig. 62. WALL WITH FLYING BUTTRESSES

Roofs

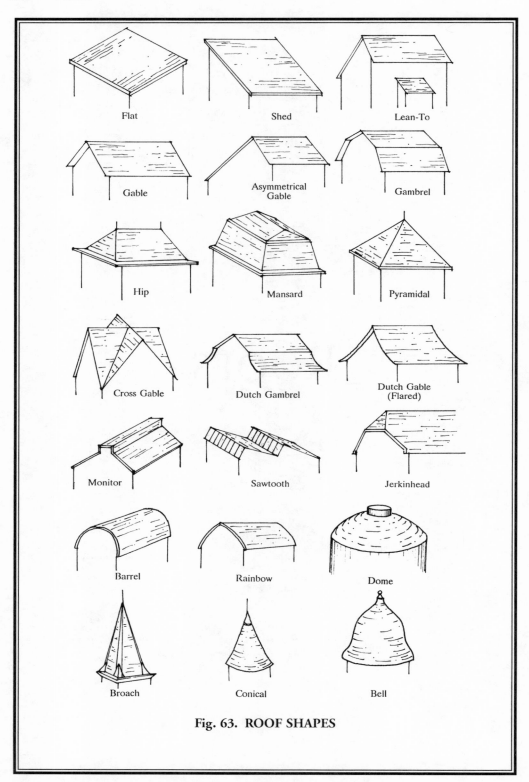

Flat

Shed

Lean-To

Gable

Asymmetrical Gable

Gambrel

Hip

Mansard

Pyramidal

Cross Gable

Dutch Gambrel

Dutch Gable (Flared)

Monitor

Sawtooth

Jerkinhead

Barrel

Rainbow

Dome

Broach

Conical

Bell

Fig. 63. ROOF SHAPES

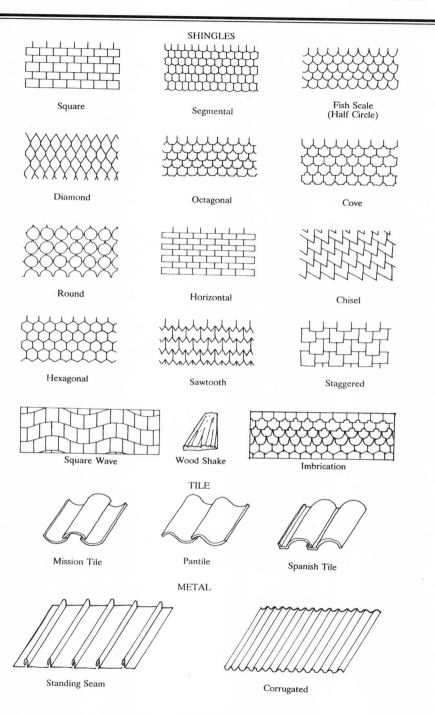

Fig. 64. ROOF COVERING

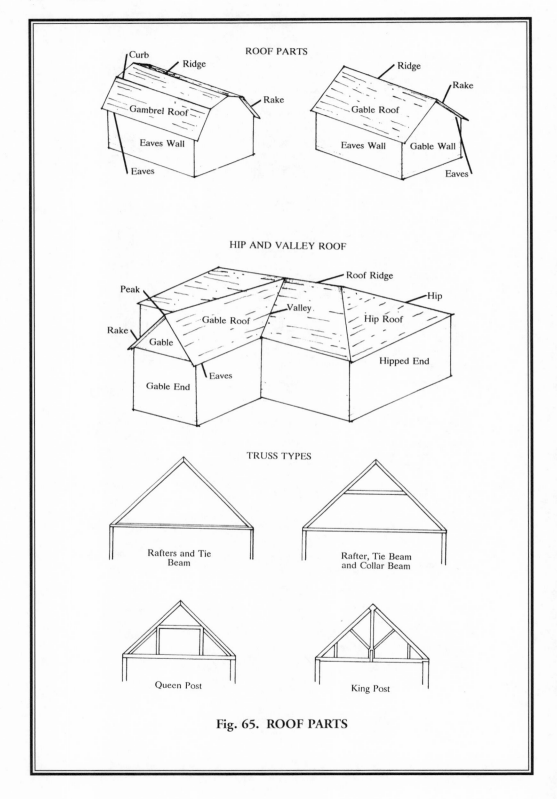

ROOF PARTS

Curb
Ridge
Rake
Gambrel Roof
Eaves Wall
Eaves

Ridge
Rake
Gable Roof
Eaves Wall
Gable Wall
Eaves

HIP AND VALLEY ROOF

Roof Ridge
Peak
Hip
Valley
Rake
Hip Roof
Gable Roof
Gable
Eaves
Hipped End
Gable End

TRUSS TYPES

Rafters and Tie Beam

Rafter, Tie Beam and Collar Beam

Queen Post

King Post

Fig. 65. ROOF PARTS

FRAME ROOF

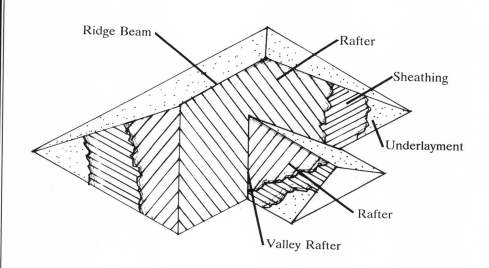

TRUSS ROOF

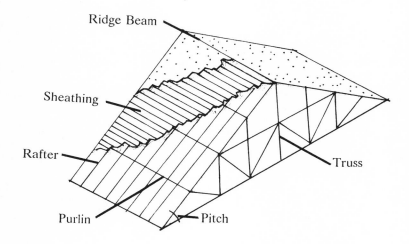

Fig. 66. ROOF STRUCTURE

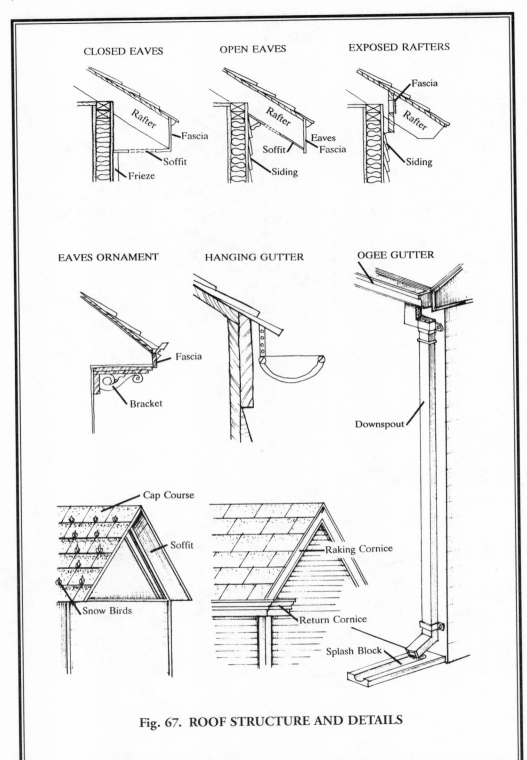

CLOSED EAVES

OPEN EAVES

EXPOSED RAFTERS

Rafter
Fascia
Soffit
Frieze

Rafter
Eaves
Fascia
Soffit
Siding

Fascia
Rafter
Siding

EAVES ORNAMENT

HANGING GUTTER

OGEE GUTTER

Fascia
Bracket

Downspout

Cap Course
Soffit
Snow Birds

Raking Cornice
Return Cornice
Splash Block

Fig. 67. ROOF STRUCTURE AND DETAILS

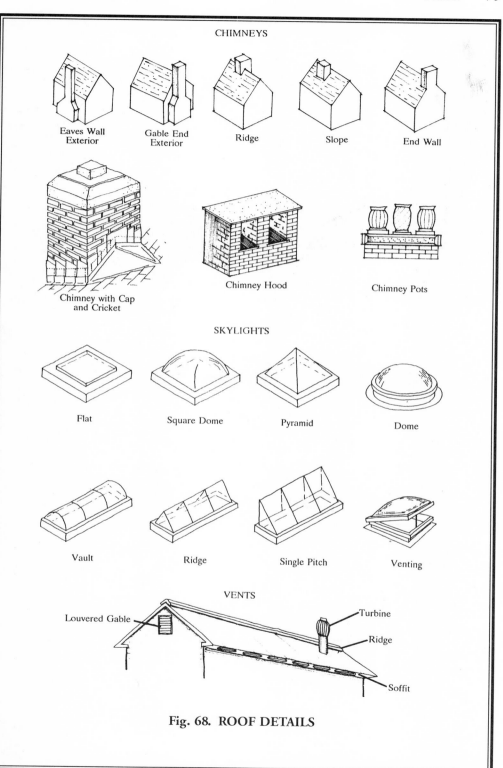

CHIMNEYS

Eaves Wall
Exterior

Gable End
Exterior

Ridge

Slope

End Wall

Chimney with Cap
and Cricket

Chimney Hood

Chimney Pots

SKYLIGHTS

Flat

Square Dome

Pyramid

Dome

Vault

Ridge

Single Pitch

Venting

VENTS

Louvered Gable

Turbine

Ridge

Soffit

Fig. 68. ROOF DETAILS

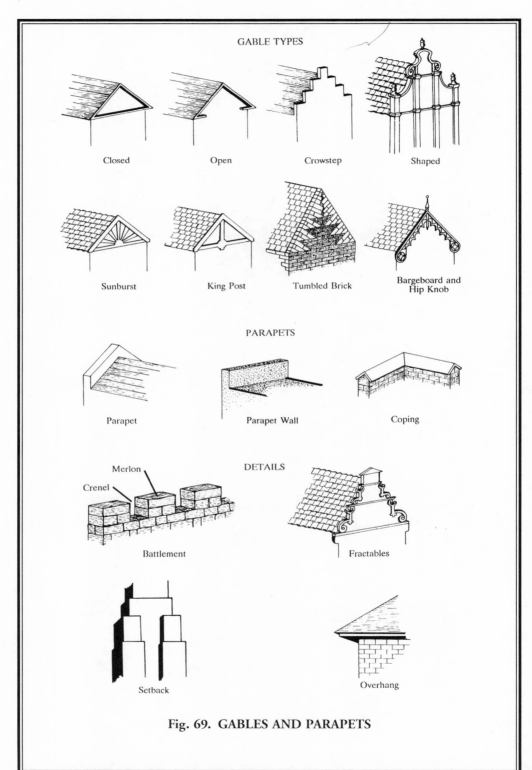

GABLE TYPES

Closed

Open

Crowstep

Shaped

Sunburst

King Post

Tumbled Brick

Bargeboard and Hip Knob

PARAPETS

Parapet

Parapet Wall

Coping

DETAILS

Merlon

Crenel

Battlement

Fractables

Setback

Overhang

Fig. 69. GABLES AND PARAPETS

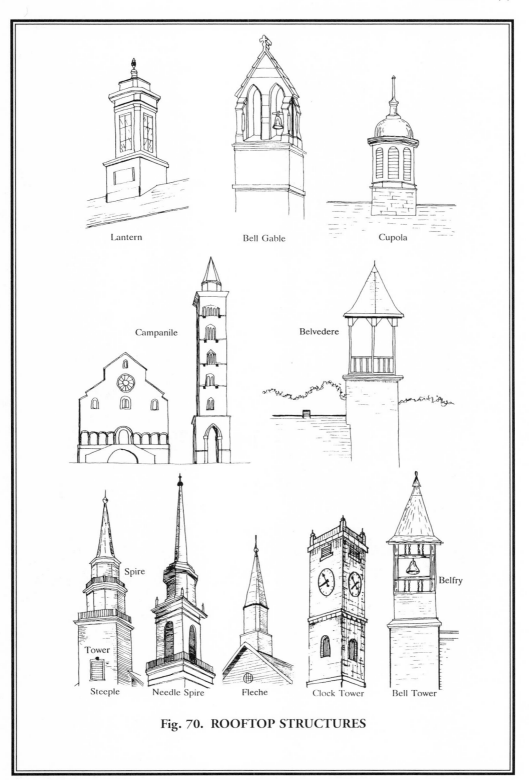

Lantern Bell Gable Cupola

Campanile Belvedere

Spire

Tower

Steeple Needle Spire Fleche Clock Tower Bell Tower

Belfry

Fig. 70. ROOFTOP STRUCTURES

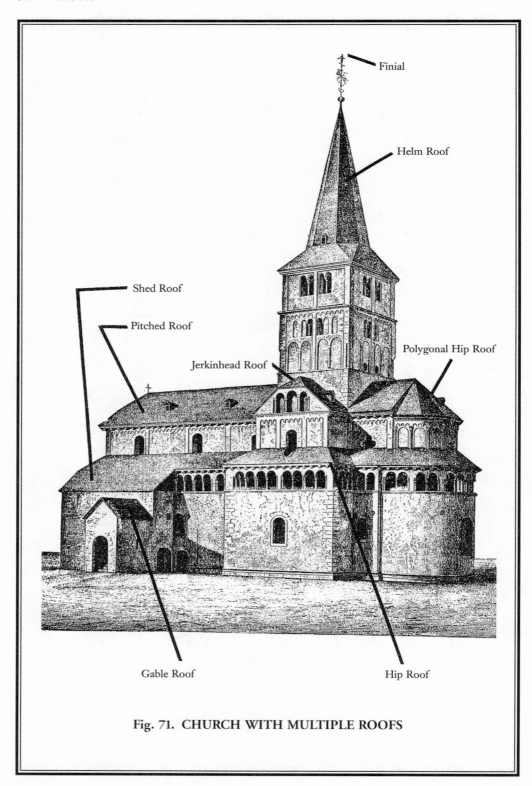

Finial

Helm Roof

Shed Roof

Pitched Roof

Polygonal Hip Roof

Jerkinhead Roof

Gable Roof

Hip Roof

Fig. 71. CHURCH WITH MULTIPLE ROOFS

COLUMNS

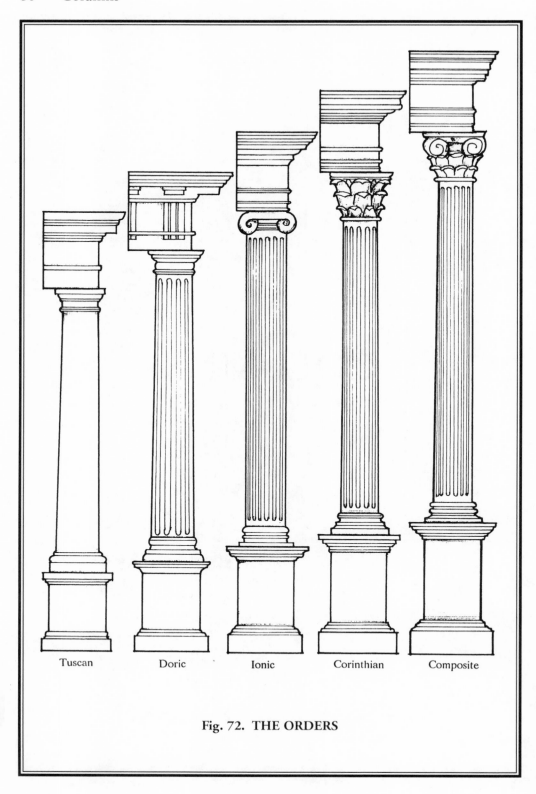

Tuscan Doric Ionic Corinthian Composite

Fig. 72. THE ORDERS

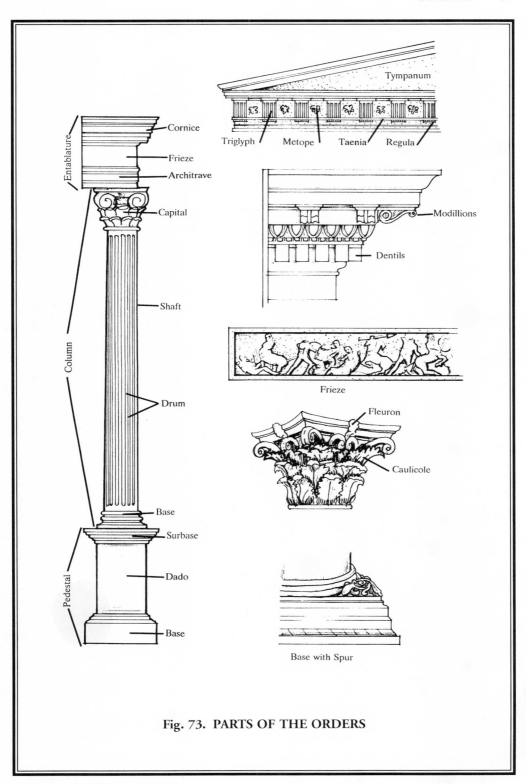

Fig. 73. PARTS OF THE ORDERS

Cornice
Frieze
Architrave
Capital
Shaft
Drum
Base
Surbase
Dado
Base
Entablature
Column
Pedestal

Tympanum
Triglyph Metope Taenia Regula

Modillions
Dentils

Frieze

Fleuron
Caulicole

Base with Spur

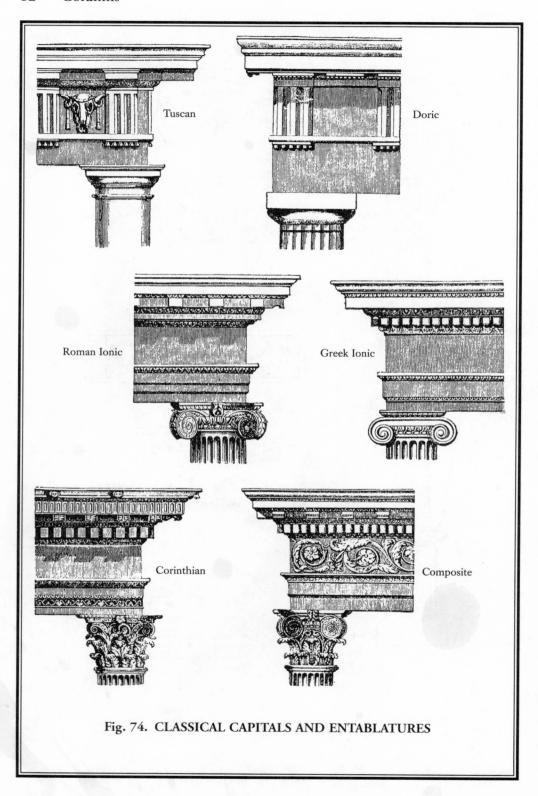

Fig. 74. CLASSICAL CAPITALS AND ENTABLATURES

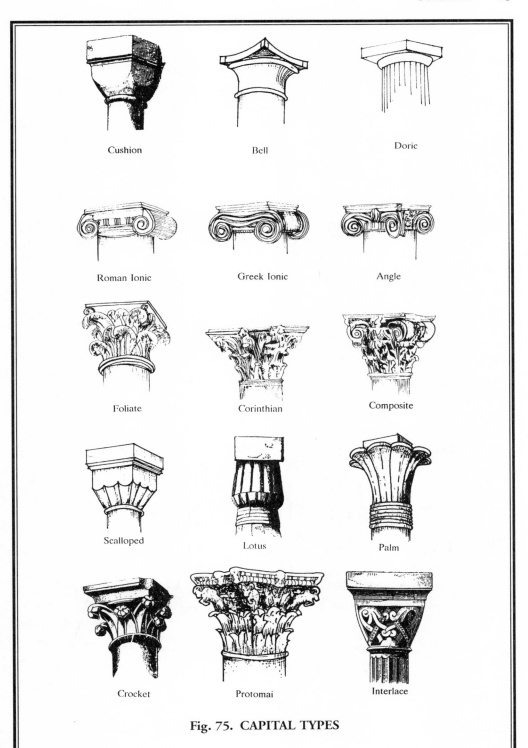

Cushion

Bell

Doric

Roman Ionic

Greek Ionic

Angle

Foliate

Corinthian

Composite

Scalloped

Lotus

Palm

Crocket

Protomai

Interlace

Fig. 75. CAPITAL TYPES

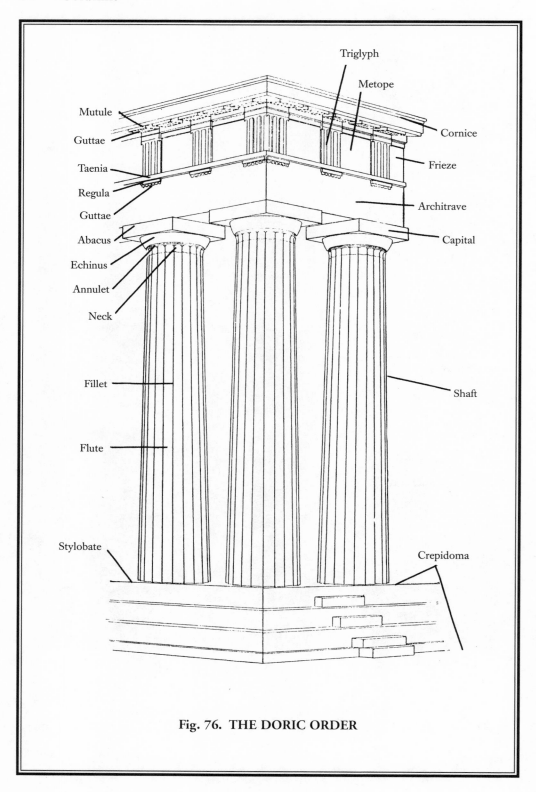

Fig. 76. THE DORIC ORDER

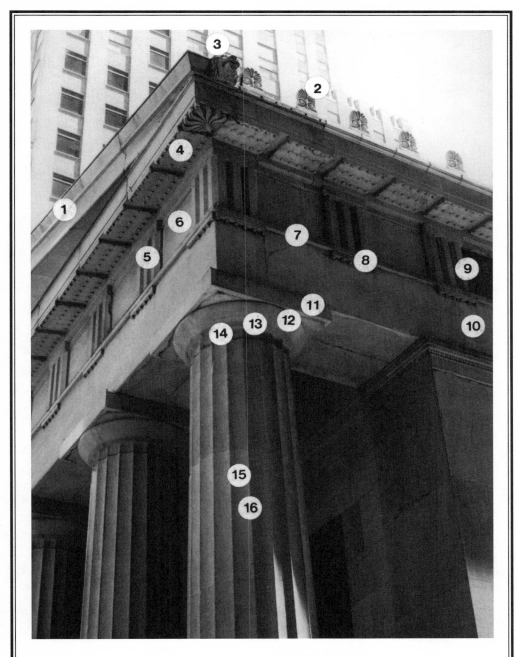

Fig. 77. THE DORIC ORDER
[1]Pediment [2]Antefix [3]Acroterion [4]Mutule with Guttae
[5]Triglyph [6]Metope [7]Taenia [8]Regula with Guttea [9]Frieze
[10]Architrave [11]Abacus [12]Echinus [13]Annulet [14]Neck [15]Flute [16]Fillet

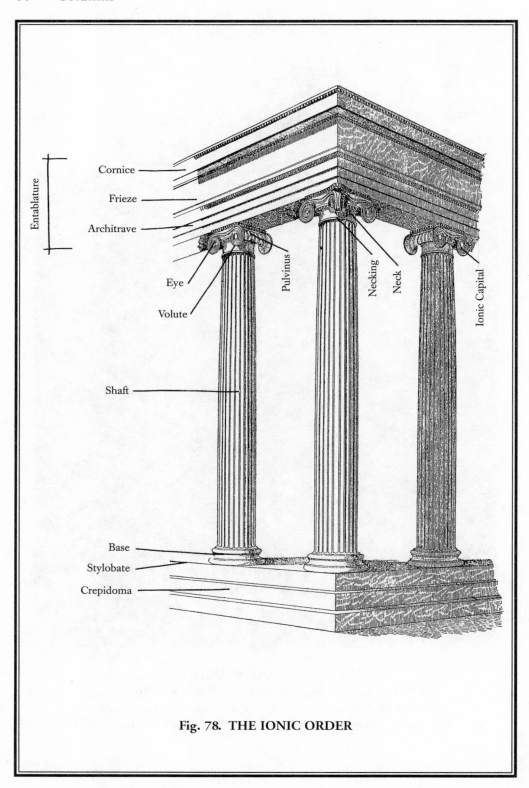

Fig. 78. THE IONIC ORDER

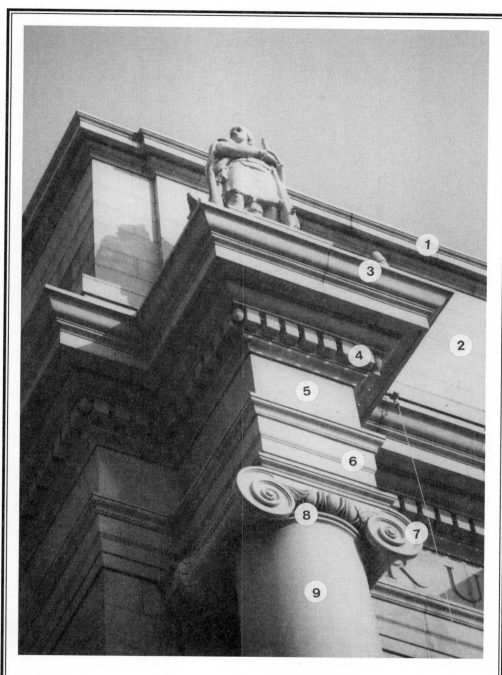

Fig. 79. THE IONIC ORDER
[1]Attic Cornice [2]Attic Story [3]Cornice [4]Dentil Molding
[5]Frieze [6]Architrave [7]Volute [8]Necking [9]Shaft

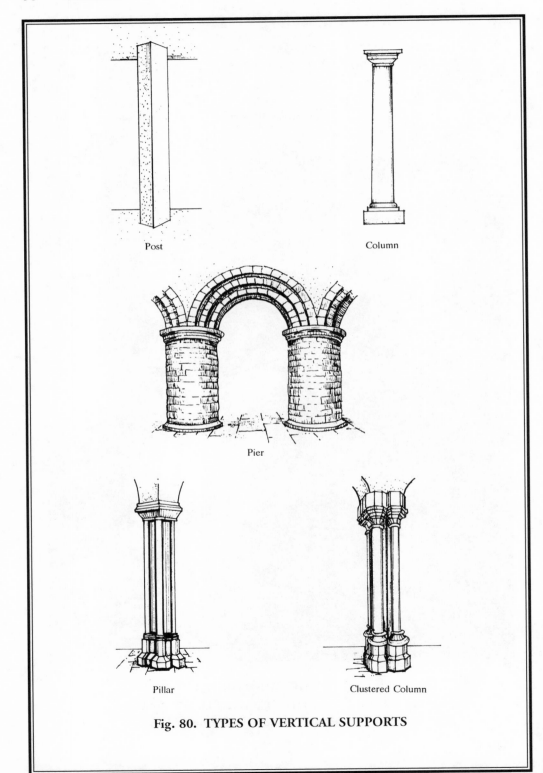

Post

Column

Pier

Pillar

Clustered Column

Fig. 80. TYPES OF VERTICAL SUPPORTS

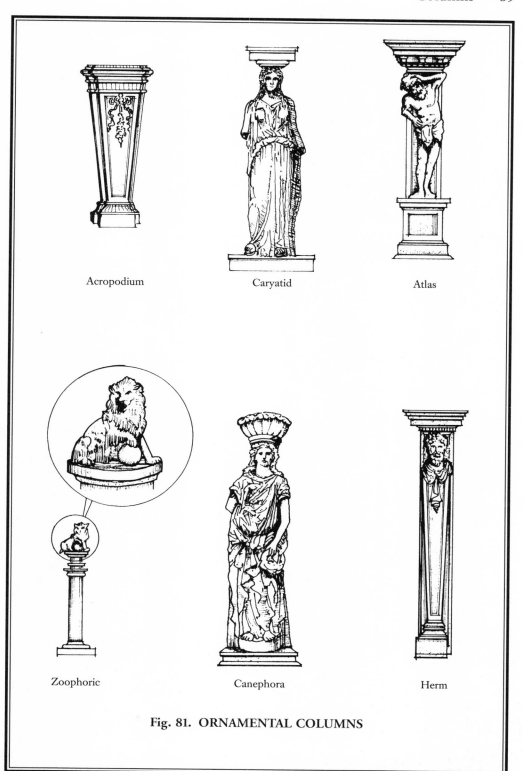

Acropodium Caryatid Atlas

Zoophoric Canephora Herm

Fig. 81. ORNAMENTAL COLUMNS

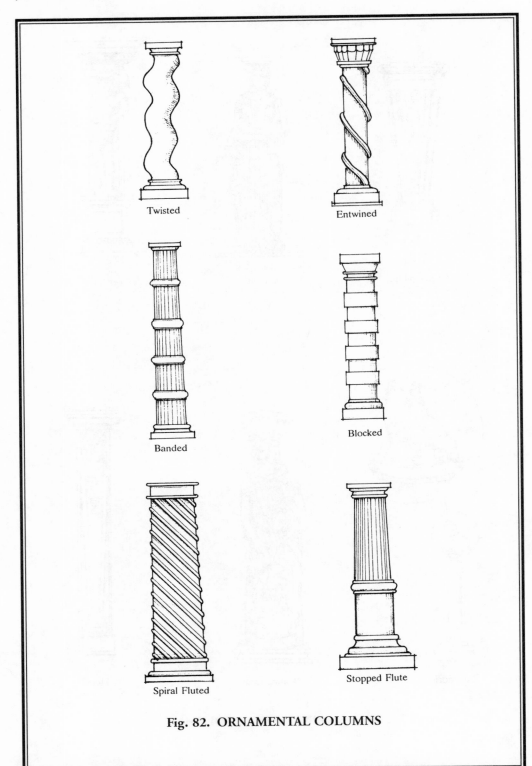

Twisted

Entwined

Banded

Blocked

Spiral Fluted

Stopped Flute

Fig. 82. ORNAMENTAL COLUMNS

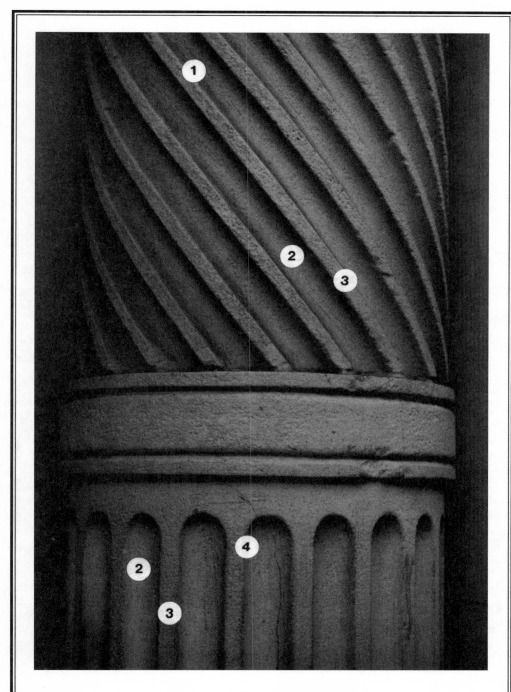

Fig. 83. FLUTED COLUMN
[1]Spiral Fluting [2]Flute [3]Fillet [4]Regular Fluting

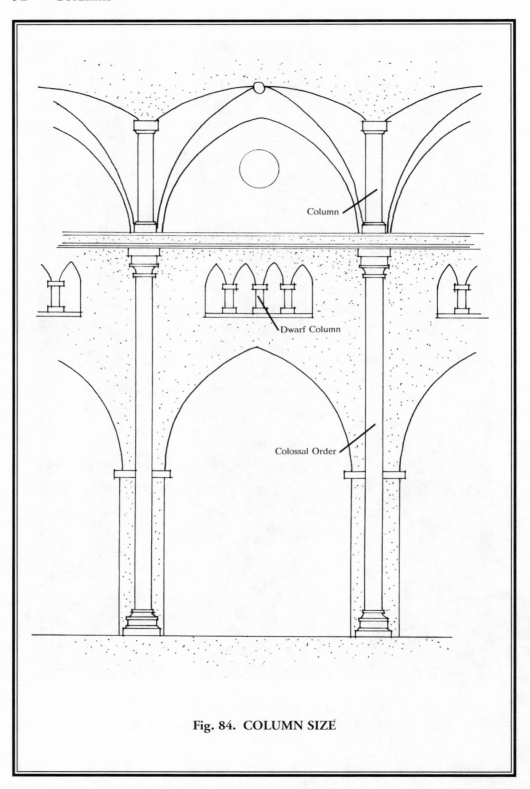

Fig. 84. COLUMN SIZE

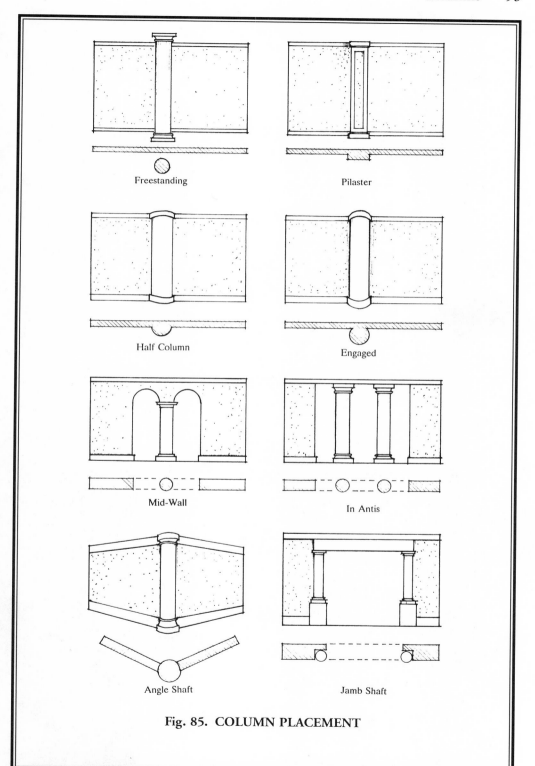

Freestanding

Pilaster

Half Column

Engaged

Mid-Wall

In Antis

Angle Shaft

Jamb Shaft

Fig. 85. COLUMN PLACEMENT

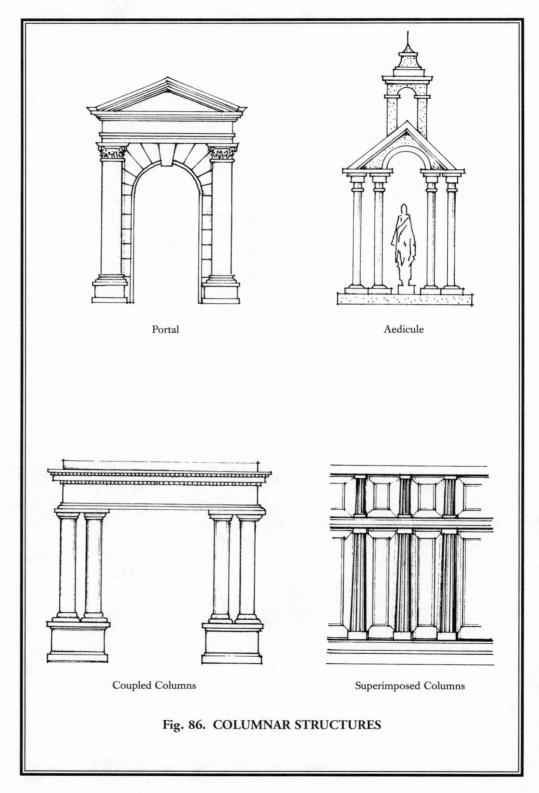

Portal

Aedicule

Coupled Columns

Superimposed Columns

Fig. 86. COLUMNAR STRUCTURES

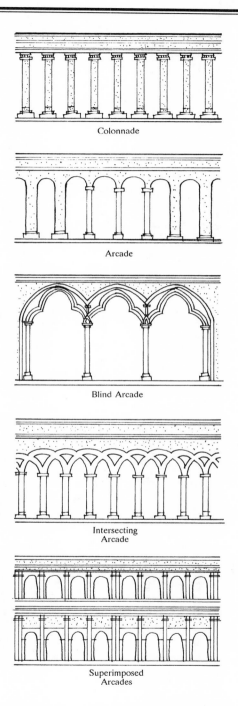

Colonnade

Arcade

Blind Arcade

Intersecting
Arcade

Superimposed
Arcades

Fig. 87. COLONNADES AND ARCADES

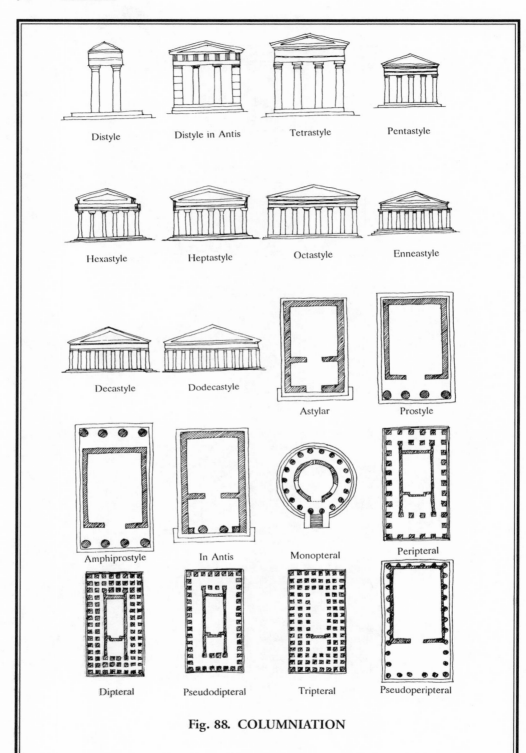

Fig. 88. COLUMNIATION

ELEVATION

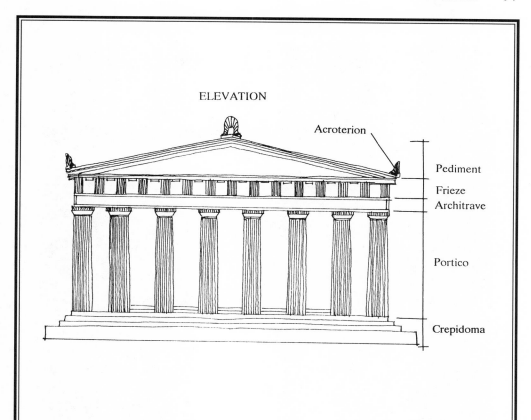

Acroterion

Pediment

Frieze
Architrave

Portico

Crepidoma

PLAN

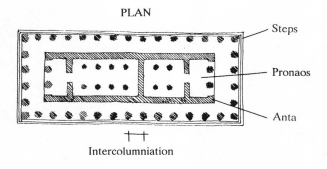

Steps

Pronaos

Anta

Intercolumniation

Fig. 89. TEMPLE PARTS

Fig. 90. PAIRED COLUMNS
[1]Cornice [2]Inscribed Frieze [3]Architrave with Bead and Reel Molding
[4]Composite Capital [5]Shaft [6]Base [7]Podium [8]Molded Surround [9]Latticework

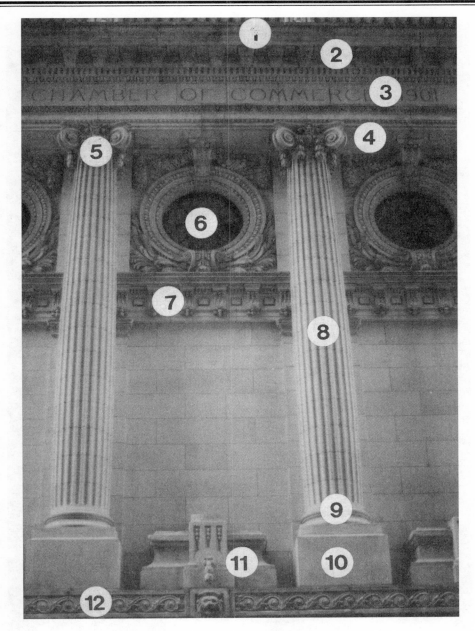

Fig. 91. FLUTED IONIC COLUMNS
[1]Cornice [2]Modillion [3]Inscribed Frieze [4]Paneled Soffit
[5]Roman Ionic Capitals with Festoons [6]Bull's Eye Window with Volute,
Keystone, Garlands, and Molded Surround [7]Intermediate Cornice with Modillions
[8]Fluted Shaft [9]Base [10]Pedestal [11]Ornamented Pedestal [12]Scroll Molding

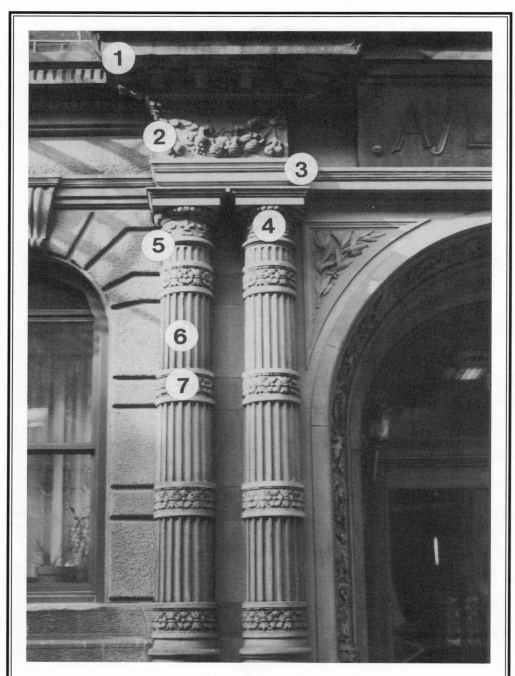

Fig. 92. PAIRED BANDED COLUMNS
[1]Cornice [2]Frieze with Garland [3]Molded Architrave
[4]Doric Capital with Fleur-de-lis Molding [5]Necking [6]Fluted Shaft [7]Foliate Band

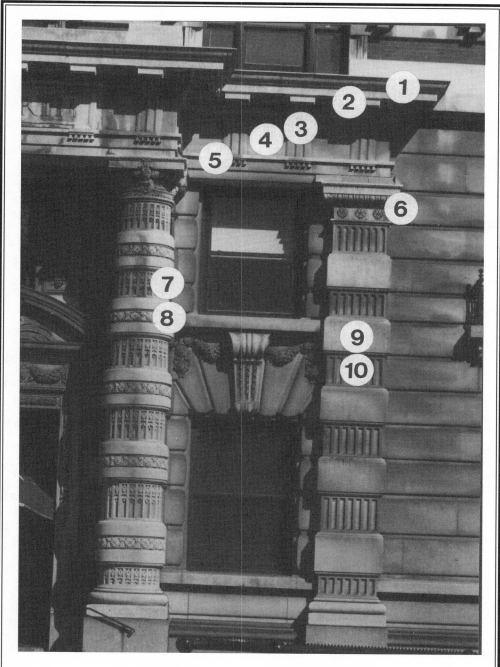

Fig. 93. BANDED COLUMN AND PILASTER
[1]Cornice [2]Modillions [3]Triglyph [4]Metope [5]Regula [6]Ornamented Doric Capital
[7]Flutes with Foliate Ornament [8]Ornamented Band [9]Block [10]Fluted Pilaster

STAIRS

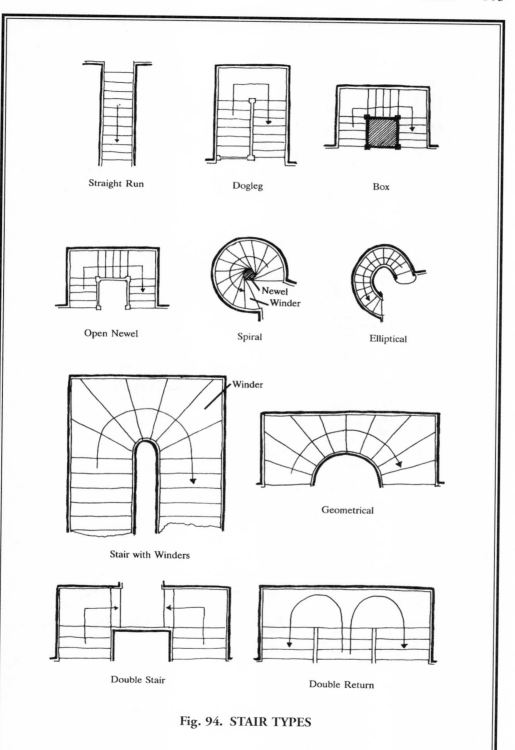

Straight Run

Dogleg

Box

Open Newel

Spiral

Newel
Winder

Elliptical

Winder

Stair with Winders

Geometrical

Double Stair

Double Return

Fig. 94. STAIR TYPES

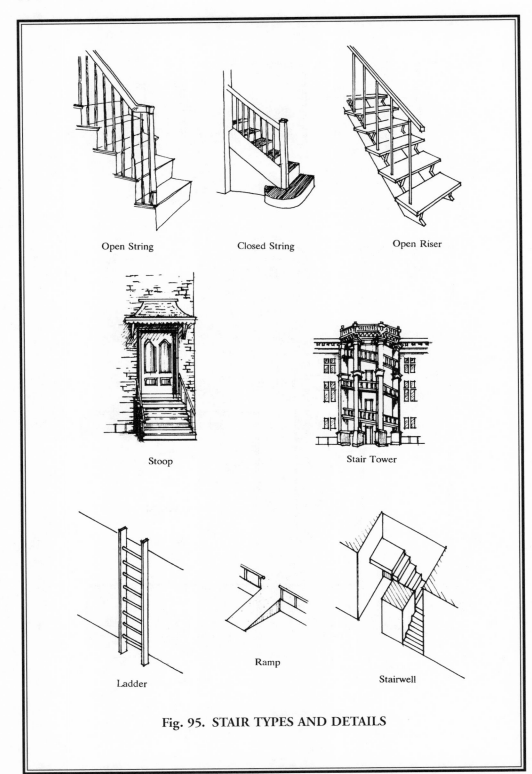

Open String Closed String Open Riser

Stoop Stair Tower

Ladder Ramp Stairwell

Fig. 95. STAIR TYPES AND DETAILS

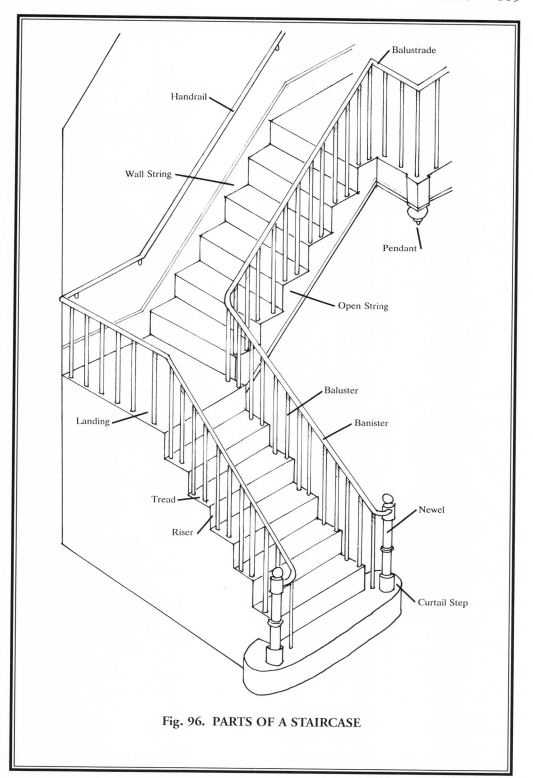

Fig. 96. PARTS OF A STAIRCASE

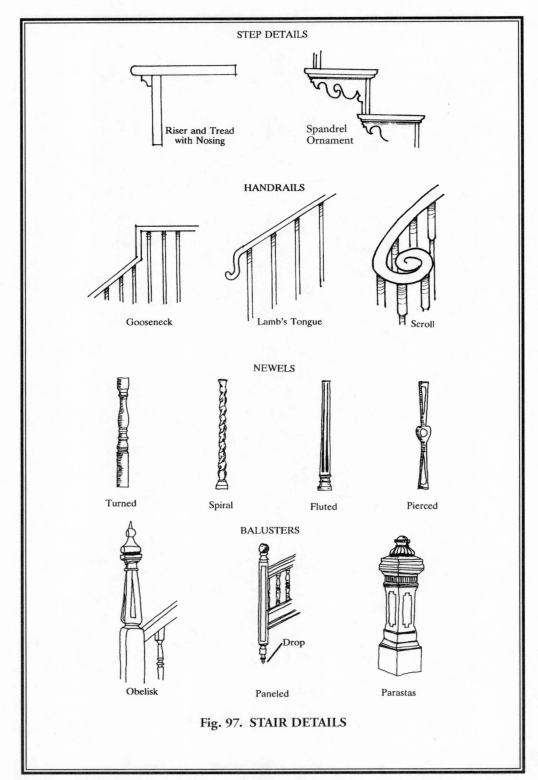

STEP DETAILS

Riser and Tread
with Nosing

Spandrel
Ornament

HANDRAILS

Gooseneck

Lamb's Tongue

Scroll

NEWELS

Turned

Spiral

Fluted

Pierced

BALUSTERS

Obelisk

Drop

Paneled

Parastas

Fig. 97. STAIR DETAILS

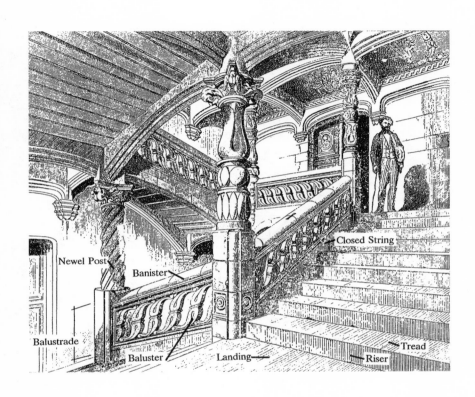

Fig. 98. OPEN NEWEL STAIRCASE

ORNAMENT
AND
MOLDINGS

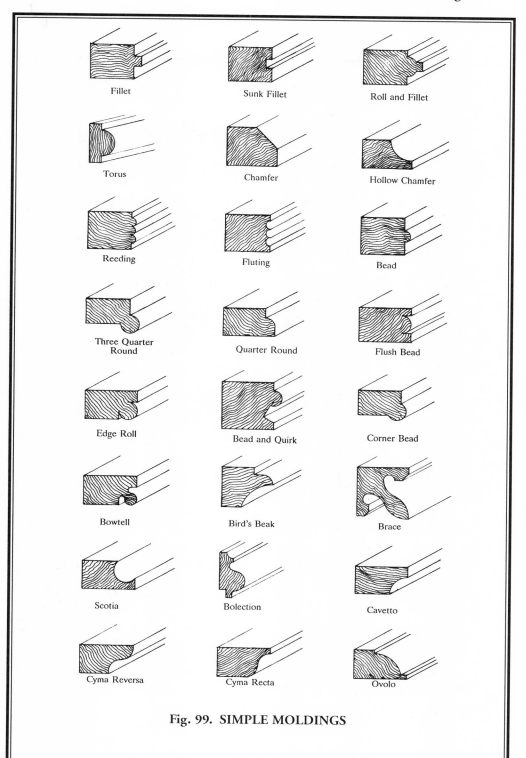

Fig. 99. SIMPLE MOLDINGS

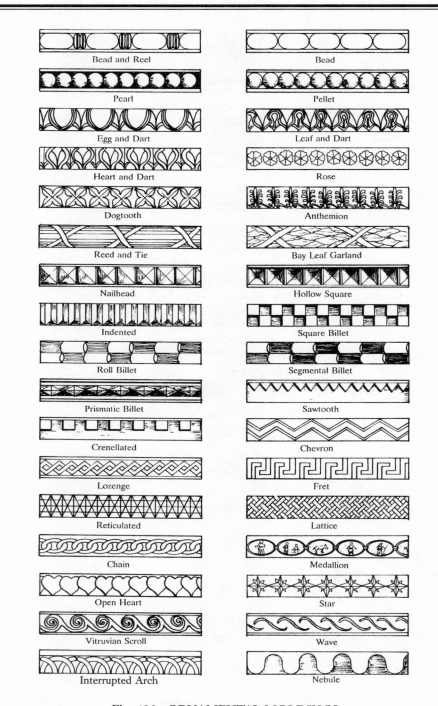

Bead and Reel

Bead

Pearl

Pellet

Egg and Dart

Leaf and Dart

Heart and Dart

Rose

Dogtooth

Anthemion

Reed and Tie

Bay Leaf Garland

Nailhead

Hollow Square

Indented

Square Billet

Roll Billet

Segmental Billet

Prismatic Billet

Sawtooth

Crenellated

Chevron

Lozenge

Fret

Reticulated

Lattice

Chain

Medallion

Open Heart

Star

Vitruvian Scroll

Wave

Interrupted Arch

Nebule

Fig. 100. ORNAMENTAL MOLDINGS

Diaper

Herringbone

Honeycomb

Coffering

Strapwork

Interlace

Plait

Gadrooning

Arabesque

Latticework

Fig. 101. ORNAMENTAL PATTERNS

Fig. 102. ROSETTE AND GUILLOCHE MOLDING
[1]Rosette [2]Guilloche [3]Pearl

Fig. 103. MOLDED ARCHITRAVE
[1]Leaf and Dart Molding [2]Bell Flower Molding

Fig. 104. BANDED COLUMN WITH BELL FLOWER ORNAMENT

Fig. 105. BLOCKED PILASTER WITH FLUTED BLOCKS

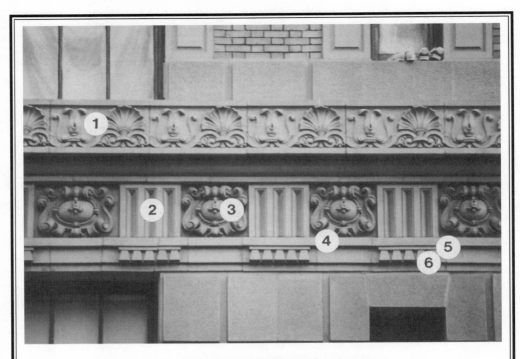

Fig. 106. ORNAMENTAL FRIEZES
[1]Anthemion and Bell Flower Molding [2]Triglyph
[3]Metope with Cartouche [4]Taenia [5]Regula [6]Guttae

Fig. 107. ROPE MOLDING

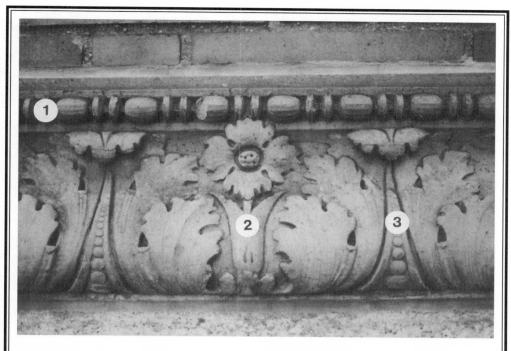

Fig. 108. DECORATIVE MOLDINGS
[1]Bead and Reel Molding [2]Acanthus Flower [3]Acanthus Leaf

Fig. 109. TABLET FLOWER MOLDING

Fig. 110. SCROLL MOLDING

Fig. 111. BALL FLOWER MOLDING

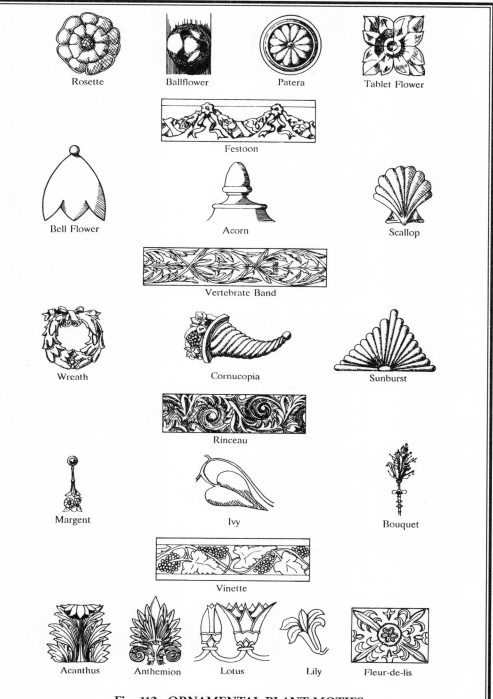

Fig. 112. ORNAMENTAL PLANT MOTIFS

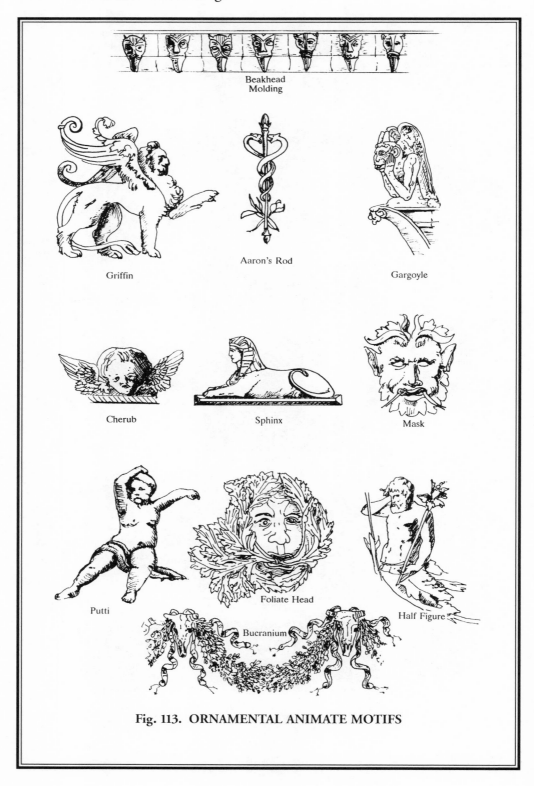

Beakhead
Molding

Griffin

Aaron's Rod

Gargoyle

Cherub

Sphinx

Mask

Putti

Foliate Head

Half Figure

Bucranium

Fig. 113. ORNAMENTAL ANIMATE MOTIFS

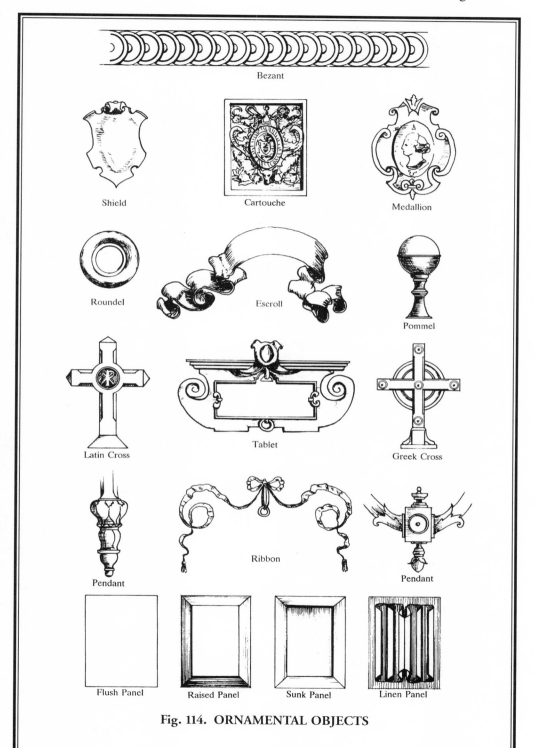

Fig. 114. ORNAMENTAL OBJECTS

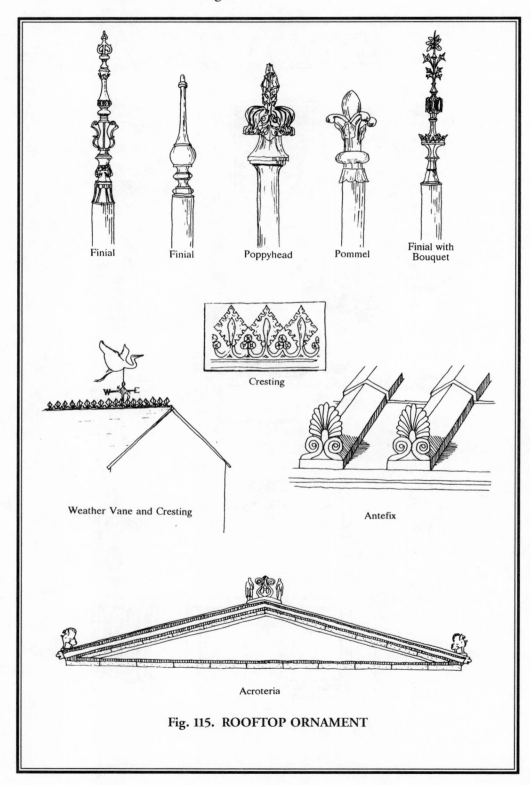

Finial Finial Poppyhead Pommel Finial with Bouquet

Cresting

Weather Vane and Cresting

Antefix

Acroteria

Fig. 115. ROOFTOP ORNAMENT

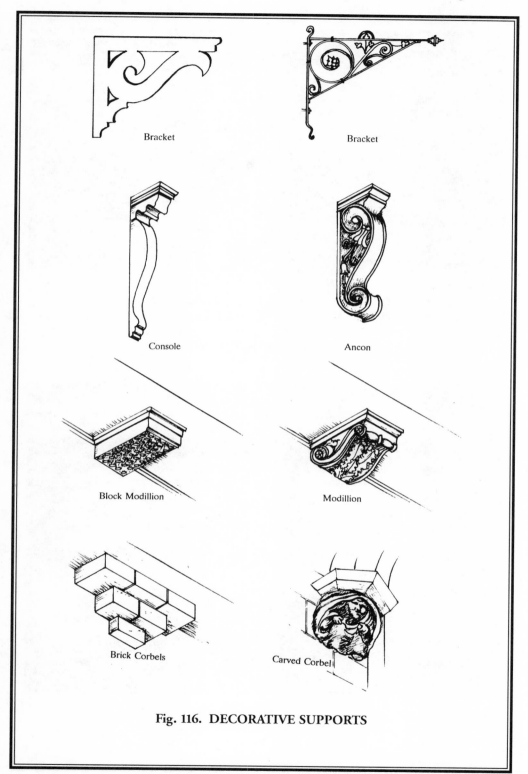

Fig. 116. DECORATIVE SUPPORTS

Fig. 117. INDENTED BRICK MOLDING

Fig. 118. STONE CORBEL TABLE

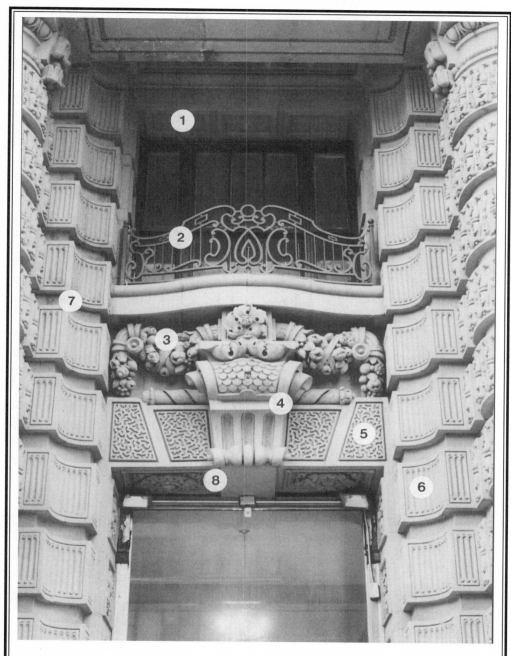

Fig. 119. ORNAMENTED ENTRANCEWAY
[1]Paneled Soffit [2]Balcony with Decorative Balustrade [3]Festoon
[4]Oversized Volute Keystone [5]Vermiculated Stonework [6]Hollow Chamfer
[7]Blocked Pilasters with Fluted Blocks [8]Paneled Soffit with Rosettes

Arches,
Vaults
and Domes

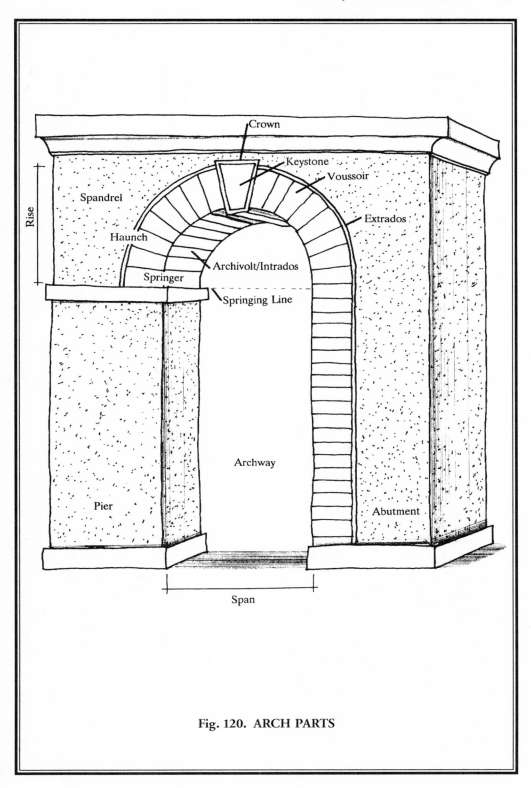

Fig. 120. ARCH PARTS

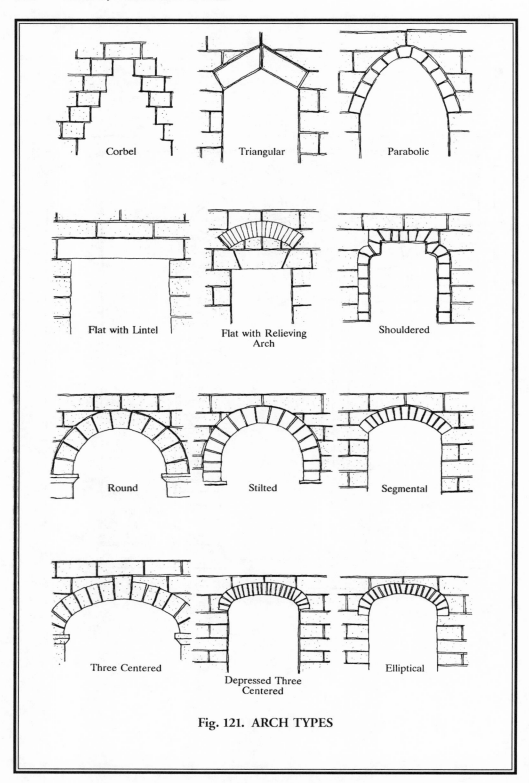

Fig. 121. ARCH TYPES

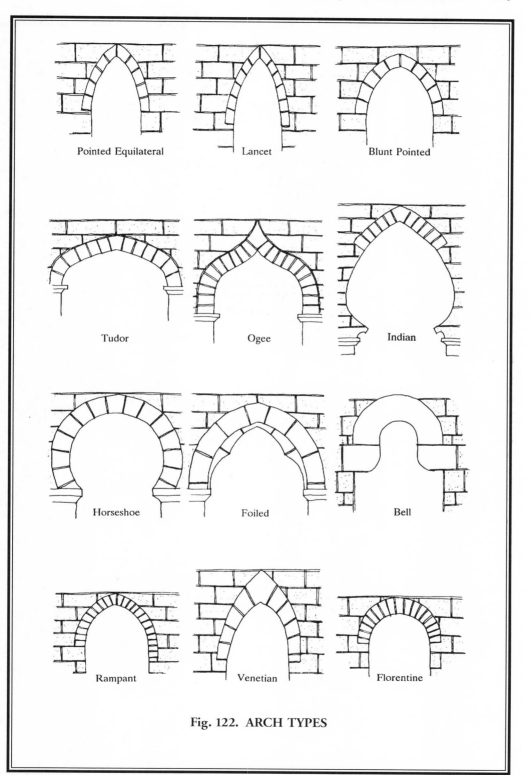

Fig. 122. ARCH TYPES

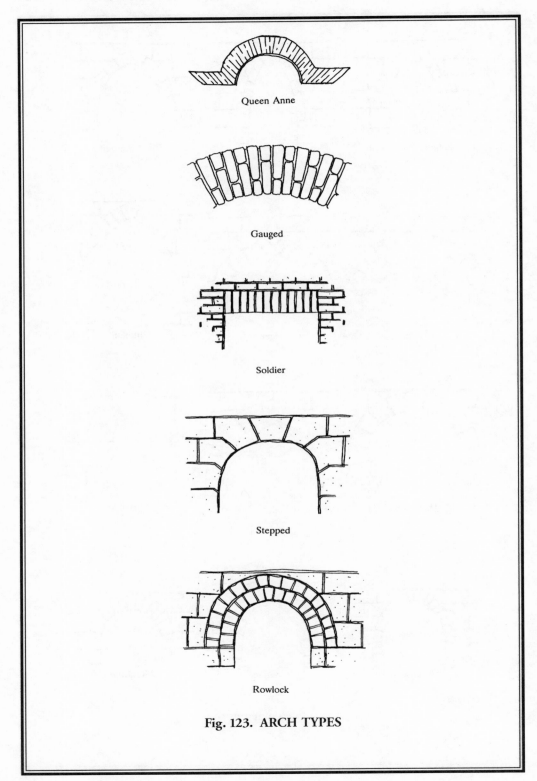

Fig. 123. ARCH TYPES

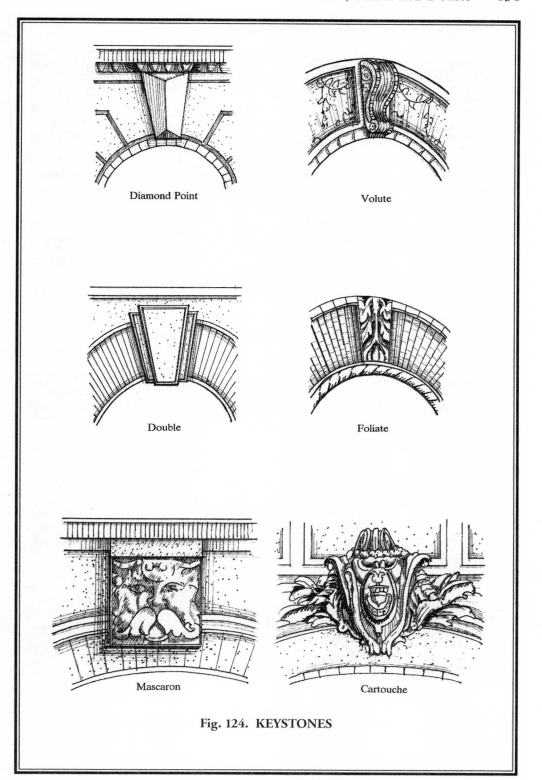

Diamond Point

Volute

Double

Foliate

Mascaron

Cartouche

Fig. 124. KEYSTONES

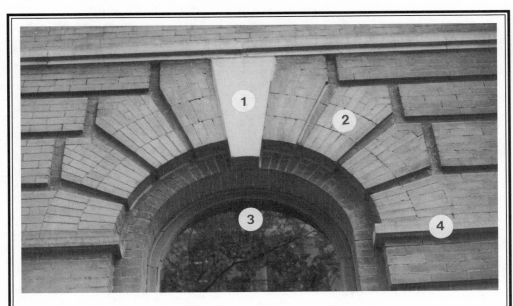

Fig. 125. STEPPED ARCH
[1]Keystone [2]Stepped Brickwork Voussoirs [3]Round Arched Opening [4]Impost

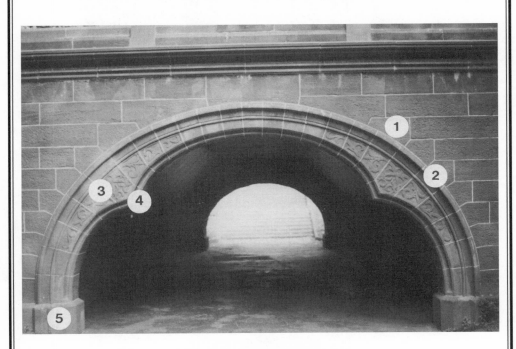

Fig. 126. TREFOIL ARCH
[1]Stepped Voussoir [2]Extrados [3]Arabesque Ornament [4]Cusp [5]Impost

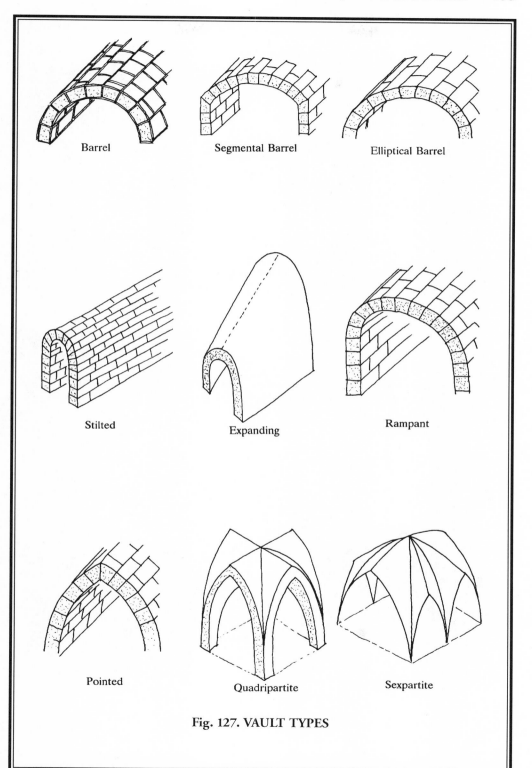

Barrel

Segmental Barrel

Elliptical Barrel

Stilted

Expanding

Rampant

Pointed

Quadripartite

Sexpartite

Fig. 127. VAULT TYPES

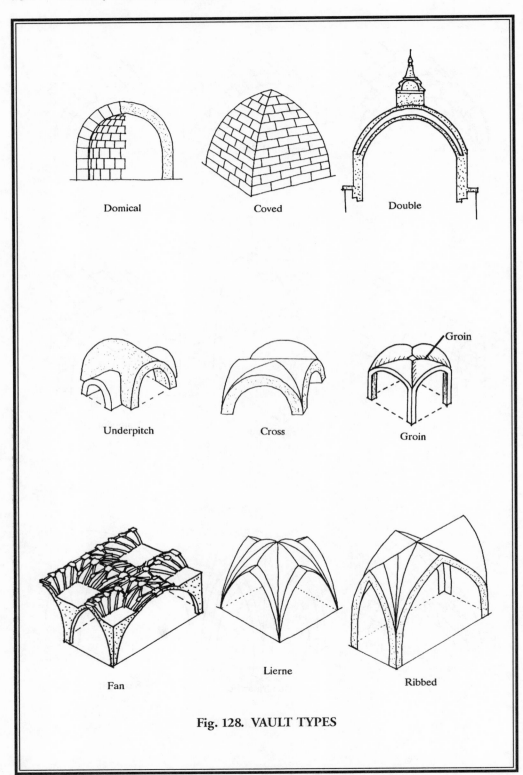

Domical

Coved

Double

Underpitch

Cross

Groin

Groin

Fan

Lierne

Ribbed

Fig. 128. VAULT TYPES

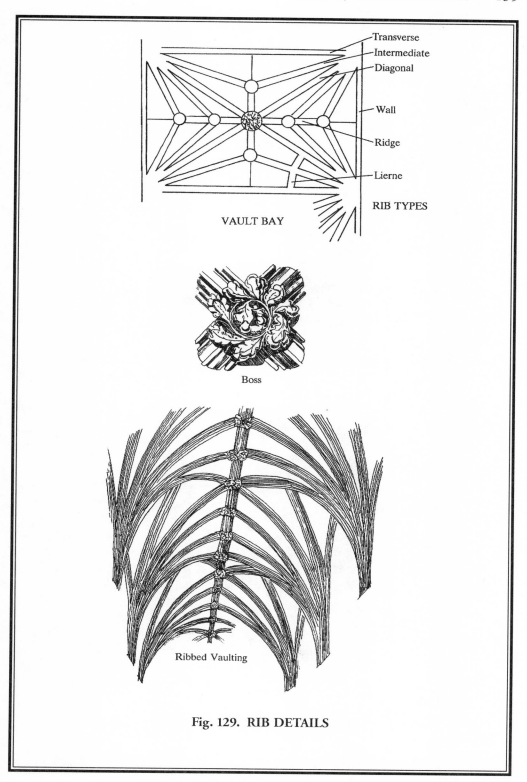

Transverse
Intermediate
Diagonal

Wall

Ridge

Lierne

RIB TYPES

VAULT BAY

Boss

Ribbed Vaulting

Fig. 129. RIB DETAILS

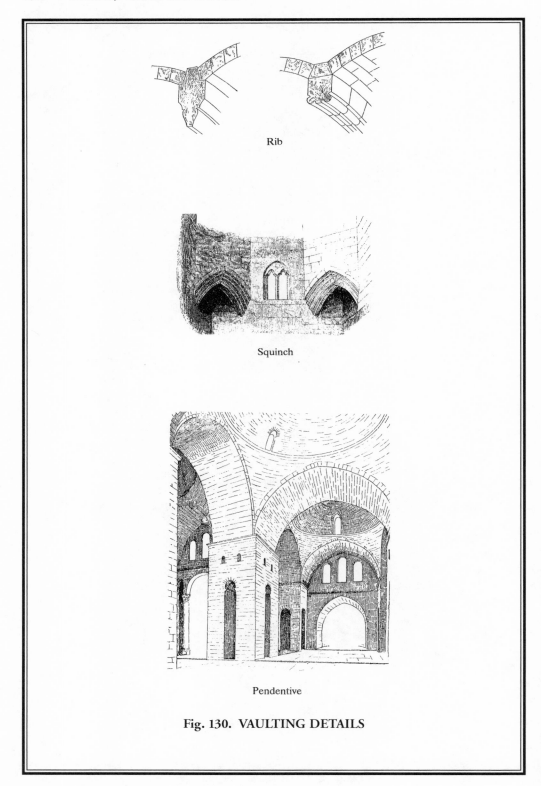

Rib

Squinch

Pendentive

Fig. 130. VAULTING DETAILS

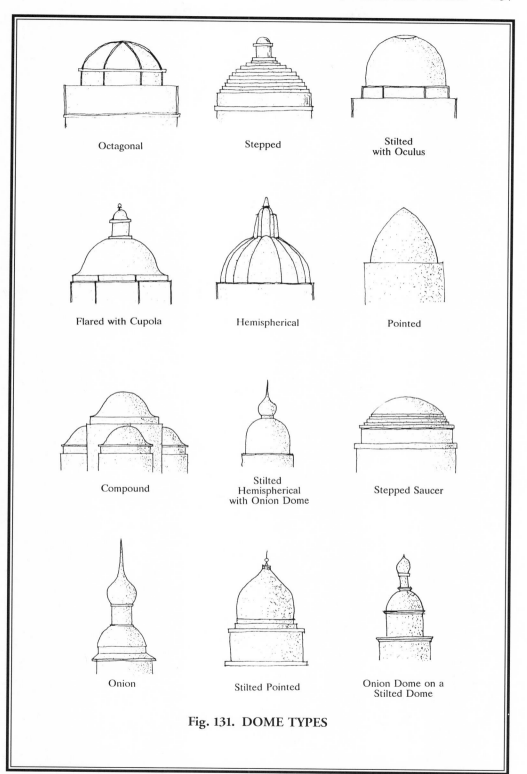

Octagonal

Stepped

Stilted
with Oculus

Flared with Cupola

Hemispherical

Pointed

Compound

Stilted
Hemispherical
with Onion Dome

Stepped Saucer

Onion

Stilted Pointed

Onion Dome on a
Stilted Dome

Fig. 131. DOME TYPES

THE DICTIONARY

A

Aaron's rod a staff entwined with leaves or a snake [113]

abacus the uppermost member of a capital, having the appearance of a flat slab on which the entablature rests [76, 77]

abutment a structure, typically of masonry, that supports a weight and counteracts the lateral thrust of a vault, an arch, or another force [55, 120]

acanthus a plant whose large, stylized, scalloped leaves on a curving stem are commonly found on Corinthian and composite capitals and whose leaves and flowers are often used on other carved ornament [25, 108, 112]

accolade an ornamental treatment composed of two ogee curves rising to a central finial, typically found over a door, a window, or an arched opening [9]

accordion door/accordion window a door/window composed of two or more panels that are hinged to each other and fold against each other as they open by sliding along a horizontal track; also called a folding door/window [2, 29]

acorn an ornament in the shape of an acorn, often used as a pendant or finial ornament [112]

acropodium a large pedestal, richly decorated, for a statue [81]

acroterion (*pl.* acroteria) the ornament placed at the peak and at the ends of a pediment, or the pedestal for such ornament, or the pedestal together with the ornament [77, 89, 115]

aedicule a niche, framed by columns, entablature, and pediment, containing a statue [62, 86]

affronted the placement of two similar figures so that they face each other [31]

air brick brick with interior holes for ventilation; also called cored brick or ventilating brick [41]

alternating coursed describing masonry laid in regular continuous courses, with each course consistent in height, and alternating courses of varying height [43]

American bond *see* **common bond**

amphiprostyle describing a building with porticoes on both ends, but not on the sides [88]

anchor *see* **tie iron**

ancon (*pl.* ancones) a scrolled console that supports a door or window cornice (*see also:* bracket, console, corbel, modillion) [116]

angle bead *see* **corner bead**

angle capital/angular capital an Ionic capital with four equal sides, its volutes projecting diagonally rather than in parallel planes [75]

angle shaft a column placed at the corner of a building [85]

annulet a molding forming a ring, especially the moldings defining the lower part of the Doric capital, above the neck [76, 77]

anta (*pl.* antae) the extension of the side walls of a temple to the front of the temple so as to flank the columns in the front portico, the extensions may be finished by a pilaster, and the portico and the columns are said to be "in antis" [89]

antefix a cresting on the edges of a roof, originally intended to conceal the ends of roof tiles, often taking the form of anthemion leaves [77, 115]

anthemion a leaf ornament resembling a fan and based on the radiating blossoms of the honeysuckle or palmette plant, used singly or as a running ornament, often alternating with the lotus [25, 100, 106, 112]

anthemion band/anthemion molding a band or molding composed of anthemions [106]

antis *see* **anta, in antis**

apron a panel below a window sill, often decorated; also called a skirt [6, 21]

apron molding a small molding taking the place of an apron [1, 17]

arabesque an intricate ornament, either carved, inlaid, sculpted, or painted, and composed of an overall pattern of various combinations of intertwined plant and geometric forms [21, 101, 126]

Arabic arch *see* **horseshoe arch**

arcade a series of arches supported by columns, piers, or pilasters (*see:* blind arcade, intersecting arcade) [87]

arch a self-supporting structure that spans an opening, usually rounded and composed of voussoirs (for types see: Arabic, bell, blunt, corbel, depressed, discharging, drop, elliptical, equilateral, flat, Florentine, foiled, four-centered, gauged, Gothic, horseshoe, Indian, Islamic, jack, lancet, Moorish, ogee, one-centered, parabolic, pointed, Queen Anne, rampant, relieving, round, rowlock, segmental, semicircular, shouldered, soldier, splayed, stepped, stilted, straight, Syrian, three-centered, trefoil, triangular, Tudor, two-centered, Venetian) [4, 9–20, 22, 25, 33, 100, 120–126]

arch brick wedge shaped brick used in arch construction [41]

architrave the lowest member of an entablature, being the beam that spans from column to column, resting on the capitals [73, 76–79, 89, 90, 92]; the ornamental molding around the opening of a door or window [23, 26, 27, 31, 103]

archivolt an architrave (ornamental molding) carried around the curved opening of the face of an arch and following the contour of the extrados [120]

archway a passage, especially a long one, through or under an arched structure [120, 137]

arrow slit a narrow opening in a fortified wall providing space for defense [57]

arrowhead *see* **dart**

ashlar building stone of a high quality finish, with squared edges and even faces, used for the face of a wall (*for bond types see:* alternating coursed, broken coursed, random, regular coursed, uncoursed; *see also:* cut stone, fieldstone) [44, 50]

astylar/astyle a facade or temple without columns or pilasters [88]

asymmetrical gable roof a gabled roof with sloping sides of unequal length [63]

atlas (*pl.* atlantes) a male figure in a standing or kneeling position, struggling to support an entablature or other load; also called a telamon (*see also:* canephora, caryatid, herm) [81]

attached column *see* **engaged column**

attenuated appearing vertically stretched or elongated [33, 139]

attic the uppermost story of a building, lower in height than those below, typically located above the main wall cornice; the area of a building formed by a sloping roof [60, 79, 132]

awning an adjustable covering, typically of canvas, placed over door and window openings to protect against the elements [138]

awning window a window that is hinged at the top and swings outward [2]

<div style="text-align:center">

B

</div>

bagnette *see* **bay leaf garland**

balconette a false balcony, typically small in size, or an ornamental railing at a window [20, 60]

balcony a projecting platform enclosed by a balustrade, typically placed in front of an upper window or door and supported by brackets or pillars, or cantilevered [60, 119]

ball flower an ornament composed of three petals enclosing a ball, typically used in moldings [111, 112]

balloon framing wood frame construction whose vertical structural members extend the full height of the two-story frame at the exterior walls [54]

baluster one of a series of short posts, typically circular in section and often quite ornamental, used to support a hand rail or coping, and forming a balustrade; also called a banister or a spindle [20, 96, 97, 98, 134]

balustrade a series of balusters and the handrail or coping they support, or a structure similarly composed, the composition acting as a railing, fence, parapet, or enclosure, often decorative in character [14, 26, 58, 96, 98, 119, 132–134, 136]

band / band course a simple, flat, horizontal molding used to mark divisions in a wall or column, typically larger than a stringcourse (*see also:* frieze, lintel course, sill course, stringcourse) [15, 17, 58, 60, 62, 92, 93]

banded having bands of varying depth or material which create horizontal divisions in a wall, column, or other member; similar to blocked [35, 37]

banded column / banded pilaster a column/pilaster whose drums alternate with narrower rounded bands, typically of varying texture [35, 82, 92, 93, 104]

banister the handrail of a staircase [96, 98]

barbican a structure in a medieval fortification that flanks the approach to a gate and serves as a watchtower [57]

bargeboard a board or other covering, often decorative, hung from the edge of a gable roof to hide the rafters or beams; also called a vergeboard or a gableboard [6, 58, 69, 136]

barrel roof a roof with a semicircular cross-section [63]

barrel vault a vault with a semicircular cross-section, held on parallel supports, and extending a considerable length; also called a semicircular vault or a tunnel vault [127]

bartizan a small turret, often supported by corbels, projecting at the top of a tower or located on a fortified wall near a gate [57]

base the lowest of the three main parts of a column, being the part on which the shaft rests [73, 78, 90, 91]; the lowest part of a building or other architectural member, often distinguished in its treatment from the upper parts of the building or member [45, 60]

base course the lowest masonry course of a wall or other member [58]

base molding the molding at the upper edge of a baseboard [61]

base shoe the molding at the lower edge of a baseboard [61]

baseboard a horizontal board, plain or molded, which extends around an interior wall, covering the juncture of the floor and the wall, typically topped by a base molding and joined to the floor by a base shoe [61]

basement a story of a building at least partially below ground level [135]

basketweave a masonry bond or ornamental treatment resembling the woven pattern of a basket [39]

batten a narrow piece of wood that covers the edges of joined boards (*see also:* board and batten) [51, 59]

batten door a door whose body is constructed of vertical boards attached to horizontal battens [28]

batten joint two elements joined at right angles, the joint covered with a narrow strip of wood [51, 59]

battered a wall whose surface slopes inward toward the top [55]

battled treated with battlements; also called crenellated or embattled [57]

battlement a parapet on a fortified wall consisting of alternating open parts (crenels or embrasures) and solid parts (merlons), and used for defense; also called an embattlement [56, 57, 69]

bay one of a series of principal uniform architectural divisions, usually vertically oriented, formed by principal structural members such as columns, often including fenestration [60, 132–135, 139]; a division of vaulting marked by two transverse ribs [129]

bay leaf garland a molding composed of laurel or bay leaves bound with ribbons; also called a bagnette [100]

bay window a window with a polygonal shape that projects from the exterior surface of a wall, typically rising from the ground (*see also:* oriel, bow window) [21]

bead / bead molding a semicircular, convex molding; also called a half-round (*for types see:* flush) [99]; a molding composed of a series of round or elongated elements [100]

bead and quirk a molding composed of a bead above a single quirk or a pair of quirks [99]

bead and reel a rounded convex molding composed of disks alternating with beads, either single or multiple, round or elongated [24, 90, 100, 108]

bead stop *see* **stop**

beaded edge siding a horizontal siding in which the lower edges of the boards are ornamented with a horizontal bead molding [51]

beaded joint a masonry joint with a central bead [40]

beakhead an ornament having the form of a bird's head and beak, often used in moldings [113]

beam a main horizontal structural framing member that supports a transverse load (*see also:* summer beam) [52]

bearing wall a wall intended to support a load [55]

bed the underside of a horizontally placed masonry unit [42]

bed joint the horizontal joint between two masonry units [40]

belfry the room at the top of a bell tower that contains the bells [70]

bell arch an arch supported by corbels, the composition having the appearance of a bell [122]

bell canopy / bell cote *see* **bell gable**

bell capital a capital whose flared shape resembles that of a bell [75]

bell flower ornament, simple or elaborated, resembling a curvilinear flower in the shape of a bell [24–26, 103, 104, 106, 112]

bell gable an open-sided structure, set on the ridge of a roof, from which bells are hung; also called a bell canopy or a bell cote [70]

bell roof a roof with a curvilinear cross-section shaped like a bell [63]

bell tower a tower that houses bells, either separate from or attached to another building (*see also:* campanile) [70]

belt course *see* **stringcourse**

belvedere a building or part of a building, usually at roof level, which commands a view [70]

bevel an angle, other than a right angle, made by the joining of two surfaces [44]

bevel siding an exterior horizontal wood siding in which each board is treated with angled, horizontal cuts resembling a series of clapboards [51]

beveled treated with a bevel or bevels [44]

bezant an ornament typically found on an archivolt, based on a medieval coin and consisting of a series of flat disks [114]

bifold door a door consisting of two pairs of separately hinged folding leaves [29]

billet a molding composed of a series of short cylinders, or blocks with square sections, arranged at regular intervals in one row, or alternating in two or more rows (*for types see:* prismatic billet, roll billet, segmental billet, square billet) [100]

bird's beak a molding whose profile resembles a bird's beak with curved sides meeting at a point [99]

blank describing an element or feature without ornament, detail, or treatment of any kind [138]

blind blank, having no opening (said of architectural members that are typically open, like windows, arches, etc., but do not function and are applied to a wall to complete a design) [2, 7, 26]

blind arcade an arcade applied to the surface of a wall; also called a wall arcade [87]

blind tracery tracery applied to the surface of a wall, rather than to a window [7]

block bond *see* **Flemish bond**

block corner transom a rectangular transom with a pane of glass whose corners are shouldered [3]

block modillion a modillion in the form of a plain block, an uncut modillion [14, 116]

blocked treated with or composed of regular projecting squared blocks, as in a column, door surround, etc. [82, 93, 105]

blocked column / blocked pilaster a column/pilaster treated with regularly projecting blocks, typically of varying texture; also called a rusticated column/pilaster [82, 93, 105, 119]

blunt arch a two-centered arch rising to a slight point [122]

board and batten wall covering consisting of joined, flush vertical boards, with the joints covered by narrow, vertical wood strips called battens [51]

bolection molding a projecting molding that covers the joint between two members of varying surface levels [99]

bond the pattern in which bricks or stones are arranged in the formation of a wall (*for brick bond types see:* American, basketweave, block, checkerboard, clip, common, cross, diagonal, English, Flemish, flying, garden,

header, herringbone, one-third running, ornamental, perforated, running, stack, stretcher; *for stone bond types see:* alternating coursed, broken coursed, coursed, galleting, polygonal, random, regular coursed, roughly coursed, uncoursed) [39, 43]

boss a small projecting, richly carved ornament, often incorporating foliage, located at the intersection of members (such as ribs), or at the termination of members (such as moldings or dripstones) [129]

bottom rail the bottom, horizontal structural member of a door or window [1, 27]

bouquet the floral ornament at the top of a finial [112, 115]

bow window a bay window with a curved plan (*see also:* bay window, oriel) [19]

bowed curved or rounded [5, 19]

bowed dormer a dormer with a curved face [5]

bowtell a convex molding, three-quarters of a circle in section, emerging from concave grooves [99]

box head window a window whose sash slide vertically into or above the head to provide maximum ventilation [2]

box stair a staircase enclosed by walls; also called an enclosed stair [94]

boxed eaves *see* **closed eaves**

brace molding a molding composed of two ogees joined at their convex ends [99]

bracing structural elements provided for additional strengthening or support [53]

bracket a general term for a member, often treated with scrolls or ornament, projecting from a wall and intended to support a weight, as a cornice, etc.; sometimes reserved for wooden support members such as are often found in porches of Victorian-era residences; when used in a series, the series is called bracketing (*see also:* ancon, console, corbel, modillion) [6, 30, 38, 58, 67, 116, 135]

brattishing *see* **cresting**

brick a regularly shaped piece of clay, hardened by the heat of the sun or a kiln and used in multiples for building walls and structures, produced in a variety of sizes (*for types see:* air, arch, bullnose, cored, corbelled, gauged, half, header, jumbo, king closer, molded, Norman, quarter closer, queen closer, Roman, rowlock, sailor, scored, shiner, soldier, standard, stretcher, three-quarter, ventilating) [13, 16, 22, 33, 39–42, 48, 116, 133]

brickwork the finish, pattern, color, and texture of brick and mortar masonry [22, 48, 56, 125]

broach a spire, especially one that is slender, straight, and pointed, that springs directly from a tower, often with pyramid-like elements making the transition, or the pyramid-like elements themselves [63]

broken coursed describing masonry laid in courses of varying height, with selected courses broken into multiple courses at various locations [16, 43]

broken pediment a triangular pediment whose peak is missing, the empty space often filled with an ornamental feature (*see also:* open bed pediment) [9]

bucrane, bucranium an ornament in the form of the head or skull of an ox, often accompanied by a garland and typically used on friezes, especially of the Doric order [113]

bulkhead a boxlike structure that rises above a floor or roof to shelter and provide access to a stair, elevator, etc., which may be fitted with a sloping door [29]

bullnose a blunt, curved corner [41]

bullnose brick brick with one rounded corner [41]

bull's eye a small, circular or oval window or other opening (*see also:* oculus) [4, 24, 58, 91]

butt edge siding an exterior horizontal wood siding in which boards of consistent depth are applied so that each board abuts the adjacent board without overlap; also called flush siding [51]

butt joint a plain joint between two elements at right angles [59]

buttress a structure, typically of masonry, projecting from a wall and counteracting the thrust of an arch, vault, roof, or other structure (*see also:* flying buttress) [55, 62]

C

cable molding *see* **rope molding**

came a strip, typically of lead, which holds the panes of glass in casement and stained glass windows [3]

campanile a bell tower separate from the main church building [70]

canephora (*pl.* canephorae) a figure resembling a young woman supporting a basket on her head (*see also:* atlas, caryatid, herm) [81]

cap *see* **surbase**

cap course the topmost course of shingles, tiles, etc., on the ridge of a roof [67]

capital the topmost member of a column, pilaster, etc., which takes a variety of forms and typically carries an architrave, arcade,

etc. (*for types see:* bell, composite, Corinthian, crocket, cushion, Doric, foliate, interlace, Ionic, lotus, palm, protomai, scalloped, Tuscan) [73–76, 78, 90–93]

capped siding *see* **drop siding**

captain's walk *see* **widow's walk**

cartouche a panel or shield, often inscribed at the center and provided with an ornamented frame shaped like a scroll or curled paper [34, 106, 114, 124]

caryatid the figure of a woman used as a support in place of a column (*see also:* atlas, canephora, herm) [81]

case / casing a finished frame, flat or molded, consisting of jamb and lintel, and placed in an opening to receive a door or window [1]

casement a hinged window that swings open to the side [2, 6, 18, 26]

castellated *see* **battled**

caulicole in a Corinthian capital, the stalk that rises from the acanthus leaves and supports the volutes [73]

cavetto molding a concave molding with the profile of a quarter of a circle; also called a quarter hollow [99]

chain molding a molding that represents the joined links of a chain [100]

chair rail a horizontal interior molding placed at the height of a chair back to protect the wall, or at the top of a dado (*see also:* dado) [61]

chamfer a molding or the corner of an element that is cut off at an angle (*see also:* hollow chamfer) [99, 119]

checkerboard bond masonry bond in which bricks are laid to produce the effect of a checkerboard [39]

cheek an upright member, usually one of a pair, forming the sides of an opening [36]

cherub a sculpted figure, often a child with wings, used as ornament (*see also:* putti) [22, 113]

chevron molding a molding composed of a series of V-shaped figures; also called zigzag molding [100]

Chicago window a horizontal window composed of a central, fixed, single pane flanked by narrower sash, which are often double-hung [2]

chimney a structure erected for the conveyance of smoke to the outside of a building, especially the part of that structure that rises above the roof (*for types see:* eaves wall exterior, end wall, gable end exterior, ridge, slope) [68, 132, 137]

chimney cap / chimney hood a covering that shelters the opening of a chimney [68]

chimney pot an ornamental, often cylindrically shaped extension of a flue above the chimney top [68]

chisel shingles shingles that are triangular in shape with the point of one shingle centered over the triangle below [64]

cinquefoil an element composed of five foils and five cusps [8]

circle corner transom a rectangular transom with a pane of glass whose four corners take the shape of quarter-circles [3]

circle end transom a rectangular transom with a pane of glass whose ends take the shape of half-circles [3]

circular arch *see* **round arch**

circular stair *see* **spiral stair**

clapboard an exterior horizontal wood siding applied so that the thicker edge of each board overlaps the board below; a type of weatherboard [49, 51, 132]

classical describing architecture based on the styles of Hellenic Greece and or Imperial Rome, or the Greek and Roman architecture itself [32, 74]

classroom window a wide window with at least two lights placed side by side below a fixed light or lights [2]

clip bond a masonry bond formed by headers laid diagonally in an angled notch formed by the clipped corners of stretchers (*see also:* diagonal bond) [39]

clipped gable *see* **jerkinhead roof**

clock tower a tower whose main purpose is the housing of a clock in a prominent position [70]

cloistered vault *see* **coved vault**

closed balustrade a solid balustrade, typically used in porch construction [58]

closed eaves eaves in which the triangular space between the rafters and the exterior wall is enclosed with a horizontal soffit; also called boxed eaves [67]

closed gable a gable in which all three sides are treated with continuous and uninterrupted moldings [69]

closed string a string with top and bottom edges parallel and grooves cut into the face to receive and conceal the ends of the treads and risers of a stair [95, 98]

closed string stair a stair constructed with closed strings, so as to conceal the ends of the treads and risers [98]

closer *see* **quarter closer**

closing stile *see* **locking stile**

clustered column / clustered pier multiple columns joined together to act as a single structure [80]

coffer one of a series of deeply recessed, polygonal ceiling panels, often highly ornamented; also called a lacunar [101]

coffering a series of coffers [101]

collar beam a secondary horizontal member connecting a pair of rafters [65]

collar joint the vertical joint between the long sides of two masonry units [40]

colonette or **colonnette** a small, decorative column [21]

colonnade a series of columns carrying an entablature and possibly a roof (*see also:* portico) [87]

colossal column / colossal order a column that rises more than one story; also called a giant column [84]

column a principal architectural member, vertically oriented, long and slender in proportions, usually circular in plan, intended to support an entablature or other load, and usually composed of a base, shaft, and capital (*for types see:* banded, blocked, clustered, colonnette, colossal, composite, Corinthian, coupled, Doric, dwarf, engaged, entwined, giant, Ionic, spiral, stopped flute, twisted; *see also:* pier, pilaster, pillar, post) [20, 25, 58, 72–93]

columnar composed, at least in part, of a column or columns [86]

columniation the arrangement of columns in an architectural composition (*for types see:* amphiprostyle, decastyle, dipteral, distyle, distyle in antis, dodecastyle, enneastyle, heptastyle, hexastyle, monopteral, octastyle, pentastyle, peripteral, prostyle, pseudodipteral, pseudoperipteral, tetrastyle, tripteral; *see also:* intercolumniation) [88]

common bond a brick masonry bond composed of five or six stretcher courses to one header course; also called American bond [39]

composite one of the five classical orders of architecture, being an elaboration of the Corinthian order [72, 74, 75, 90]

compound dome a structure composed of multiple domes and vaults [131]

concave joint a curved, recessed masonry joint [40]

conical roof a cone-shaped roof [63, 136, 137]

console a version of a bracket, often decorative, in the form of a vertical scroll, of greater height than depth, projecting from a wall to support a cornice or other member (*see also:* ancon, bracket, corbel, modillion) [34, 36, 116]

continuous sill a sill that serves more than one window without interruption [21, 137]

continuous stud in balloon framing, a stud in the exterior wall that rises the full two-story height of the wall [54]

coping the uppermost course of a wall or parapet, typically sloping to shed water and protect the wall below [41, 69]

corbel a projecting stone or brick, often used in a series (when it is called corbelling), with each member stepped progressively forward, used to support another member (*see also:* ancon, bracket, console, corbel table, modillion) [41, 116, 118, 136]

corbel arch an arch formed by the progressive cantilevering of masonry units; also called a false arch [121]

corbel table a series of corbels, often with connecting arches, supporting a parapet, cornice, or course of masonry [56, 118, 139]

cored brick *see* **air brick**

Corinthian one of the five classical orders of architecture, characterized by a capital with volutes rising from acanthus leaves [72, 74, 75]

corner bead a molding at the external angle of two intersecting surfaces; also called an angle bead [99]

corner board a vertical board at the corner of a wood frame structure, against which the horizontal siding abuts [49]

cornerstone a stone prominently placed near the base of a corner of a building to commemorate the date of construction, the architect, and other important information [60]

cornice the uppermost division of an entablature; a horizontal ornamental molding at the top of a building or other prominent architectural element, such as a window or door [12, 21, 31, 32, 35, 58, 60, 67, 73, 76, 78, 79, 90-93, 133, 134, 135, 136, 137, 138, 139]

cornucopia ornament representing a horn filled with fruit [112]

corrugated metal sheetmetal formed into parallel ridges and used to cover roofs [64]

coupled *see* **paired**

course a continuous horizontal range of masonry units [40]

coursed a stone bond in which masonry units are arranged according to height, forming continuous horizontal joints, when constructed with fieldstone, multiple units may be required to achieve the height of a single course [43, 50]

cove shingles shingles whose lower edges have concave chamfered corners [64]

coved vault a vault composed of four quarter-cylindrical elements meeting at a point; also called a cloistered vault [128]

crenel the open space between two merlons in a battlement; also called an embrasure [56, 57, 69]

crenellated *see* **battled**

crenellated molding a molding composed of notches representing merlons and crenels [100]

crepidoma the stepped platform of a temple [76, 78, 89]

crest an upright ornamental member, often perforated, which surmounts another member [115]

cresting a series of crests at the top of a structure, especially on the ridge of a roof; also called brattishing [115, 136]

cricket a small projecting structure placed on a sloping roof to divert water away from joints [68]

crocket an ornament carved to resemble leaves, flowers, or bunches of foliage, and used to decorate the angles of spires, pinnacles, or sloping or vertical edges [62, 75]

crocket capital a capital composed of leaves that terminate in crockets [75]

cross *see* **Greek cross, Latin cross** [114]

cross bond a brick masonry bond in which Flemish bond courses alternate with courses of stretchers; also called Flemish cross bond [39]

cross gable a roof composed of two gables intersecting at right angles [63, 137]

cross vault a vault formed by the intersection of two barrel vaults at right angles [128]

crown a decorative terminal element [135]; the top of an arch [120]

crown molding any molding forming the topmost finishing member of a structure or architectural feature [61]

crowstep one of the steps in a crowstep gable

crowstep gable a gable composed of a series of steps meeting at the ridge, each step of which is called a crowstep [69]

cruciform shaped like a cross [4]

cupola a rooftop structure, typically composed of a dome on a circular or polygonal base, simple or elaborate in design, small or large in size, originally intended to provide ventilation, but may be strictly decorative (*see also:* bell gable, lantern) [70, 131]

curb the horizontal structural member between two slopes of a roof [65]

curtail step a step with rounded ends, typically found at the bottom of a flight of stairs [96]

curtain wall a non–load-bearing exterior wall, applied in front of a framed structure and not supported by its beams or girders, called a window wall if composed primarily of glass [140]

cushion capital a capital almost cubical in shape, with the lower part rounded toward the shaft [75]

cusp in tracery, a point made by the joining of two foils [8, 126]

cusped arch *see* **foiled arch**

cut stone stone worked to a particular size and shape for the place it is to occupy in a wall or other structure; may be treated with a variety of surface textures (*for bond types see:* alternating coursed, broken coursed, random coursed, regular coursed, uncoursed; *see also:* ashlar, fieldstone) [43]

cyma recta an ogee molding composed of a concave arc above a convex arc [99]

cyma reversa a reverse ogee molding composed of a convex arc above a concave arc [99]

dado the part of a pedestal between the base and the surbase (also called a die) [73]; a covering for the lower part of an interior wall, between the baseboard and the chair rail [61]

dagger a tracery element with a round or pointed head, a pointed foot, and a cusped interior [8]

dart the pointed member between the oval elements in egg and dart ornament; also called an arrowhead [17, 100, 103]

decastyle describing a portico composed of ten columns [88]

dentil one of a series of small, square, tooth-like blocks forming a molding that is used typically in cornices [19, 31, 32, 73, 79, 133, 135]

depressed arch an arch struck from centers located below the springing line; also called a drop arch [121]

detail any architectural feature small in proportion to the larger whole [1, 8, 27, 45, 49, 58, 59, 67–69, 95, 97, 129, 130]

diagonal bond brick masonry bond in which every sixth course is composed of headers set diagonally and joined by clip bond (*see also:* clip bond) [39]

diagonal rib a rib that crosses a vault bay on a diagonal [129]

diamond point stonework with faces cut in the form of pyramids; also called prismatic [44, 124]

diamond shingles shingles that take the shape of diamonds [64]

diaper an all-over pattern consisting of repeated figures placed on a grid [101]

die *see* **dado**

diminished arch an arch whose rise is less than a semicircle, as in a segmental arch [121]

Diocletian window *see* **Palladian window**

dipteral describing a portico composed of two rows of columns [88]

discharging arch *see* **relieving arch**

distyle describing a portico composed of two columns [88]

distyle in antis describing a portico composed of two columns between antae [88]

dodecastyle describing a portico composed of twelve columns [88]

dogleg stair a half-turn stair with no open well [94]

dogtooth one of a series of diagonally placed ornamental elements taking the form of four leaves radiating from a raised center; also called tooth ornament; a molding consisting of a series of dogtooth ornaments [100]

dome a vault covering a circular base (*for types see:* compound, hemispherical, onion, pointed, saucer, stepped, stilted) [63, 131]

dome skylight a round skylight with a domed surface [68]

domical like a dome, pertaining to a dome [128]

door the architectural element that occupies an opening in a wall, and closes or provides access to a room or other space (*for types see:* accordion, batten, bifold, bulkhead, double, double-acting, double pocket, Dutch, flush, folding, French, glass, glazed, grille, half, louvered, multilight, overhead, paneled, pivoting, pocket, portcullis, revolving, rolling, sash, screen, single pocket, sliding, storm, swing, trap, undercut, vision light, wicket) [27–38]

Doric one of the five classical orders of architecture, characterized by a simple cushion capital and a frieze composed of triglyphs and metopes [20, 37, 72, 74–77, 92, 93]

dormer a window built into a sloping roof with a roof of its own, in a variety of shapes, including: bowed, flared, flat, gabled, half-round, hipped, jerkinhead, lucerne, pedimented, round headed, segmental, shaped gable, or shed (*see also:* eyebrow, inset, internal, wall dormer) [5, 6, 134]

double-acting door *see* **swing door**

double door two single doors hung in a single frame [28]

double-hung window / double-hung sash window a window composed of two sash that slide vertically past each other to close different parts of the window opening [1, 2, 11, 16, 19–21, 23, 56, 132, 134, 135, 138, 139]

double keystone a keystone that appears to be composed of two plain keystones of varying size, superimposed [20, 124]

double lancet window a window composed of a pair of sharp-pointed arches separated by a mullion, or a pair of narrow windows with sharply pointed arches [4]

double pocket doors two doors that slide in opposite directions into openings in a wall [29]

double return stair a stair that divides in two after an intermediate landing [94]

double stair a stair with two lower parts joining into one central stair after an intermediate landing [94]

double vault a domical vault composed of an inner shell below a higher outer shell [128]

dovetail any member with two sides that flare into a wedge shape, especially one intended to fit a joint [59]

downspout a vertical pipe that conducts water away from a roof [67]

draft *see* **margin**

drip / drip molding / dripstone a projecting molding with a groove on its underside to divert water away from the wall below, or a molding resembling such an element; also called a hood molding (*see also:* label molding) [10, 17, 58, 60]

drop the bottom part of a newel that does not meet a floor but hangs down into the open space below, often ornamented [97]

drop arch *see* **depressed arch**

drop ornament *see* **pendant**

drop siding an exterior, horizontal wood siding in which the boards have grooves along one upper edge, into which the lower edge of the board above interlocks, leaving the lower part of the groove visible; also called capped siding [51]

drop window a vertically sliding window whose sash can drop below sill level to maximize the ventilation area [2]

drum one of the cylindrical elements that compose the shaft of a column [73]

Dutch door a door divided into two independently operating parts, one above the other; also called a stable door [29]

Dutch gable a gable with flared sides; also called a flared roof [63]

Dutch gambrel a gambrel roof with flared, lower pitches [63]

dwarf lower in height than normal [84, 133]

E

ear *see* **shoulder**

eaves the overhanging part of a sloping roof (note: the singular "eave" is incorrect; *see also:* closed eaves, open eaves) [65, 67, 135]

eaves fascia a vertical board nailed to the ends of rafters [67]

eaves wall the wall below the eaves of a roof [65]

eaves wall exterior chimney a chimney constructed on an eaves wall, whose entire height, from the ground up, is visible at the exterior (*see also:* end wall chimney, gable end exterior chimney, ridge chimney, slope chimney) [68]

echinus the convex molding located below the abacus in the Doric order or the egg and dart molding in an Ionic capital [76, 77]

edge roll an inset convex molding, typically three-quarters of a circle in profile [99]

egg and dart a molding consisting of egg-shaped elements alternating with arrow- or dart-like elements; also called egg and

anchor, egg and arrow, egg and tongue [17, 100]

egg and leaf a molding consisting of egg-shaped elements alternating with leaf-like elements [24]

eight-over-eight a window light arrangement composed of a sash divided into eight panes above another sash divided into eight panes [16]

elbow *see* **shoulder**

elevation a wall of a building [132]

elliptical arch / elliptical vault an arch/vault whose intrados/cross-section takes the shape of a part of an ellipse [121, 127]

elliptical arched window / door a window/door whose head takes the shape of a part of an ellipse [12]

elliptical stair a stair that winds around an elliptical newel or well, or a stair whose plan takes the shape of an ellipse [94]

embattled *see* **battled**

embattlement *see* **battlement**

embrasure *see* **crenel**

encarpus *see* **festoon**

enclosed stair *see* **box stair**

end wall chimney a chimney constructed on the end wall of a building, but only visible above the ridge of the roof (*see also:* eaves wall exterior chimney, gable end exterior chimney, ridge chimney, slope chimney) [68]

endiaper to ornament with a diaper pattern

engaged attached to a wall, as in a column [20, 85]

engaged column a non-structural column, partially built into a wall, projecting more than one-half its diameter; also called an attached column (*see also:* freestanding, half column, pilaster) [85]

English bond a brick masonry pattern with alternating courses of headers and stretchers [39]

enneastyle describing a portico composed of nine columns [88]

entablature the horizontal member composed of an architrave, a frieze, and a cornice, and typically carried by columns or pilasters, but also used with other architectural features, such as doors and windows [27, 32, 37, 73, 74, 134]

entwined wrapped, typically in a spiral fashion with a vine-like element [19, 82]

entwined column a column whose straight shaft is wrapped with a spiral molding; also called a wreathed column [82]

equilateral arch a two-centered arch whose span equals the chords of the curves [122]

escroll a scroll or ribbon with scrolled ends, typically inscribed and used as ornament on an architectural feature [114]

expanding vault a vault that is larger at one end than the other [127]

exposed rafters rafters that extend beyond the wall of a building and are not enclosed by a soffit or other trim [67]

extrados the exterior curve of an arch [120, 126]

eye the center of a volute; an oculus at the peak of a dome [78]

eyebrow a low dormer with no vertical sides and a roof that takes the form of a wave, the roof covering running continuous with that of the main building [5]

F

facade the front wall of a building, or any architecturally distinguished wall of a building, or a wall that stands separate from the building behind, suggesting a building of different size or character [55, 132, 135]

face the exposed surface of an architectural element, especially a masonry unit [42]; to finish the surface of an architectural element [132]

facing a material applied to a wall to finish it and provide a more attractive surface than that underneath, as in siding or veneer

false arch *see* **corbel arch**

false window a blind window (*see* **blind**)

fan vault a vault with ribs that radiate like the ribs of a fan [128]

fanlight a window, usually semicircular in shape, located above a door or window, often with mullions radiating like a fan; also called a lunette [3, 33, 37, 38]

fascia / facia the broad, flat board that covers the ends of rafters; in classical architecture, the plain horizontal band of an architrave [67]

festoon an ornament consisting of a garland of fruits and flowers, heavy in the middle and suspended at both ends; also called a swag or an encarpus [34, 91, 112, 119]

fielded panel *see* **raised panel**

fieldstone building stone used in its rough, irregular shape, as found in the field (*for bond types, see:* coursed, polygonal, roughly coursed; *see also:* ashlar, cut stone) [43]

fill soil and other related materials used to raise the grade level [59]

fillet a narrow, flat band with a square section, often used to separate moldings; the narrow vertical band separating the flutes of a column (*see also:* roll and fillet, sunk fillet) [76, 77, 83, 99]

finial an ornament typically consisting of a bunch of foliage, which terminates a spire, pinnacle, or other upward-oriented member [6, 8, 62, 71, 115, 133, 136, 138]

finish floor material used for the final surface in floor construction [59]

fish scale a decorative pattern in which shingles, whose lower edges form half-circles (also called half-circle shingles), are overlapped and resemble the scales of fish [64]

fixed window a window that does not open [2]

flank to stand at both sides of an architectural feature [132, 134, 137, 138]

flared spread outward [5, 63]

flared dome a dome whose lower edges flare outward to meet the walls below [131]

flared dormer a dormer whose roof is flared upward at the face of the window [5]

flared roof a Dutch gable roof; any roof whose lower edges flare outward [5, 63]

flashing sheet metal placed over the joints in construction to prevent water leakage [6]

flat describing an element with no perceptible slope [5, 63, 68, 121, 135]

flat arch an arch with a horizontal intrados; also called a jack arch or a straight arch [121]

flat dormer a dormer with a flat roof [5]

flat headed window a window opening with a straight head [135]

flat roof a roof with no perceptible slope [5, 63]

flat skylight a skylight with no perceptible slope [68]

fleche a small and slender spire, typically constructed of wood and rising from the roof of a church; also called a spirelet (*see also:* needle spire, spire, steeple) [70]

Flemish bond a brick masonry bond, the courses of which are composed of alternating headers and stretchers, with each header centered over the stretcher below; also called block bond [39, 48, 56, 133]

Flemish cross bond *see* **cross bond**

fleur-de-lis (also -lys; *pl.* fleurs-) an ornament composed of three pointed members, the center one upright and the sides curved outward, all separated by a horizontal bar from three similar members, or a single vertical one, below [59, 92, 112]

fleuron the flower in the center of the Corinthian abacus, or any small floral ornament [73]

Florentine arch a rounded arch whose intrados and extrados are not concentric [122]

flowing tracery tracery composed of curvilinear mullions [7]

flush even with the surrounding surface [114]

flush bead / flush bead molding a bead molding whose outermost surface is even with the adjacent surface [99]

flush door a door whose surface is completely smooth [28]

flush joint a masonry joint finished even with the surrounding surface [40]

flush siding *see* **butt edge siding**

flute one of a series of vertical parallel grooves, typically used in the shafts of columns, but also used in moldings (*for types see:* spiral, stopped) [17, 76, 77, 93]

fluted treated with flutes [17, 24, 25, 32, 48, 82, 83, 91, 92, 97, 105, 119]

fluting a series of flutes [82, 83, 99]

flying bond a brick masonry bond composed mainly of stretchers with an occasional header; also called garden bond [39]

flying buttress a buttress often used in architecture of the Gothic period, composed of a solid vertical member and a sloping member that is carried on an arch and connects the vertical member with the wall, intended to absorb the lateral thrust of the roof [62]

foil in tracery, one of a series of inwardly projecting, curved members that meet in points, called cusps, on the inner side of an arch (*see also:* cinquefoil, multifoil, quatrefoil, trefoil) [8]

foiled treated with foils

foiled arch an arch whose intrados is composed of foils; for example, a trefoil arch; also called a cusped arch [122]

folding door / folding window *see* **accordion door / window**

foliage ornament that represents leaves [19]

foliate / foliated ornamented with leaves or leaf-like elements [75, 92, 93, 113, 124]

foliate capital a capital composed primarily of foliage that is often curled [75]

foliate head carved ornament consisting of a head encircled with a wreath of foliage [113]

footing the lowest part of the foundation, which transmits the load to the ground [59]

fortified describing a structure or member provided with defensive elements, such as crenels and merlons [56, 57]

foundation the substructure of a building, which supports the structure and transmits the load to the ground [49, 52–54, 58, 59, 132, 134]

four-centered arch a shallow pointed arch struck from four centers, as in a Tudor arch [122]

four-over-one a window light arrangement composed of a sash divided into four panes above another sash composed of a single pane [3]

fractable a stepped or curved coping, often ornamental, on the stepped gable wall of a building, carried above the roof [69]

frame / framing the structural elements surrounding a door or window in a wall, to which the door or window is attached, consisting of two jambs, a lintel, and a sill [1]; the basic elements composing a structure [66]

frame construction a method of building relying primarily on wooden structural members [52]

freestanding describing an element or feature that is not supported along its height [85]

French doors a pair of glass doors that open in the middle [29]

fret geometric ornament composed of lines joined at right angles and repeated over a surface; also called a key, labyrinth fret, or a Greek key (*see also:* meander) [100]

fretwork a series of frets

frieze the member of an entablature located between the architrave and cornice, may be plain or ornamented with sculpted figures or foliage, or triglyphs and metopes, depending on the order used [73, 76–79, 89–92]; a long, narrow, horizontal band, typically treated with continuous ornament and located near the top of a wall (*see also:* band, lintel course, sill course, stringcourse) [58, 60, 67, 106]

G

gable / gable roof / gabled roof a roof having two slopes that meet at a ridge and form a triangle [63, 65, 71, 132]; the triangular-shaped part of a wall under a pitched roof, from cornice to peak, often ornamented (*for types see:* asymmetrical, closed, crowstep, Dutch, open, shaped) [65, 69, 132, 135–137]

gableboard *see* **bargeboard**

gabled dormer a dormer with a gable roof, the front of the dormer being a gable end [5, 6]

gable end / gable wall the end wall of a structure having a gable [65]

gable end exterior chimney a chimney constructed on the gable end of a building, whose entire height from the ground up is visible at the exterior (*see also:* eaves wall exterior chimney, end wall chimney, ridge chimney, slope chimney) [68]

gable vent a device, often a louvered panel, installed in the gable end of a building to ventilate the interior [68, 132]

gadrooning ornament consisting of a series of non-parallel convex curves; also called nulling (*see also:* reeding) [19, 101]

galleting the insertion of small stones in mortar joints for decorative effect [40, 43]

gambrel roof a roof with two pitches on each side, the lower pitch being steeper [63, 65]

garden bond *see* **flying bond**

gargoyle a carved ornament representing a grotesquely formed animal, traditionally serving as a waterspout, and commonly used as ornament near the roof [62, 113]

garland ornament composed of leaves, fruits, and flowers woven together in a band or wreath (*see also:* festoon) [91, 92]

gate a barrier placed in a wall or other structure for security or privacy, which opens to permit access or view [12]

gauged arch an arch composed of gauged bricks [123]

gauged brick brick made to specific dimensions, especially that which is tapered for the construction of an arch [41]

geometrical stair a stair without newels at the turning points [94]

giant column / giant order *see* **colossal column / order**

girder any horizontal member functioning as a beam, but larger than a beam [54]

girt a horizontal wood framing member that carries the joists of upper floors [52]

glass door a door composed primarily of a single pane of glass [28]

glazed furnished with glass [28]

gooseneck the curved or angled part of a handrail that meets a newel or turns a corner [97]

Gothic arch a general term for a pointed arch [3, 4]

grade the level of the ground [59]

grating *see* **grille**

Greek cross a cross composed of four equal arms [114]

Greek Ionic an Ionic capital with parallel volutes [74, 75]

Greek key *see* **fret**

griffin an imaginary creature typically composed of the paws of a lion and the wings and beak of an eagle [113]

grille an openwork structure of bars, typically constructed of metal and often decorative, which screens an opening, typically a window or door [15, 17, 25, 28, 31, 34]

groin the edge formed by the intersection of two vaults [128]

groin vault a vault produced by two equal barrel vaults meeting at right angles, with groins at the intersections [128]

grouped describing three or more elements arranged in close proximity to each other (*see also:* coupled) [25]

gryphon *see* **griffin**

guilloche an ornament composed of two or more curved bands that continuously intertwine, creating round openings that are often filled with ornament [102]

gutta (*pl.* guttae) one of a series of cone-shaped or cylindrical ornaments, located on the underside of the mutules and regulae situated at each triglyph on a Doric architrave [35, 76, 77, 106]

gutter a channel attached to the eaves of a building to carry away rainwater from the roof (*see also:* hanging gutter, ogee gutter) [67]

H

half brick a brick approximately one-half the length of a standard brick, used in locations where a full brick will not fit [42]

half circle shingle *see* **fish scale shingle** [64]

half column a column that is built into a wall, projecting one-half its diameter (*see also:* engaged, freestanding, pilaster) [85]

half door one-half of a Dutch door; a door that is shorter than its opening, with open space above and below [29]

half figure an ornamental figure composed of the upper part of a human or animal figure emerging from foliage and scrolls; also called a protome [113]

half-round *see* **bead**

half-round dormer a dormer whose face takes the shape of a semicircle [5]

half story a story within a sloping roof or with a wall height less than that of the stories below [134]

half timbering a type of construction composed of exposed timber framing, the spaces filled with masonry or plaster [51]

handrail a hand support placed along the side of a stair to assist in climbing or descending [96, 97, 135]

handrail scroll a spiral ornament at the end of a handrail (*see also:* gooseneck, lamb's tongue) [97]

hanging gutter a metal gutter, typically of simple profile, hung from the eaves of a roof by a metal tie or other hanging device (*see also:* ogee gutter) [67]

hanging stile the vertical structural member of a door, to which the hinges are attached [27]

hatch *see* **trap door**

haunch the middle part of an arch between the crown and the impost [120]

hanging stile the vertical structural member of a door, to which the hinges are attached [27]

head the top horizontal member of a window or door frame [1, 27]

header a brick or other masonry unit laid on its broad side with its short end showing; any member laid transverse to other similar members [1, 40, 42, 53]

header bond masonry bond composed only of headers [39]

header course a masonry course composed only of headers [40]

head joint the vertical joint between the short ends of two masonry units [40]

heart and dart a molding composed of alternating heart-like figures and darts [100]

helix the volute of a Corinthian or Ionic capital

helm roof a roof composed of four steeply pitched faces rising from gables to form a spire [71]

hemispherical dome a dome that takes the shape of one-half of a sphere [131]

heptastyle describing a portico composed of seven columns [88]

herm / hermes a pillar or post composed of the representation of a human head or a human figure whose waist emerges from a tapering pedestal; also called a term or terminal figure (*see also:* atlas, caryatid, canephora) [81]

herringbone a zigzag pattern, often used ornamentally [101]

herringbone bond a brick masonry pattern composed of stretchers laid diagonally and alternating in groups to form a zigzag pattern [39]

hexagonal shingles shingles that take the shape of hexagons [64]

hexastyle describing a portico composed of six columns [88]

hip the external angle formed by the juncture of two sloping roof surfaces [65]

hip and valley roof any roof composed of both hips and valleys [65]

hip knob a finial located on a ridge or at the point of a gable where bargeboards meet, often ending in a pendant [69]

hip roof / hipped roof a roof in which all four sides slope upward, forming four hips [5, 63, 71, 132, 134]

hipped end the triangular end of a hipped roof, sloping back to the ridge [65]

hipped gable *see* **jerkinhead roof**

hollow chamfer a corner that is cut away, the cutaway surface taking a concave shape [119]; a molding with a similar appearance [99]

hollow square molding a molding composed of a series of indented pyramids [100]

honeycomb ornament with a hexagonal structure or pattern [101]

honeysuckle ornament *see* **anthemion**

hood a cover, often decorated, placed over an opening, especially over a door or window [9 23, 30, 36, 38, 135, 138]

hood molding *see* **drip molding**

hopper window a window sash that opens inward and is hinged at the bottom or sides [2]

horizontal pivot window a window with sash that pivot about a horizontal axis [2]

horizontal shingles shingles with the shape of long, narrow rectangles [64]

horseshoe arch an arch whose curve is greater than a semicircle; also called an Arabic arch, a Moorish arch, or an Islamic arch [122]

hung sash any vertically sliding window sash that is hung on cords or chains attached to counterweights, as in a double-hung sash [2, 11, 16, 19–21, 23, 56]

I

imbricate to provide with a pattern of imbrication [64]

imbrication overlapping rows of shingles or other elements of various shapes producing a pattern, often colorful, resembling overlapping scales; also called scale ornament [64]

impost the part of a wall or abutment from which an arch springs, often distinguished by moldings, or taking the form of a course or block of masonry [11, 16, 22, 125, 126]

in antis the condition created when columns are flanked by extended walls of a temple or other structure (*see also:* anta) [85, 88]

incised (of ornament) formed by cutting, engraving, or indenting (*see also:* inscription, pierced) [21]

indented molding a molding whose edge is indented with triangular tooth-like shapes [100, 117]

Indian arch a pointed arch whose lower portion is a curve greater than a semicircle [122]

inscribed treated with an inscription [90, 91]

inscription lettering, often monumental, on an architectural member [31]

inset dormer a dormer, the structure of which is partially contained within and below the roof line [5]

inside stop *see* **stop**

intercolumniation the space between two columns or the system for establishing such spacing [89]

interlace ornament composed of bands that cross and recross [101]

interlace capital a capital treated with interlace ornament [75]

interlacing arcade *see* **intersecting arcade**

intermediate cornice a horizontal ornamental molding above a prominent architectural element that is a part of a larger composition with its own more elaborate cornice [60, 91]

intermediate rib a vaulting rib connecting two other ribs [129]

internal dormer a window, with no roof of its own, which projects down from, and is set within, a sloping roof [5]

interrupted arch molding a molding composed of a series of interrupted and often overlapping arches [100]

interrupted pediment *see* **broken pediment**

intersecting arcade an arcade composed of arches whose archivolts cross; also called an interlacing arcade [87]

intrados the concave undersurface, or soffit, of an arch [120]

Ionic one of the five classical orders of architecture, characterized by a capital composed of two volutes (*see also:* angle capital) [20, 26, 72, 74, 75, 78, 79, 91, 134]

Islamic arch *see* **horseshoe arch**

ivy ornament representing the leaves and vines of the ivy plant [112]

jack arch *see* **flat arch**

jalousie window a window composed of a series of thin, narrow strips of glass that adjust for ventilation [2]

jamb the vertical member at the sides of a door or window frame (*see also:* reveal) [1, 10, 27]

jamb shaft a small column placed at the jamb of a door, window, or other opening [14, 19, 22, 85]

jerkinhead a roof, the lower half of which is gabled, the upper half of which is angled back to the ridge to form a small hip; also called a clipped gable or hipped gable [5, 63, 71]

joint the place where two elements, or parts of elements, unite (*for types of wood joints see:* batten, butt, dovetail, shiplap, tongue and groove); the mortar filling the horizontal or vertical spaces between masonry units (*for types see:* beaded, bed,

collar, concave, flush, galleting, head, raked, struck, V-shaped, weathered) [40, 59]

joist a horizontal wood framing member that supports floor boards or a ceiling surface [52–54, 59]

jumbo brick a brick larger than standard size [41]

K

key *see* **fret**

keystone the central voussoir of an arch; the middle of an archivolt, often elaborately embellished [11, 12, 16, 18, 20, 22, 26, 33, 35, 37, 56, 91, 119, 120, 124, 125]

king closer a brick with one corner cut off at a 45-degree angle, used in locations where a full brick will not fit [42]

king post a truss composed of two inclined members, a horizontal tie beam, a central vertical member (also called a king post) that connects the peak with the beam, and possibly other secondary vertical and inclined members, or a similar ornamental composition [65, 69]

kneeler a stone that is angled on one side to support an inclined element [59]

L

label / label molding a drip molding that extends horizontally across the top of a door or window opening and returns vertically downward for a short distance [10]

label stop an ornamental termination at the ends of a drip molding or label molding, sometimes extending horizontally away from the opening for a short distance [10]

labyrinth fret *see* **fret**

lacunar *see* **coffer**

ladder a frame for climbing, composed of two vertical side pieces with connecting horizontal pieces [95]

lamb's tongue the ornamental end of a handrail that is shaped like a tongue [97]

lancet / lancet window a narrow window in the form of a sharply pointed arch [4]

lancet arch an acute, pointed, two-centered arch whose centers are farther apart than the width of the arch [122]

landing the resting place between two flights of stairs, or the part of a floor at the head of a flight of stairs [96, 98]

lantern a rooftop structure, typically polygonal in plan and of tall, slender proportions, with openings on its sides to light the interior, possibly composing the upper portion of a cupola, or a similar structure used for decorative purposes [70]

lath a narrow strip of wood used in a series to provide a base for walls and ceilings [51]

Latin cross a cross composed of three short arms and one long arm, with the vertical member longer than the horizontal, and the upper three members equal in length [114]

lattice a structure of wood or metal bars or other elements that cross each other at regular intervals, typically used to screen one area from another [58]

lattice molding a molding of latticework; also called a trellis molding [100]

latticework a pattern composed of members crossing each other orthogonally, diagonally, or curvilinearly [25, 90, 101]

leaded glass / leaded light / leaded window a window composed of rectangular or diamond-shaped panes of clear or stained glass set in lead cames [3]

leaf and dart a molding composed of a series of alternating leaf-like figures and darts; also called leaf and tongue [100, 103]

lean-to an extension to a building, with the roof of the extension having a single slope and appearing to lean against the main building, which is taller, or the roof of the extension (*see also:* shed roof) [63]

ledgement a molded course near the base of a building [58, 60]

ledger the horizontal structural member that carries the joists [54]

lierne rib an ornamental rib located between the main ribs of a vault [129]

lierne vault a vault that incorporates lierne ribs [128]

light a single piece of glass in a door or window; also called a pane [1, 3]

light arrangement the number and pattern of panes in a window [3]

lily a flowering plant with long stems and leaves often replicated in moldings and ornament [112]

linen panel a panel with a treatment representing a piece of cloth laid in vertical folds [114]

lintel a horizontal member located above an opening, as a door or window opening, to carry the weight of the wall above [1, 20, 121]

lintel course a course of masonry at the level of a window or door lintel, distin-

guished from the surrounding wall surface by its greater projection or decorative finish, which may match that of the lintel (*see also:* band, frieze, sill course, stringcourse) [58, 60]

lock rail / locking rail the horizontal structural member of a door, located between the vertical stiles at door knob or lock height [27]

lock stile / locking stile the vertical structural member of a door, which includes the doorknob and which closes against the jamb; also called a closing stile or striking stile [27]

lotus a water lily represented in ornament, often stylized as an upright, open flower [112]

lotus capital a capital in the shape of a lotus bud [75]

louver a system of overlapping horizontal slats placed in an opening to regulate ventilation [68]

louvered treated with louvers [68, 132]

louvered door / louvered shutter a door/shutter fitted with horizontal slats that can be moved up or down to control light and ventilation [1, 28, 133, 134]

lozenge a decorative element, usually one of a series, in the shape of a diamond or a square set diagonally [100]

lozenge fret, lozenge molding a molding composed of continuously joined lozenges [100]

lucarne / lucerne a small dormer window, especially one whose face takes the shape of a segment of a circle and whose roof is distinct from the roof of the main building [5]

lunette a semicircular or crescent-shaped window (*see also:* fanlight) [4, 134]

M

mansard / mansard roof a roof having two slopes on all four sides, the lower slope steeper and longer than the upper slope [63, 135]

margent a thin strip of floral and foliage ornament hanging from a point [112]

margin the narrow border on the face of a stone; also called a draft [44]

mascaron / mask an ornament representing a grotesque human or a partly-human face or head, often used on keystones, etc. [24, 113, 124]

masonry the art of composing brick, stone, and or concrete into structures, or the materials themselves [15, 39–50]

Mayan arch *see* **triangular arch**

meander the continuous single line with angled turns that composes a fret [100]

medallion an ornamental tablet, panel, or plaque, typically oval in shape and providing the background for a carved figure [100, 114]

medallion molding a molding composed of a series of medallions [100]

meeting rail the part of a door or window frame that abuts a similar member when the door or window is closed; also called a meeting bar [1]

merlon one of the upright, solid parts of a battlement that alternates with the crenels [56, 57, 69]

metope the plain or carved square panels between the triglyphs in a Doric frieze [73, 76, 77, 93, 106]

mid-wall column a column that supports a wall at a point along the length of the wall, the column diameter falling in line with the depth of the wall [85]

mission tile a semi-cylindrical roofing tile made of clay and laid with convex sides alternately up and down (*see also:* pantile, Spanish tile) [64]

modillion a version of a bracket, of greater depth than height and used in a series, often taking the form of a scroll decorated on the underside with an acanthus leaf, especially when part of a Corinthian cornice (*see also:* ancon, block modillion, bracket, console, corbel) [14, 25, 35, 73, 91, 93, 116, 134]

molded formed into a particular shape [13, 41, 48]; treated with moldings [23, 26, 30, 31, 33, 37, 90, 91, 92, 103, 133, 134]

molded brick specially made brick of varying sizes and shapes, often with curved profiles, used specifically for decorative effect [13, 41]

molding a decorative member of long proportions, shaped into one of a variety of contours to introduce variations of light, shade, and shadow into a design (*for types see:* anthemion, ballflower, base, bay leaf garland, bead, bead and quirk, bead and reel, billet, bird's beak, bolection, bowtell, brace, cavetto, chain, chamfer, chevron, corner bead, crenellated, crown, cyma recta, cyma reversa, dogtooth, drip, edge roll, egg and dart, fillet, flush bead, fluting, fret, heart and dart, hollow chamfer, hollow square, indented, interrupted arch, label, lattice, leaf and dart, lozenge, medallion, nailhead, nebule, necking, open heart, ovolo, pearl, pellet, picture, prismatic billet, quarter hollow, quarter round, quirk, reeding, reed and tie, reticulated, roll and fillet, roll billet, rope, rose, sawtooth, scotia, scroll, segmental billet, sprung, square billet, star, struck, sunk fillet, tablet flower, three-quarter round, torus, Vitruvian scroll, wave) [10, 17, 19, 24, 25, 27, 31, 58, 61, 79, 90–92, 99–100, 102, 103, 106–114, 117]

monitor roof a roof with a raised section along the ridge, fitted with windows for light and ventilation [63]

monopteral describing a monopteron (*see also:* peripteral) [88]

monopteron a circular building surrounded by a single row of columns, a monopteral structure [88]

Moorish arch *see* **horseshoe arch**

mouchette an element of curvilinear tracery representing a curved dagger [8]

mullion the vertical member that divides multiple windows or doors in a single opening, or the lights of a window, or the panels of a door (*see also:* muntin) [3, 15]

multifoil describing an element provided with more than five foils and five cusps [8]

multilight / multipane describing a window or door composed of many panes of glass, typically more than twelve [3, 15, 16, 18, 20, 28, 30, 32, 33, 36, 133]

munnion *see* **mullion, muntin**

muntin a small, slender mullion; a secondary framing member that divides the panes of a window or the panels of a door [1, 15, 27]

mutule a flat, square block projecting from the soffit of a Doric cornice, placed over the triglyphs and metopes, and decorated with guttae [76, 77]

N

nailhead one of a series of pyramidal-shaped elements resembling the four-sided, pyramidal heads of wrought nails [100]

nailhead molding a molding composed of a series of nailhead ornaments [100]

nebule molding a molding whose lower edge is composed of undulating curves [100]

neck the part of a column between the capital and the shaft, defined by moldings [76–78]

necking neck; the moldings defining the neck of a column [78, 79, 92]

needle spire an especially tall and slender spire [70]

newel / newel post the post at the top, bottom, and turning points of a stair, typically larger and more elaborate than the balusters [96–98]; the central upright post around which a circular staircase winds [94]

newel stair *see* **spiral stair**

niche a recess in a wall, often with a curved plan, to hold a statue, vase, etc. [61]

nogging a type of construction in which a timber frame is infilled with brickwork [51]

Norman brick brick longer than standard American brick [41]

nosing a rounded projecting edge [97]

nulling *see* **gadrooning**

obelisk a tall, slender structure with a square plan and sloping sides ending in a pyramid; a similar form used ornamentally [97]

octagonal dome a dome composed of eight curved sections [131]

octagonal shingles shingles that take the shape of octagons [64]

octagonal window a window that takes the shape of an octagon [4]

octastyle describing a portico composed of eight columns [88]

oculus the opening at the peak of a dome (*see also:* bull's eye) [131]

ogee an S-curved line composed of a convex and a concave part, typically used on moldings and ornament [4, 122]

ogee arch a pointed arch, the sides of which take the shape of ogees with convex curves at the point [122]

ogee gutter a gutter with a profile in the shape of an ogee (*see also:* hanging gutter) [67]

ogee molding a molding with an ogee profile, as in the cyma recta, cyma reversa, and brace moldings [99]

ogee window a window with an opening that takes the shape of two ogees meeting at a point [4]

one-centered arch any arch struck from a single center, such as a round arch [20, 37, 121, 125]

one-over-one a window light arrangement composed of a single pane above another single pane [3, 19, 21, 56, 135, 138]

one-third running bond running bond with the vertical joints of one course falling at one third of the distance of adjacent courses [39]

onion dome a pointed, bulbous roof [131]

open bed pediment a pediment whose lower horizontal member is open in the middle (*see also:* broken pediment) [9, 26, 37]

open eaves eaves in which the triangular space between the rafters and the exterior wall is not enclosed, but an inclined soffit is attached to the rafters, creating a continuous surface, and other trim is applied [67]

open gable a gable whose lower horizontal member is not continuous [69]

open heart molding a molding composed of a series of overlapping heart-shaped elements [100]

open newel stair a stair constructed with newels around an open shaft [94, 98]

open riser stair a stair in which the space between the treads is open to allow light to the area below [95]

open string a string whose top edge matches the profile of the stairs [95, 96]

order any of five patterns of arrangement consisting of the base, shaft, and capital of a column and the entablature above (Tuscan, Doric, Ionic, Corinthian, or composite), each version having its characteristic elements and proportions (*see also:* colossal order) [72, 73, 76–79, 84]

oriel a bay window at an upper story, supported by corbels, brackets, or an engaged column or pier (*see also:* bow window) [19]

ornament any feature added to a structure or member for decorative effect [21, 23, 24, 26, 31, 34, 36, 56, 93, 97, 99–119]

ornamental bond any of a variety of masonry bonds used to produce decorative effects in wall surfaces; also called patterned brickwork [39]

oval window a window that takes the shape of an oval [4]

overdoor a decorated panel directly above a door [9]

overhang the projection of a structure beyond the wall surface below [69]

overhead door any door that opens by a vertically lifting movement [29]

oversize large in size or scale in relation to an adjacent element [22, 34, 119]

ovolo a convex molding with a profile larger than a one-quarter of a circle and smaller than one-half of a circle [99]

ox eye window a window that takes the shape of a long ellipse [4]

P

paired grouped in pairs; also called coupled (*see also:* grouped) [19, 33, 35, 90, 92]

Palladian window a large window arrangement divided into three parts by columns, pilasters, etc., with flat lintels at the sides flanking a taller arched central lintel; also called a Diocletian window, Serlian window, or Venetian window [4, 20]

palm capital a capital formed of elements resembling the leaves of a palm tree [75]

palmette *see* **anthemion**

pane a single piece of window glass; also called a light [1]

panel a flat surface distinguished from the surrounding area by a molding or other ornament (*see also:* linen panel, raised panel, sunk panel) [11, 20, 23, 27, 30, 33, 36, 48, 114]

paneled treated with a panel or panels [18, 25, 28, 33, 35, 38, 44, 61, 91, 97, 119, 132, 133, 137]

paneled door / paneled shutter a door/shutter with stiles, rails, and possibly muntins, forming frames around panels [1, 28, 32, 133, 135, 137]

pantile a roofing tile with an S-shaped section (*see also:* mission tile, Spanish tile) [64]

parabolic arch an arch with a parabolic intrados [121]

parallel faced siding an exterior, horizontal wood siding in which boards of consistent depth are applied with the lower edge overlapping the board below [51]

parapet the vertical extension of an exterior wall above the line of the roof, often decorated [60, 69]

parapet wall a low wall extending upward from a roof [69]

parastas a pedestal-like wall at the end of a monumental stair [97]

partition wall an interior wall that separates adjacent rooms within a single story of a building, but does not support a load [55]

party wall a wall shared by two adjacent buildings [55]

patera a small disk decorated with leaves or petals, used in panels, friezes, etc. (*see also:* rosette) [112]

patterned brickwork *see* **ornamental bond / brickwork**

pavilion a central prominent bay of a facade, often distinguished by size, projection, or ornamentation [134, 137]

pavilion roof *see* **pyramidal roof**

peak the highest point of a roof, a gable, or any other architectural element [65]

pearl a nearly spherical element typically used in a series or in combination with other ornament [100]

pearl molding / pearling a molding composed of a series of pearl elements [11, 100, 102]

pedestal a substructure for a column, statue, etc., often composed of a base, dado, and cornice (*see also:* podium) [23, 26, 35, 58, 73, 91, 136]

pediment the gable end of a roof, often triangular or segmentally shaped, located over a portico and above the cornice in classical architecture, or a similar feature above doors and windows, etc. (*for types see:* broken pediment, open bed pediment, Queen Anne arch pediment, segmental pediment, swan's neck pediment) [5, 9, 26, 34, 37, 77, 134]

pedimented provided with a pediment [26, 37]

pellet molding a molding composed of a series of small, hemispherical elements [100]

pendant a suspended hanging ornament, often richly decorated; also called a drop ornament [36, 58, 96, 114]

pendentive a concave wall surface that forms the transition between a circular dome and a square or polygonal base from which the dome rises (*see also:* squinch) [130]

pent roof *see* **shed roof**

pentastyle describing a portico composed of five columns [88]

perforated bond a masonry bond in which stretchers are laid alternately with open spaces [39]

peripteral describing a building surrounded by a single range of columns (*see also:* monopteral) [88]

picture molding a horizontal, interior molding from which pictures are hung, or a molding placed at such a height [61]

pier a vertical structural member, more massive than a column, often square or rectangular in plan, which supports a load; a supporting member that comprises

a substantial part of a wall (*see also:* column, pilaster, pillar, post) [58, 80, 120, 137, 138]

pierced ornament consisting of perforations through a surface [58, 97]

pilaster a member appearing to be an engaged pier with its base, shaft and capital, but providing no support, typically rectangular in plan (*see also:* column, pier, pillar, post) [25, 26, 32, 33, 37, 38, 85, 93, 105, 119, 133, 134, 138, 139]

pillar a column-like member, isolated or providing support, which does not conform to the classical rules of architecture (*see also:* column, pier, pilaster, post) [80]

pilotis a building carried on pillars with an open ground floor, or the pillars themselves [140]

pinnacle a vertical structure, tapering as it rises, being the ornamental terminating feature of a buttress, parapet, gable, etc. [62, 136]

pitch the degree of the slope of a roof or other surface [66]

pitched roof a roof with two slopes meeting at a central ridge [132, 137]; a roof having one or more sloped surfaces [71]

pivoting door a door that opens by pivoting on hinges [29]

pivot window *see* **horizontal pivot window, vertical pivot window**

placage *see* **masonry veneer**

plain shingle *see* **square shingle**

plait an ornament composed of three or more interwoven strands producing one rope-like strand [101]

plate tracery tracery composed of openings pierced through thin slabs of stone [7]

platform framing a method of wood frame construction in which the floor

construction of each story provides a platform for the construction of the walls, and each story is built independently of the one above [53]

plinth / plinth block the square block below the base of a column, pilaster, wall, or door framing, connecting it with the ground or sill, typically treated with moldings or other ornament [27]

pocket doors doors that open by sliding into openings in the wall so that they are hidden when completely open (*see also:* single pocket door, double pocket doors) [29]

podium a continuous pedestal [90, 134]

pointed arch / vault / dome any arch/vault/dome, usually acute, with a point at its peak [122, 131]

pointed arch window a window with sides whose upper ends curve inward to meet at a point [4, 13]

polygonal fieldstone masonry constructed of stones with polygonal shapes [43]

polygonal hip roof a roof composed of multiple hips above a round or polygonal building [71, 137]

pomel / pommel a ball-shaped finial [114, 115]

poppyhead, poppy a finial in the shape of a fleur-de-lis or carved with foliage, flowers, or other ornament [115]

porch a covered entryway, being a structure with open sides attached to a building (*see also:* wraparound porch) [58, 132, 134, 136]

portal a monumental entrance, typically using columns as a major architectural element [86, 137]

portcullis a heavy, vertically sliding gate in a fortified wall [28, 57]

portico a colonnade supporting a roof at the entrance to a building, distinguished by number and placement of columns (*see also:* amphiprostyle, anta, astylar, decastyle, dipteral, distyle, distyle in antis, dodecastyle, enneastyle, heptastyle, hexastyle, monopteral, octastyle, pentastyle, peripteral, prostyle, pseudodipteral, pseudoperipteral, tetrastyle, tripteral) [89]

post an unembellished, vertical framing or support member, sometimes heavy in proportions [52, 80]

prismatic billet molding a molding composed of a series of prisms staggered in alternate rows [100]

prismatic rustication *see* **diamond-point rustication**

pronaos the inner portico of a temple [89]

prostyle describing a building with a portico only on the front [88]

protome *see* **half figure**

protomai capital a capital with figures of animals at its corners [75]

pseudodipteral describing a temple with columns arranged similar to a dipteral temple, but without the inner row [88]

pseudoperipteral describing a temple with a single row of columns all around, those on the sides and rear being engaged [88]

pulvinus the rolled element forming the side of an Ionic capital [78]

purlin a horizontal wooden roof framing member that connects the principal rafters of a roof [52, 66]

putto (*usu. in pl.* putti) a figure of a child without wings (*see also:* cherub) [17, 23, 113]

pyramid skylight a skylight with four equally sloping surfaces meeting at a point [68]

pyramidal roof a hipped roof over a square structure, the roof having four sides and no ridge, the slopes culminating in a peak, the result being a roof with the appearance of a pyramid; also called a pavilion roof [63, 136]

Q

quadripartite vault a groined vault covering a rectangular area and divided into four parts by intersecting diagonal ribs [127]

quarry-faced *see* **rock-faced**

quarry glass a small diamond-shaped pane of glass, typically used in leaded windows [3]

quarter closer a brick approximately one-quarter the length of a standard brick, used in locations where a full brick will not fit; also called a closer [42]

quarter hollow *see* **cavetto molding**

quarter round a convex molding, usually a quarter of a circle in profile, which may be ornamented with other moldings, such as the egg and dart [99]

quarter round window a window that takes that shape of one-quarter of a circle [4]

quatrefoil describing an element composed of four foils with four cusps, or the element itself [8, 62]

Queen Anne arch an arched opening composed of flat sides flanking a central rounded arch, often taking the form of a pediment over a Palladian window [9, 23, 34, 123]

Queen Anne sash / Queen Anne window a sash composed of small, rectilinear panes surrounding a single, larger pane [3]

queen closer a brick approximately one-half the width of a standard brick, used in locations where a full brick will not fit [42]

queen post truss a truss with two vertical supports connecting the inclined members with the tie beam and a horizontal member connecting the upper sides of the verticals [65]

quirk a V-shaped groove between moldings [99]

quoin one of a series of alternately large and small masonry units that typically form the corner of a building and are often distinguished from the adjacent masonry by varying surface treatment [43, 56, 60]

quoining the use of a series of quoins at the corner of a building or on other architectural members for decorative effect, or the series of quoins [60]

R

rafter one of a series of inclined wooden framing members that form the structure of a roof [52–54, 65–67]

rail a horizontal member in the frame of a door or window (*for types see:* bottom rail, meeting rail, top rail) [1, 27]; a handrail

rainbow roof a pitched roof with convex sides; also called a whaleback roof [63]

raised basement a basement not contained entirely below ground [135]

raised panel a panel with a plain central area raised above the surrounding edge or frame; also called a fielded panel (*see also:* linen panel, sunk panel) [23, 33, 36, 114]

rake an incline [65]

raked joint a recessed masonry joint with a squared edge [40]

raking arch / raking vault *see* **rampant arch / vault**

raking bond any brick masonry bond that utilizes bricks laid at an angle, as in clip bond [39]

raking cornice a cornice that follows the sloping sides of a gable or pediment [58, 67]

ramp an inclined unit used instead of steps [95]

rampant arch / rampant vault an arch/vault with imposts at different levels; also called a raking arch/vault [122, 127]

rampart a wall built for defense [57]

random coursed *see* **uncoursed**

reed one of a series of small, parallel, convex moldings, representing a bunch of reeds, being the opposite of fluting (*see also:* gadrooning) [99]

reed and tie molding a molding composed of a series of reeds tied together [100]

reeding a series of reeds [99]

regula (*pl.* regulae) one of a series of short fillets below the taenia of a Doric entablature, treated with guttae and corresponding to a triglyph above [73, 76, 77, 93, 106]

regular coursed masonry laid in continuous regular courses, with each course of equal height [43, 50]

relieving arch a blind, segmental arch often located above a door or window lintel, serving to discharge the weight of the wall above to the sides; also called a discharging arch [121]

retaining wall a wall whose primary purpose is the support of the earth and the resisting of its lateral forces [55]

reticulated ornamented with a network of regularly intersecting lines [100]

return the continuation of a member that turns away at an angle from the main part of the member onto an adjacent surface [58, 67, 137]

reveal the side of a door or window opening between the door or window frame and the outer surface of the wall; when cut diagonally it is called a splay [1]

revolving door four doors of equal size fixed at right angles with a central pivot [29]

rib a curved member, typically molded, forming the structure on which a vault is built (*for types see:* diagonal, intermediate, lierne, ridge, transverse, wall) [129, 130]

ribbed vault a vault supported by ribs [128, 129]

ribbon ornament in the form of a ribbon, often tied in a bow, with ends overlapped and intertwined [114]

ribbon strip the horizontal structural element that supports the ends of the joists [54]

ridge the horizontal line formed at the top of a roof where two opposite slopes meet [6, 65, 133]

ridge beam the horizontal roof framing member at the peak of a roof that supports the rafters; also called a pole or ridge plate [52, 66]

ridge chimney a chimney constructed on an interior wall that emerges from the roof at the ridgeline (*see also:* eaves wall exterior chimney, end wall chimney, gable end exterior chimney, slope chimney) [68, 132, 137]

ridge ornament a crest on the ridge of a roof [115]

ridge rib a horizontal vaulting rib along the crown of a vault bay [129]

ridge skylight a skylight with a gabled profile [68]

ridge vent a device installed at the ridge of a roof to ventilate the interior of a building [68]

rinceau ornament composed of vines and foliage intertwined, often in scroll-like forms, and combined with other ornament [17, 19, 112]

rise the vertical distance from the springing line of an arch to the crown of the arch [120]; the vertical distance between two consecutive treads in a stair, being the height of the riser

riser the vertical part of a step [95–98]

rock-faced describing stone with a natural stone face, or a face dressed to resemble that of natural stone; also called rough-faced [16, 44, 50, 137, 138]

roll and fillet molding a molding, almost circular in section, with a fillet at its outermost point [99]

roll billet molding a molding composed of rows of billets with cylindrical cross-sections alternating in rows; also called round billet molding [100]

rolling door a door that opens by rolling into an enclosure that is usually situated above the door [29]

Roman brick brick longer and of less height than standard American brick [41]

Roman Ionic an Ionic capital with volutes projecting diagonally [74, 75, 91]

rondel *see* **roundel**

roof the structure that covers a building (*for types see:* asymmetrical gable, barrel, bell, broach, conical, cross gable, dome, Dutch gable, Dutch gambrel, flared, flat, gable, gambrel, helm, hip, hip and valley, jerkinhead, lean-to, mansard, monitor, pavilion, pitched, polygonal hip, pyramidal, rainbow, salt box, sawtooth, shed, single-pitch, whaleback) [63-71, 115, 132–137]

rope molding a molding carved to represent the twisted strands of a rope; also called a cable molding [31, 107]

rose molding a molding composed of a series of flower-like elements [100]

rosette a carved, rounded ornament resembling a flower (*see also:* patera) [25, 102, 112, 119]

rotunda a structure with a circular plan and a domical roof [14]

rough-faced *see* **rock-faced**

roughly coursed fieldstone a masonry bond composed of fieldstones laid in rough, uneven courses, many of which are discontinuous and separated [43]

round arch an arch whose intrados takes the shape of a semicircle; also called a semi-circular arch or a circular arch [37, 121, 125]

round arched / round headed describing an element, typically a window or a door, whose head takes the shape of a half-circle [4, 11, 16, 19, 20, 22, 25, 33, 125, 133, 135, 138]

round billet molding *see* **roll billet molding**

round shingles shingles that take the shape of circles [64]

roundel a small circular panel; also called a rondel [56, 114]

row house one of a row of houses that share side walls [135]

rowlock a brick laid on its long, slender side with its short end visible [42]

rowlock arch an arch composed of elements, often brick headers, arranged in concentric rings [123]

running bond a brick masonry bond in which all units are laid lengthwise with the vertical joints of alternate courses staggered; also called stretcher bond [39]

running dog *see* **Vitruvian scroll**

running ornament, running mold any continuous ornament, as a fret

rusticated treated with rustication [15, 18, 22, 35, 45, 46]

rusticated column / rusticated pilaster *see* **blocked column / pilaster**

rustication massive blocks of cut masonry separated by deeply recessed, strongly emphasized joints, employed for striking textural effect in an exterior wall and typically the lower part of it; the joints may be chamfered or V-shaped, or banded with only the horizontal joints emphasized; the faces of the block may be rock-faced (appearing as if straight from the quarry), diamond-pointed, paneled, or vermiculated; flat, hand- or machine-tooled; the border of each block may be chamfered or beveled on two or four sides [15, 18, 22, 44, 45, 46]

S

saddle *see* **threshold**

sailor a masonry unit set vertically on end with its wide face showing [42]

saltbox a wood framed house with an asymmetrical gable roof

sash the unit that holds the window glass, especially when sliding in vertical grooves [1, 16, 20]

sash door a door with glass above the lock rail [28]

sash window a (typically double-hung) window that opens by sliding vertically, or is hung by chains or sash cords over pulleys in the frame [16, 20]

saucer dome a dome that rises a distance less than that of its radius [131]

sawtooth molding a molding with a serrated edge [100]

sawtooth roof a roof composed of a series of triangular-shaped sections, each of which is glazed at its steeper face to provide light and ventilation to the interior, typically used in industrial buildings [63]

sawtooth shingles shingles whose lower ends are cut diagonally to represent the serrated edge of a saw [64]

scale ornament *see* **imbrication**

scallop ornament representing a ribbed shell [23, 112]

scalloped capital a cushion capital with each face treated with scallops [75]

scored cut with channels or grooves [41]

scotia a deep, concave molding, typically used at the base of a column [99]

screen door an exterior door composed primarily of wire screen to allow for ventilation [28, 132]

scroll ornament in the form of a wound spiral, often applied singly to brackets or joined continuously in a molding, when it is typically called a Vitruvian scroll (*see also:* wave molding) [24, 91, 97, 100, 110]

scrolled pediment *see* **swan's neck pediment**

scrollwork any ornamental work composed, at least in part, of scrolls [36, 136]

sealant any material employed to halt the passage of liquid or gas [59]

segmental having a shape that is part of a circle [3, 4, 9, 18, 34, 121, 127, 135, 139]

segmental arch / vault an arch/vault whose intrados/cross-section takes the shape of a part of a circle, typically less than a semicircle [4, 18, 34, 121, 127, 135, 139]

segmental arched / segmentally arched describing an element, typically a window or a door, whose head takes the shape of a segment of a circle, typically less than a semicircle [4, 18, 135, 139]

segmental billet molding a molding composed of rows of billets with segmental cross-sections alternating in rows [100]

segmental pediment a pediment composed of a segment of a circle, the ends of which are joined by an unbroken, horizontal line [5, 9]

segmental shingles shingles whose ends have the shape of a segment of a circle [64]

semicircular arch *see* **round arch**

semicircular dome *see* **hemispherical dome**

semicircular vault *see* **barrel vault**

Serliana / Serlian motif / Serlian window *see* **Palladian window**

setback the distance between two vertical faces of a building, usually required by a building code, or the upper part of the building that is recessed from the lower part [69]

sexpartite vault a vault whose ribs create six triangular areas within a bay [127]

shaft the principal, vertical part of a column, between the base and the capital [73, 76, 78, 79, 90-92]

shake a thick, tapered wood shingle, typically split by hand [64]

shaped gable a gable whose shape is other than triangular or semicircular, and typically produces a decorative effect [5, 69]

sheathing a material covering the framing members and placed in preparation for a finish material on a wall or roof [53, 54, 66]

shed dormer a dormer with a shed roof and eaves parallel to that of the main roof [5]

shed roof a roof with a single slope; also called a pent roof (*see also:* lean-to roof) [63, 71]

shell *see* **scallop**

shield an element of defensive armor often used in ornament [6, 56, 114, 136]

shiner a masonry unit laid lengthwise with its broad face showing [42]

shingle a type of roof covering consisting of small units produced in standard sizes and in a variety of materials and shapes, laid in overlapping courses to prevent water infiltration (*for types see:* chisel, cove, diamond, fish scale, half-circle, hexagonal, horizontal, octagonal, plain, round, sawtooth, segmental, square, square wave, staggered; *see also:* imbrication) [64]

shiplap joint a joint made by fitting together two elements whose matching ends have been recessed for the purpose [59]

shopfront *see* **storefront**

shoulder the projection of a piece of material, usually made at right angles, but also angled or curved, and corresponding to a change in width, thickness, or direction; also called an ear or elbow [3, 4, 121]

shouldered treated with a shoulder [3, 4, 121]

shouldered arch a lintel carried on corbels, or a straight arch with rounded corners [121]

shouldered window a window whose surround is shouldered at the upper corners [3, 4]

show window the primary part of a store front, being a window used to display goods, often provided with a raised platform (called a bulkhead) and an open back [138]

shutter a small, hinged door that covers a window or other opening (*for types see:* louvered shutter, paneled shutter) [1, 133, 134]

side gabled describing a gable roofed building with the entrance on the eaves wall [132]

sidelight a slender, vertical window, typically one of a pair flanking a door [20, 32]

siding an exterior facing typically applied horizontally; also called weatherboard (*for types see:* beaded edge, bevel, butt edge, capped, drop, flush, parallel faced) [1, 67, 134]

signband a display board for advertising (*see also:* storefront) [138]

sill the bottom, horizontal framing member of a door or window opening; when covering the joint between two types of flooring material, it is called a saddle or threshold [1, 6, 13, 14, 16, 21, 27, 56, 58, 60, 138]; the horizontal framing member at the bottom of a timber-framed wall [49, 52-54, 59]

sill course a course of masonry at window sill level, often encompassing the sills and distinguished from the surrounding wall surface by its greater projection or decorative finish (*see also:* band, frieze, lintel course, stringcourse) [10, 15, 17, 19, 26, 56, 58, 60]

single pane window a window composed of one pane of glass, either fixed or operable [3]

single-pitch roof *see* **shed roof**

single-pitch skylight a skylight with one vertical side and one angled side [68]

single pocket door a single door that slides into an opening in a wall [29]

six-over-one a window light arrangement composed of a sash divided into six panes above a sash composed of a single pane [132]

six-over-six a window light arrangement composed of a sash divided into six panes above another sash divided into six panes [3, 134, 139]

skirt *see* **apron**

skylight a glazed opening in a roof, in one of a variety of shapes, to admit light and possibly ventilation to the space below (*for types see:* dome, flat, pyramid, single pitch, ridge, square dome, vault, and venting) [68]

slab a thick flat surface, typically constructed of a sturdy material and used as a floor or the base of a floor [59]

sliding door / sliding window / sliding sash a door or window that slides horizontally in a track [2, 29]

slit window a window whose proportions are tall and narrow [10, 14]

slope chimney a chimney constructed on an interior wall and emerging from one of the sloped surfaces of the roof (*see also:* eaves wall exterior chimney, end wall chimney, gable end exterior chimney, ridge chimney) [68]

snow bird / snow guard one of a number of elements, often decorative, attached to a roof in a regular pattern to prevent snow from sliding off the slope [67]

soffit the underside of an overhead architectural member (*see also:* intrados) [33, 38, 67, 91, 119]

soffit vent a device installed in the soffit of a roof to ventilate the interior of a building [68]

soldier a masonry unit set vertically on end with the slender face showing [40, 42]

soldier arch a flat brick arch composed of soldiers [123]

soldier course a course of masonry units composed solely of soldiers [40]

sole plate in wall construction, the horizontal structural member placed below the studs [53]

Solomonic column *see* **twisted column**

span the width of an arch, or the distance between two consecutive supporting elements [120]

spandrel the space between windows of adjacent stories [60, 140]; the triangular area bounded by the outer curve of an arch, a horizontal line drawn from the crown of the arch, and a vertical line drawn from the springing point [120]; in a stair string, the triangular area between the tread and riser [97]

spandrel panel a panel covering the space between windows of adjacent stories [60, 140]

Spanish tile a semi-cylindrical roofing tile made of clay and laid with the convex side up (*see also:* mission tile, pantile) [64]

sphinx a figure with the body of a lion and a human head [113]

spider web fanlight a fanlight with a pattern of mullions that resembles a spider web [3, 37]

spindle a baluster made of wood, often turned [58]

spiral column a column treated with fluting that continuously winds around the shaft [21, 82, 83, 97]

spiral fluting fluting twisted in a spiral form [21, 82, 83, 97]

spiral stair a flight of stairs with a circular plan and treads wound around a central newel; also called a circular stair or newel stair [94]

spire a tall, slender, pointed structure built on a roof or tower (*see also:* broach, fleche, needle spire, steeple) [70, 133]

spirelet *see* **fleche**

splash block a block with a central indentation placed below a downspout to carry water away from the building [67]

splay a sloped surface, larger than a chamfer, that makes an oblique angle with the surface to which it is joined, especially at a door or window opening; an angled reveal [10, 14]

splayed angled outward, treated with a splay [10, 14]

splayed arch an arched opening whose front radius is larger than its radius in back [10]

splayed jamb the angled jamb of a door or window opening that forms an oblique angle with the wall in which it is set [10]

splayed sill a sill that is angled steeply downward from the interior to the exterior [10, 14]

springer the lowest voussoir of an arch [120]; the impost

springing line the horizontal line from which an arch begins to curve [120]

sprung molding any molding with a significant projection, as in a bolection molding [99]

spur an ornamental element, often in the form of a leaf or grotesque figure, joining the base of a round column to its polygonal plinth [73]

square billet a molding composed of a series of projecting cubes alternating with open spaces [100]

square dome skylight a skylight with squared sides culminating in a dome [68]

square headed window a window with a horizontal top [4, 133]

square shingles shingles of regular square or nearly square shape [64]

square wave shingles square shingles laid in continuously undulating courses [64]

squinch a system of arches or corbelling built across the corners of a square space to support a polygonal or domed roof (*see also:* pendentive) [130]

stable door *see* **Dutch door**

stack bond a masonry bond with vertical and horizontal joints continuously aligned [39]

staggered shingles squared roofing shingles, laid in courses without continuous horizontal lines [64]

stained glass window a window composed partially or completely of panes of colored glass [3]

stair a structure composed of a tread and a riser, and used in a series to bridge the distance from one level to another (*for types see:* box, closed string, dogleg, double, double return, elliptical, geometrical, open newel, open riser, open string, ramp, spiral, straight run, stoop; *for parts see:* riser, stairwell, tread, winder) [94-98]

staircase an entire stair construction [96, 98]

stair tower a tower that contains a winding stair [95]

stairwell the vertical space occupied by a staircase; also called a well [95]

standard brick brick measuring approximately two and one-quarter inches by three and five-eighths inches by eight and one-half inches long [41]

standing seam the joint of two sheets of metal roofing formed by turning and folding, or the metal roofing itself [64]

star molding a molding composed of a series of elements representing stars [100]

steeple the tower and spire of a church, or a similar ornamental rooftop structure that diminishes in size as it rises [70, 133]

step a riser and a tread (*see also:* stair) [89, 96, 97, 137]

stepped arch an arch whose voussoirs are cut at the top to correspond to the masonry courses of the wall [123, 125]

stepped dome a dome composed of successively receding rings [131]

stepped gable *see* **crowstep gable**

stepped voussoir a voussoir that forms a stepped arch [125, 126]

stickwork a type of construction in which a timber framework is filled or partially filled with wooden boards, often placed at angles [51]

stile the vertical framing member of a door or window, which holds the rails [1, 27]

stilted arch / vault / dome an arch/vault/dome whose curve begins above the impost [14, 121, 127, 131]

stonework stone masonry [46, 48, 119]

stool the interior horizontal piece of molding located above the apron, against which

the bottom rail of a window sash abuts when it is in its closed position [1]

stoop a short series of steps leading to the entrance of a house or other building [30, 32, 36, 95, 135]

stop the vertical piece of molding of a door or window frame, against which the side rails of the door or window abut; also called a bead stop, inside stop, stop bead, window bead, or window stop [1, 27]; a carved ornament at the end of a molding [10]

stopped flute fluting that does not extend the full height of the column [82]

storefront the street level front of a store, typically including a signband and windows to display merchandise; also called a shopfront [138]

storm door / storm window an additional exterior door/window installed to provide weather protection [28]

story the space in a building between two floor levels or between a floor and the roof above, or a division of a building that suggests such a level [60]

straight arch *see* **flat arch**

straight run stair a stair that has no turns and travels in only one direction [94]

strapwork / strap ornament ornament composed of an interlaced and folded band [101]

stretcher a masonry unit laid lengthwise with its slender face showing [40, 42]

stretcher bond *see* **running bond**

stretcher course a course of masonry units composed solely of stretchers [40]

striated describing a surface or element treated with courses or layers of varying color, texture, size, and or elevation [14]

striking stile *see* **lock stile**

string / stringer a sloping board that supports the ends of the treads and risers of a stair (*see also:* closed string, open string) [95, 96, 98]

stringcourse a continuous horizontal band, typically molded and projecting from the face of a building; also called a belt-course (*see also:* band, frieze, lintel course, sill course) [10, 13, 22, 56, 58, 60]

struck joint a masonry joint that slopes in and down from the upper edge of the joint [40]

struck molding a molding formed by cutting into a material, as opposed to adding to it, as in a sunk fillet [99]

stucco an exterior wall finish composed of cement, lime, sand and water [51]

stud a vertical support typically used in a series to construct a wall [52, 53, 54, 59]

stylobate the top course of a crepidoma [76, 78]

subfloor rough flooring material laid on the joists, over which the finished floor is laid [53, 54, 59]

subsill a secondary structural element fitted below the sill in a window frame [1]

summer beam the horizontal member that supports the ends of floor joists, or rests on posts and supports the wall above [52]

sunburst ornament resembling the sun and its rays, often used in gables [69, 112]

sunk set below the surrounding surface [11, 20]

sunk fillet a hollow molding with a narrow, square cross-section [99]

sunk molding any molding recessed behind the surrounding surface, as in a sunk fillet [99]

sunk panel a panel recessed behind the surrounding surface (*see also:* raised panel) [11, 20, 114]

supercolumniation the use of superimposed orders

superimposed / superposed one element placed above another; when referring to the orders, the order of superimposition is typically composite over Corinthian over Ionic over Doric over Tuscan [86]

surbase the cornice of a pedestal (also called a cap), basement story, plinth, or other lower member [73]

surround a decorative window or door frame, including the lintel, sill, and hood, and any other associated features [18, 20, 23, 26, 31–33, 35, 56, 90, 91, 132, 134]

swag *see* **festoon**

swan's neck pediment a broken pediment whose sides are S-shaped; also called a scrolled pediment [9, 136]

swing door a door that swings a full 180 degrees; also called a double-acting door [29]

Syrian arch a semicircular arch with low supports, the distance from the impost to the crown being greater than the distance from the impost to the ground [137]

T

tablet a panel, usually inscribed and attached to a wall [60, 114]

tablet flower a squared representation of a flower used in ornament and moldings [109, 112]

taenia / tenia the topmost member of a Doric architrave, taking the shape of a narrow fillet [35, 73, 76, 77, 106]

telamon (*pl.* telamones) *see* **atlas**

temple a building dedicated to a deity or a god, typically treated with columns in colonnades, or a structure resembling such a building [89]

term *see* **herm**

terminal figure *see* **herm**

tetrastyle describing a portico composed of four columns [88]

three-centered arch / three-pointed arch an arch that is nearly elliptical in shape, that is struck from three centers, with the central one being longest in radius [121]

three-quarter brick a brick approximately three-quarters of the length of a standard brick, used in locations where a full brick will not fit [42]

three-quarter round a convex molding, usually three-quarters of a circle in profile [99]

threshold the member covering the joint between two types of flooring material; also called a saddle or a sill [27]

through-cornice dormer *see* **wall dormer**

tie beam a beam that connects the feet of the principal rafters of a truss to prevent spreading of the sides of a roof [65]

tie iron a metal rod with an ornamental exterior element used to connect the facing to the backup material; also called an anchor [59]

tile a thin, flat, regularly shaped piece of clay, hardened by heat (*for types see:* mission tile, pantile, Spanish tile) [64]

tongue and groove a joint formed by inserting a continuously projecting part (a tongue) of one member into the groove of another member [59]

tooled a masonry surface treated with up to a dozen concave vertical grooves per inch, or a general term for stonework finished by one of a variety of stoneworking tools, for the purpose of achieving a particular textural effect [44, 47, 48]

tooth / tooth ornament / toothed ornament *see* **dogtooth**

top plate the horizontal structural element to which the rafters are attached [52–54]

top rail the top horizontal framing member of a door or window [1, 27]

torus a convex molding with semicircular profile, typically located at the base of a column just above the plinth [99]

tower a structure whose chief characteristic is its height [14, 70, 133, 137]

tracery the ornamental stone or wood framework in a Gothic window or a window based on Gothic design (*for types see:* blind, flowing, plate, wheel) [7, 8, 10, 13, 62]

transom / transom light / transom window the hinged window located above a door or a larger window and separated from the door or window by a transom bar (*for types see:* circle end, circle corner, block corner) [2, 3, 11, 15–18, 20, 26, 33, 35, 56, 134, 137, 138]

transom bar a horizontal bar separating an upper transom from a door or window below [3, 15, 18, 56, 137]

transverse rib a major vaulting rib running at a right angle to the longitudinal axis of the vaulting bay [129]

trap door a door in a ceiling, roof, or floor, intended for access or ventilation; also called a hatch door [29]

tread the horizontal part of a stair on which the foot steps [96–98]

trefoil a member composed of three foils and three cusps [8]

trefoil arch an arch whose intrados is composed of three foils [126]

trellis molding *see* **lattice molding**

triangular arch a structure composed of two diagonally placed stones supporting each other and spanning an opening; also called a Mayan arch [121]

triglyph the blocks alternating with metopes in the Doric frieze, composed of two vertical grooves at the center and two half-grooves at the edges [73, 76, 77, 93, 106]

trim the moldings around a door or window concealing the joint between the frame and the wall [1]

tripartite describing an architectural element divided in three parts [35, 136, 138]

tripteral describing a portico composed of three rows of columns or a structure composed of three wings [88]

truss an arrangement, often triangular, of structural members forming a rigid framework for building construction [65, 66]

Tudor arch a pointed, four-centered arch [122]

tumbled brick ornamental brickwork, often used in gables, in which masonry units laid at angles intersect masonry units laid horizontally [69]

tunnel vault *see* **barrel vault**

turbine vent a vertical structure located on a roof to ventilate the interior of a building through rotary action [68]

turned (of ornamental wood members) worked on a lathe to produce a circular outline, such as a baluster [58, 97, 134]

turret a small tower, typically located at the corner of a building, often supported by corbels (*see also:* bartizan) [137]

Tuscan one of the five classical orders of architecture, resembling a simplified version of the Doric [72, 74]

twisted column a column whose shaft is spiral in form; also called a Solomonic column [82]

two-centered arch a pointed arch struck from two centers, as in an equilateral arch [122]

tympanum the area bounded by a pediment, often decorated [73]

uncoursed describing masonry laid irregularly, without continuous horizontal joints; also called random coursed [43]

undercut door a door with additional clearance at the floor line to provide ventilation [28]

underlayment a material placed on a structure in preparation to receive a finished material [66]

underpitch vault a structure composed of two joined vaults that spring from the same level but rise to different heights; also called a Welsh vault [128]

undulate band *see* **vinette**

undulating molding *see* **wave molding**

urn a vase with a rounded body on a base, traditionally used to contain the ashes of the dead [20, 138]

utility window a window composed of a hopper sash over a fixed sash [2]

V-shaped joint a masonry joint worked in the shape of a V [40]

valley the internal angle formed by the intersection of two slopes of a roof, or by the slope of a roof and a roof-top element [6, 65]

valley rafter a rafter situated in the valley of a roof [66]

vane a metal ornament on a pinnacle, spire, etc., which rotates to indicate the direction of the wind [115]

vault a masonry structure based on the arch principle, providing a roof over a given area (*for types see:* barrel, coved, cross, domical, double, elliptical, expanding, fan, groin, lierne, pointed, quadripartite, rampant, ribbed, segmental, semicircular, sexpartite, stilted, tunnel) [127–130]

vault skylight a skylight with an arched cross-section [68]

vaulted covered by or treated with a vault

veneer a facing of material, especially masonry, more ornamental in appearance than the material underneath [51]

Venetian arch a pointed arch in which the distance between the intrados and extra-

dos is greater at the peak than at the impost [15, 122]

Venetian door / window *see* **Palladian door / window**

vent a device designed to allow for the circulation of air (*for types see:* gable, ridge, soffit, turbine) [68, 132]

ventilating brick *see* **air brick**

venting skylight an operable skylight, used to increase ventilation in the space below [68]

vergeboard *see* **bargeboard**

vermiculated treated with ornament, usually applied to masonry, imitating the irregular, wavy, winding channels of worm-infested wood, typically used to contrast with a surrounding smooth surface [44, 119]

vertebrate band a foliate band with a continuous central horizontal stem [112]

vertical pivot window a window whose sash pivot about a vertical axis [2]

vinette an ornament whose chief feature is an undulating vine decorated with grape clusters and leaves; also called an undulate band [112]

vision light door a door with a small window in its upper part [28]

Vitruvian scroll / Vitruvian wave a series of connected scrolls typically used in moldings; also called a running dog [100]

volute a spiral scroll, especially the one forming the characteristic element of the Ionic capital; also called a helix [12, 22, 31, 78, 79, 91, 119, 124]

voussoir a masonry unit, typically wedge-shaped, used to construct an arch [11, 22, 35, 120, 125, 126]

wainscot facing applied to the lower part of an interior wall, often below a chair rail [61]

wall a structural member that supports the roof and divides the interior of a building (*see also:* party wall) [39–62]

wall arcade *see* **blind arcade**

wall dormer a dormer whose face is flush with the face of the wall below; when a cornice at the roof-wall junction is interrupted by the dormer, it is called a through-cornice dormer [5]

wall rib a vaulting rib placed along the wall of a vault bay [129]

wall string a stair string attached to a wall [96]

water leaf an ivy or lotus leaf used in ornament

water table a masonry projection at the base of a building that protects the foundation from rain, or a similar decorative feature [58, 60]

wave molding a molding composed of a series of figures representing breaking waves [100]

weather vane *see* **vane**

weatherboard *see* **siding**

weathered joint / weather struck joint an angled masonry joint that slopes out and down from top to bottom [40]

well *see* **stairwell**

Welsh vault *see* **underpitch vault**

whaleback roof *see* **rainbow roof**

wheel tracery / wheel window a window with tracery radiating from a central point, like the spokes of a wheel [7]

wicket a small door within a larger one [28]

widow's walk a narrow platform on a roof, typically surrounded by a railing or balustrade; also called a captain's walk [134]

winder one of a series of wedge-shaped steps that turn a corner or wrap around a newel [94]

winding stair a stair composed chiefly of winders, as in a spiral stair [94]

window a glazed opening in an exterior wall to admit light and air (*for parts see:* jamb, light, mullion, sash, sill; *for types see:* accordion, awning, bay, blind, bow, box head, bull's eye, casement, Chicago, classroom, cruciform, Diocletian, dormer, double-hung, double lancet, drop, fanlight, fixed, hopper, horizontal pivot, hung, jalousie, lancet, lunette, multipane, octagonal, oval, ox eye, Palladian, quarter round, Queen Anne, round headed, sash, Serlian, shouldered, show, skylight, sliding, splayed, stained glass, transom, utility, Venetian, vertical pivot, wheel) [1–26, 56, 62]

window bead / window stop *see* **stop**

window wall *see* **curtain wall**

wraparound porch a porch that is constructed so as to be continuous from one side of a building to another [136]

wreath an ornament taking the form of a circular garland of flowers, fruits, leaves, etc. [112]

wreathed column *see* **entwined column**

Z

zigzag a line with a continuous series of sharply angled turns, used for ornamental effect, as in herringbone bond and chevron moldings

zigzag bond *see* **herringbone bond**

zigzag molding *see* **chevron molding**

zoophoric a column supporting a sculpture of an animal [81]

APPENDIX:
DESCRIBING ARCHITECTURE

The illustrations and definitions provided in this book can help in identifying the names of specific architectural elements. To assist in properly using the names of these elements in accurate descriptions of architectural compositions, a checklist is provided on the following pages. This checklist outlines most of the elements typically used in writing complete descriptions of most types of buildings. By composing descriptions according to the format provided, a clear, organized depiction of a building can be achieved.

For clarity, building descriptions should be arranged in a logical format. For example, a building could be described from the bottom up, or from the top down. This checklist is organized for a description that first addresses the overall character of a building, then the overall form of the building, followed by descriptions of the exterior walls of the building, beginning with the front elevation. Each elevation is described, beginning with the first story and then moving to upper stories, and major features are identified before minor details.

This outline should be used as a guide. The great variety of buildings in existence prevents any one checklist from applying completely to all buildings or addressing every possible combination of architectural elements. Particular characteristics of individual buildings may require modifications to the outline provided. Also, it should be recognized that it may not be necessary to address all elements included in this checklist for every building description. The length of the description will depend upon the purpose for which the description will be used and the complexity of the building. The key is consistency in both organizational format and level of detail throughout the description.

Although this checklist is presented in outline form, descriptions are typically prepared in narrative form. Examples of narrative building descriptions based on this checklist, using terminology identified in previous sections, are included after the checklist.

Building Description Checklist

I.　GENERAL CHARACTERISTICS
 A.　Building Type
 B.　Date of Construction
 C.　Architect and/or Builder
 D.　Style (if applicable)

II.　BUILDING SITE
 A.　Placement of building on lot
 B.　Lot size
 C.　General relationship to surrounding buildings

III.　BODY OF BUILDING
 A.　Building Form
 1.　Overall Shape/Plan Form
 2.　Length, width, height
 3.　Number of stories, half stories, attic, basement (full, partial, raised)
 B.　Overall Roof Form
 1.　Shape(s)
 2.　Orientation (front gabled, side gabled)
 3.　Slope (low, moderate, steep)
 4.　Materials
 C.　Construction Type
 1.　Foundation Material/Type
 2.　Superstructure Type
 3.　Wall Facing Material

IV.　BUILDING FACADE (FRONT ELEVATION)
 A.　Overall Organization
 1.　Orientation (Which direction does the facade face?)
 2.　Number of Bays
 3.　General Arrangement of Windows and Doors (symmetrical, asymmetrical; regular, irregular)
 B.　Specific Elements
 1.　Entrance (Note minor and major alterations.)
 a.　Location
 b.　Composition (Note glazing, surround, transom, sidelights, fanlights, door type.)
 c.　Materials
 d.　Secondary Entrances (Note type, location, materials, details.)
 2.　Porch/Stoop (Note minor and major alterations.)
 a.　Dimensions (Note height [number of stories covered] and length [full front or entry] of porch.)
 b.　Construction type/materials
 c.　Porch Elements (Note roof type, support type [columns, posts], balustrades [balusters and handrail], floor, steps, entrance, details, ornament.)
 3.　Windows (If windows are consistent throughout, indicate once.)
 a.　Location
 b.　Shape
 c.　Number

 d. Glazing pattern (one-over-one, six-over-one, etc.)

 e. Material

 f. Type of operation

 g. Details (Note significant sills, lintels, surrounds, pediments, hoods, etc.)

 h. Alterations (Note whether the size of openings has been altered or sash have been replaced.)

 4. Other features and decorative elements (Note minor and major alterations.)

 a. Pilasters, quoins, stringcourses, brackets, finials, bargeboards, sculpture, balustrades, etc.

 5. Roof (Note minor and major alterations.)

 a. Shape, slope, materials (if not mentioned previously)

 b. Cornice eaves, returns, gutters (Note type, materials, details.)

 c. Chimneys (Note location, materials.)

 d. Dormers (Note location, materials, shape, details.)

 e. Rooftop structures (Note number, type, location, materials, details.)

V. SIDE AND REAR ELEVATIONS: Indicate direction elevation faces and follow checklist for facade description.

VI. LATER ADDITIONS TO BUILDING: Note date of construction, location, materials of construction, and follow checklist for facade description.

VII. OUTBUILDINGS

 A. Type/Use

 B. Number

 C. Location

VIII. OTHER FEATURES OF SITE

Note number, location, and type of additional features, including, but not limited to driveways, landscaping, paths, gardens, fountains, orchards, fields, bodies of water.

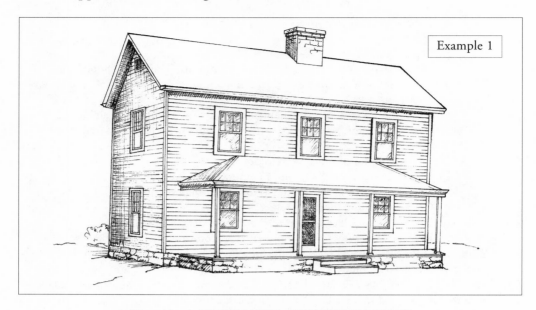

Example 1

Fig. 132. A SIMPLE TWO-STORY RESIDENCE

This mid–nineteenth century residence is executed in a simple manner. It is situated on a large lot, and though oriented toward the street that runs along its south side, it is relatively isolated from other structures in the area. This house rises two stories in height and has an attic. It takes the form of a simple rectangular block with a side-gabled roof. The wood frame structure rests on a stone foundation and is faced with clapboards. The moderately pitched roof is covered with asphalt shingles.

The symmetrical facade of the building, which faces south, is three bays wide. The central entrance of the house has a plain surround, a paneled wood door, which is a replacement, and a screen door. The entrance is flanked by single six-over-one double-hung wood windows, which also have plain surrounds. The first story of the front elevation is sheltered by a replacement porch with a shingled, hipped roof supported by plain wood posts. The porch has a stone foundation, and two steps lead to its center bay. The porch has no balustrade.

Second-story windows match those of the first story. A ridge chimney constructed of stone rises from the center of the roof. The side elevations of the house have single windows centered at the first and second stories. These windows match those of the front elevation. Both side elevations have a small louvered gable vent. The arrangement of the rear elevation of the house is similar to that of the front elevation, but the windows have been replaced with one-over-one double-hung wood sash.

All historic outbuildings once associated with this residence have been demolished. A modern, metal shed stands to the northeast. A shallow stream runs through the northern end of the property. A dirt driveway is situated along the western end of the house.

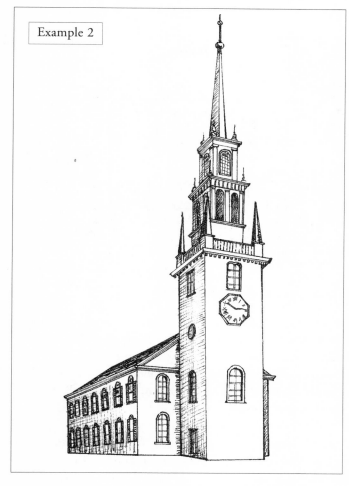

Example 2

Fig. 133. A CHURCH WITH A STEEPLE

This church, constructed in the early eighteenth century by local craftsmen, is situated in the southeastern corner of a large city lot. The church is composed of a main block fronted by a prominent steeple. The main body of the church is a gabled rectangular block that rises two stories in height. It is constructed of brick laid in Flemish bond on a stone foundation. The side elevations of the block are seven bays long and feature two rows of round headed windows with multipane, double-hung wood sash, and louvered shutters. Similar windows are found at both stories of the eastern gable end.

Attached to the eastern gable end of the main block of the church is a steeple that rises well above the ridge of the main roof. The steeple is composed of a square tower, constructed of brick laid in Flemish bond, which terminates in a graceful wooden spire. The tower has round-headed and square-headed windows, an octagonal clock on its eastern side, a cornice with dentils, and a balustrade with dwarf spires rising from its corners. An entrance is situated on the north side of the tower. It is composed of a pair of paneled wood doors with a molded surround.

The spire that rises from the tower is composed of three tiers that progressively diminish in size. The two lower tiers of the spire feature multipane, round arched windows flanked by pilasters and cornices topped by corner finials. The uppermost tier of the steeple is a four-sided spire that terminates in a tall finial with an ornamental ball.

The church is surrounded by an expansive, landscaped yard. A small cemetery, bounded by a decorative wrought iron fence, is situated at the northwest corner of the lot. A parking lot has been constructed across the street to the south.

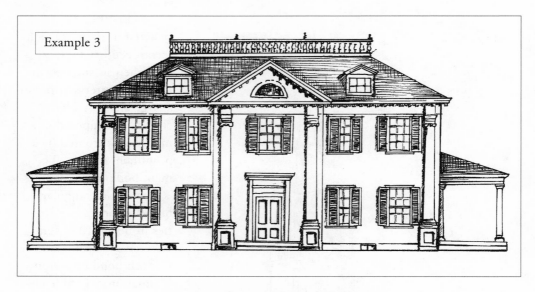

Example 3

Fig. 134. A TWO-STORY RESIDENCE

This residence, constructed in the Georgian style in 1823, is centered on a large, square lot that slopes down to a stream at the north. The house takes the form of a horizontal, symmetrical block flanked by low porches and topped by a low, hipped roof with slate shingles. The frame house with wooden siding rises two and one-half stories above a stone foundation. Windows of the first and second stories typically have six-over-six, double-hung wood sash and louvered shutters.

The symmetrical facade of the house, which faces south, is five bays wide. The central bay takes the form of a slightly projecting pavilion with a pediment resting on giant pilasters. The pilasters have paneled podiums and Ionic capitals. Centered within the pavilion at the first story is an entrance composed of a paneled wood door, a transom, and a molded surround with a projecting entablature. A window is centered above the doorway at the second story. A lunette is centered within the pediment of the pavilion, which is treated with modillions.

Giant pilasters are also located at the ends of the facade. The shingled roof of the house has two pedimented dormers with multipane sash, and it is crowned by a widow's walk with a balustrade composed of turned balusters. The roof cornice is treated with prominent modillions.

Single-story porches extend from both side elevations of the house. The porches are composed of raised wood floors, Doric columns and pilasters, and hipped, shingled roofs. The side elevations are symmetrically arranged with five bays each. The design of the rear (north) elevation follows that of the front facade.

Constructed in 1872, this three-story residence exemplifies the Second Empire style in row house architecture. It is the last remaining house in a row originally composed of seven houses. The structure has a long, rectangular form with the short end of the rectangle facing the street. The brick residence rises three stories above a raised basement. The front facade, which faces north, is three bays wide. Its entrance is situated at the western end of the facade and is composed of an original

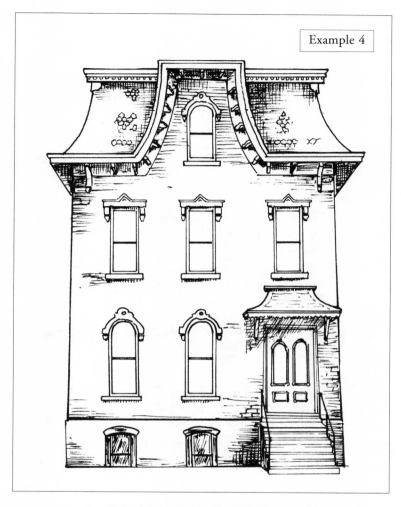

Fig. 135. A THREE-STORY RESIDENCE

paneled wood door with a molded surround, sheltered by a shingled, flared hood with brackets. The entrance is reached by a straight, concrete stoop with a wrought iron handrail. The stoop is a replacement.

The windows of the facade are equally spaced. The first and third stories have round arched windows; the second story has flat-headed windows. The windows have one-over-one double-hung wood sash and ornamental cast iron hoods with central crowns and decorative brackets. Basement windows have simple segmental arches of stone.

The most prominent feature of the house is the mansard roof, which has flared sides, molded edges, patterned shingles, a dentilled cornice, and a central bracketed gable that echoes the shape of the main roof. There are large, decorative brackets in the eaves. A modern addition has been constructed at the rear of the building. An alley runs along the southern edge of the lot.

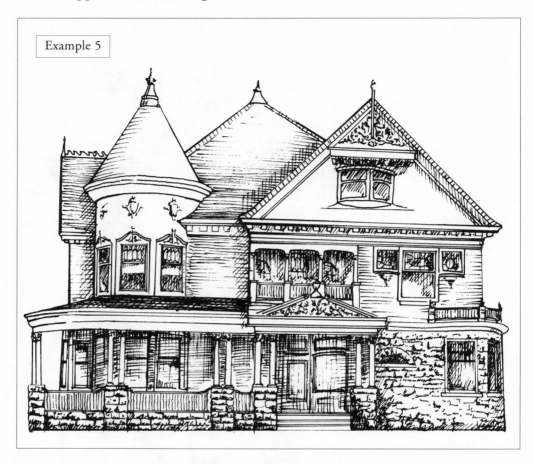

Example 5

Fig. 136. A QUEEN ANNE STYLE RESIDENCE

This Queen Anne style residence was constructed in 1882 on a large corner lot surrounded by other grand residential buildings. This two and one-half story residence displays a picturesque massing composed of a central square block with a steeply-pitched pyramidal roof, large projecting gabled bays on the southern (front) and western elevations, a round tower on the southwest corner, and a wraparound porch. Lower portions of the walls are composed of rock-faced stonework. Upper walls are faced with clapboards and ornamented with patterned wood shingles. The roof is covered with slate shingles, has a cornice with modillions, and is capped by a copper pinnacle with a finial.

The gabled bay on the southern facade of the house features a variety of windows, surface textures, and ornament. It includes the entrance to the house, which is situated at the western end of the bay and is accessed through a front gabled entry porch. This porch is composed of paired Corinthian columns on tall stone pedestals supporting a gable filled with scrollwork and topped by a pinnacle. The entrance has a heavy paneled door. Adjacent to the door is a large curved window with a transom. Outside the entry porch on the lower wall of the bay is situated an elliptical window.

Double-hung windows with divided lights in the upper sash turn the corner of the rounded wall in this area. A cornice and a stone and wood balustrade define the top of this part of the bay.

The second story of the front gabled bay features a recessed porch with turned columns and spindles and a tripartite window composition with a central double-hung window flanked by smaller windows, which are supported by corbels. These windows feature ornamentally divided sash. The prominent gable of this front bay is defined by a deeply projecting cornice with modillions, and a projecting bargeboard with scrollwork and pinnacle. Centered within the gable is a curved window with paired sash. An iron cresting embellishes the ridge of the gabled roof.

Extending westward from the entry porch is a wraparound porch that joins the gabled bay on the western elevation. The porch has a stone foundation. Its balustrade is composed of turned spindles and handrails interspersed with heavy stone pedestals upon which rest paired, classically inspired, Corinthian columns. The porch roof is covered with slate shingles.

The round tower that rises from the southwest corner of the central block of the house features exposed stonework at the first story and a stucco facing above the porch. Tower windows of the first story have one-over-one double-hung sash. Second-story windows also have double-hung sash, but the upper sash have multiple panes. These windows have decorative wood surrounds with modified swan's neck pediments and central foliate ornament. Shields with scrollwork are centered above each window. The conical roof of the tower is covered with slate shingles, has a wide cornice, and is capped by a copper pinnacle with finial.

The western gabled bay features a bay window at the first story and round and double-hung windows at the second story. The treatment of the western gable matches that of the southern gable.

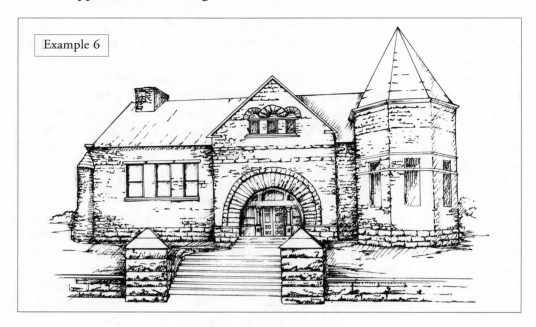

Fig. 137. A STONE LIBRARY

This prominent, Richardsonian Romanesque style library, constructed in 1895, is situated on a raised city lot that is surrounded by a low, rock-faced stone wall. Broad steps marked by heavy piers at the sidewalk form a processional to the main entrance. The massive building is constructed of rock-faced masonry. It takes the shape of a low, side-gabled, rectangular block, with an entrance pavilion forming a cross gable and two towers—one diminutive, one grand—marking the corners of the facade. The moderately pitched roof is covered with slate shingles. A ridge chimney of stone projects from the roof near the western end of the building.

The gabled entrance pavilion, which faces south, has an entrance portal composed of a broad Syrian arch defined by bold stonework. The archway is filled with a recessed pair of paneled doors flanked by columns on tall pedestals and double-hung windows. The door arrangement is topped by transoms delineated by a heavy transom bar. Two bands of contrasting color masonry separate the portal from the gable above. Centered in the gable are three small, double-hung windows that share a continuous stone sill and a continuous stone lintel. Round arches above the windows are emphasized by rock-faced stonework. The cornice of the gable has a small return.

Situated to the west of the entrance pavilion is a band of three double-hung windows. These windows also share a continuous sill and a continuous lintel. At the western corner of the building is a small turret with a conical roof. At the eastern end of the building is a prominent octagonal tower with a polygonal hip roof. Each face of the tower has one window with a transom; a thin, continuous band of stone acts as a transom bar. The polygonal hip roof of the tower is covered with slate shingles.

A small parking area has been constructed at the northeast corner of the lot. Concrete sidewalks encircle the building.

This late nineteenth century commercial building exemplifies the Italianate style. It is situated in the heart of the commercial district on Main Street and is flanked by other closely spaced commercial structures. The long, rectangular building is constructed of brick and stone and has a three-bay-wide facade that faces west. This three-story building is divided vertically into a base, a midsection, and a cornice. The base of the building comprises the first story. Piers of rock-faced stone and a cornice above a signband frame the storefront opening. The replacement storefront is composed of a recessed, nearly centered store entrance, which is flanked by large show windows with transoms, but without bulkheads. A secondary entrance at the western end (left) of the storefront provides access to the floors above. A retractable fabric awning has been installed below the signband.

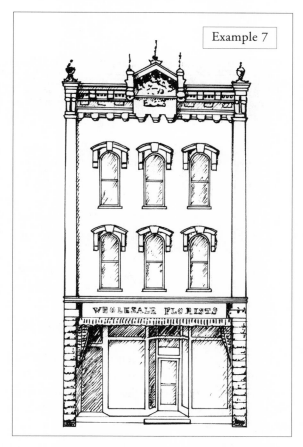

Fig. 138. A THREE-STORY COMMERCIAL BUILDING

The symmetrical midsection of the building is faced with brick. It is two stories in height and is framed at the sides by tall Doric pilasters. Three round headed window openings appear at both the second and third stories. The windows feature elaborate cast-iron hoods, simple sills, and one-over-one, double-hung wood sash.

The cast iron cornice of the building is an elaborate composition framed at the sides by the entablatures of the midsection pilasters. The entablatures are capped by urns. The cornice, which includes corbels, panels, modillions, and dentils is interrupted by a central pediment. The pediment, which has its own corbels, modillions, and inscription panel, terminates in a tripartite arrangement of finials.

The brick side elevations of the building are blank due to the proximity of the neighboring buildings. The rear elevation, which faces an alley, has been painted. The first story of this elevation has a pedestrian entrance with a replacement door and an overhead wood door at a loading dock. Both the second and third stories have segmental window openings with brick arches at their heads and multipane double-hung sash. A corbelled brick cornice terminates the third story.

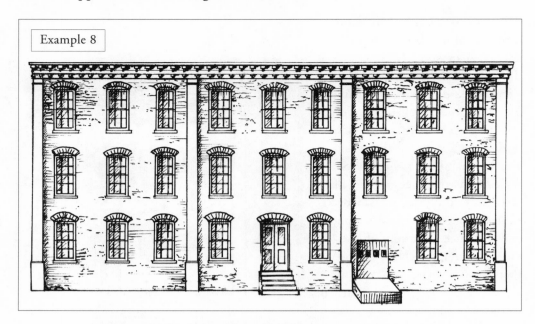

Example 8

Fig. 139. A THREE-STORY INDUSTRIAL BUILDING

This late nineteenth century industrial building takes the form of a low rectangular block and displays a typical design of the period. The building is situated in an industrial area that fronts the river. The three-story brick building on a stone foundation is composed of three main vertical bays defined by attenuated brick pilasters on tall bases. Each of the main bays contains three subsidiary vertical bays defined primarily by segmentally arched window openings. Windows have six-over-six, double-hung sash, simple stone sills, and rock-faced stone heads. At the first story, the center bay has a central entrance composed of a pair of paneled wood doors reached by a low series of stone steps. In the eastern bay, one window has been replaced by an overhead door with a loading dock. The entire composition is crowned by a cornice composed of brick corbel tables.

Both brick side elevations of the building have fourteen segmentally arched window openings of irregular arrangement. Several openings have been filled with concrete block. Other windows have replacement sash. The rear elevation of the building, which faces the river, is accessed by a private drive.

This modern skyscraper, constructed in 1952, exemplifies the International style of architecture. The structure is composed of two rectangular glass blocks — one horizontally oriented, the other a vertical shaft. Both blocks are clad in a thin steel and glass curtain wall.

The horizontal block of the building forms a podium for the vertical block. The lower structure rises two stories in height and is supported by pilotis. It encircles a garden courtyard. Each bay of the curtain wall of this volume is composed of a large, single-pane window above a tinted spandrel panel.

Example 9

Fig. 140. A MODERN OFFICE BUILDING

The vertical block of the building rises twenty stories in height near one end of the lower structure. Each bay of the curtain wall of this volume includes a large window and two tinted spandrel panels. The arrangement of the curtain wall shifts at the upper three stories to a series of tinted panels. Free of traditional ornament, the clean lines and bold forms of this building render it a dramatic composition.

SELECTED BIBLIOGRAPHY

The works listed here are those that have been helpful to the author and those that will be helpful to readers seeking additional information on identifying and describing architecture.

Blumenson, John J.-G. *Identifying American Architecture,* 2d. ed. New York: Norton and Company, 1981.

Burchard, John and Albert Bush-Brown. *The Architecture of America.* Boston: Little, Brown and Company, 1961.

Carley, Rachel. *The Visual Dictionary of American Domestic Architecture.* New York: Henry Holt and Company, 1994.

Ching, Francis D.K. *Building Construction Illustrated.* New York: Van Nostrand Reinhold, 1975.

Condit, Carl W. *American Building,* 2d. ed. Chicago: The University of Chicago Press, 1982.

Gillon, Edmund V., Jr. *Pictorial Archive of Early Illustrations and Views of American Architecture.* New York: Dover, 1971.

Greene, Fayal. *The Anatomy of a House: A Picture Dictionary of Architectural and Design Elements.* New York: Doubleday, 1991.

Griesbach, C.B. *Historic Ornament: A Pictorial Archive.* New York: Dover, 1975. (Originally from the portfolio *Muster-Ornamente aus allen Stilen in historischer Anordnung,* published by C. B. Griesbach in Gera, Germany, in the late nineteenth century.)

Haneman, John Theodore. *Pictorial Encyclopedia of Historic Architectural Plans, Details and Elements.* New York: Dover, 1984. (Originally published as *A Manual of Architectural Compositions: 70 Plates with 1880 Examples,* by the Architectural Book Publishing Company, New York in 1923.)

Harris, Cyril M. (ed.) *Dictionary of Architecture and Construction.* New York: McGraw-Hill, 1975.

Huntington, Whitney Clark, and Robert E. Mickadeit. *Building Construction: Materials and Types of Construction,* 5th ed. New York: John Wiley and Sons, 1981.

Jones, Frederic H., Ph.D. *The Concise Dictionary of Architecture.* Los Altos, CA: Crisp Publications, Inc., 1990.

London, Mark. *Masonry: How to Care for Old and Historic Brick and Stone.* Washington, D.C.: The Preservation Press, 1988.

McAlester, Virginia, and Lee McAlester. *A Field Guide to American Houses.* New York: Knopf, 1984.

McKee, Harley J. *Introduction to Early American Masonry, Stone, Brick, Mortar and Plaster.* Washington, D.C.: The Preservation Press, 1973.

Meyer, Franz S. *Meyer's Handbook of Ornament.* London: Omega Books. Ltd., 1987.

Mullins, Lisa C. (ed.) *The Architectural Treasures of Early America.* Harrisburg: The National Historical Society, 1987-88.

Parker, J. Henry. *Classic Dictionary of Architecture,* 4th ed. rev. New York: New Orchard Editions, 1986.

Petrie, Flinders. *Decorative Symbols and Motifs for Artists and Craftspeople.* New York: Dover, 1986. (Originally published as *Decorative Patterns of the Ancient World* by the British School of Archaeology in Egypt and Bernard Quaritch, London, in 1930.)

Pevsner, Nikolaus and John Fleming and Hugh Honour. *The Penguin Dictionary of Architecture,* 3rd ed. New York: Penguin, 1980.

Phillips, Steven J. *Old-House Dictionary.* Washington, D.C.: National Trust for Historic Preservation, 1992.

Pierson, William H., Jr. *American Buildings and Their Architects.* New York: Anchor Books, 1976.

Pugin, Augustus C. *Pugin's Gothic Ornament: The Classic Sourcebook of Decorative Motifs.* New York: Dover, 1987. (Originally published as *Gothic Ornaments Selected from Various Buildings in England and France* by Priestley and Weale, London, in 1831.)

Ramsey, Charles G., and Harold R. Sleeper. *Architectural Graphic Standards,* 6th ed. New York: John Wiley & Sons, 1970.

Reid, Richard. *The Book of Buildings: A Traveller's Guide.* New York: Crescent Books, 1980.

Rooney, William. *Architectural Ornamentation in Chicago.* Chicago: Chicago Review Press, 1984.

Spence, William P. *Residential Framing.* New York: Sterling Publishing Co., 1993.

Stella, Jacques. *Baroque Ornament and Designs.* New York: Dover, 1987. (Plates originally published in Paris in 1658.)

Stokoe, James. *Decorative and Ornamental Brickwork: 162 Photographic Illustrations.* New York: Dover, 1982.

Sturgis, Russell. *Architecture Sourcebook.* New York: Van Nostrand Reinhold, 1984.

_____. *Illustrated Dictionary of Architecture and Building.* 3 vols. An unabridged reprint of the 1901-02 ed. New York: Dover, 1989.

Tunick, Susan. *Field Guide to Apartment Building Architecture.* New York: Friends of Terra Cotta/New York State, 1986.

Ware, Dora, and Maureen Stafford. *An Illustrated Dictionary of Ornament.* New York: St. Martin's, 1974.

Whiffen, Marcus. *American Architecture Since 1780: A Guide to the Styles.* Cambridge, MA: The M.I.T. Press, 1981.

White, Antony and Bruce Robertson. *Architecture & Ornament.* New York: Design Press, 1990.

Woodbridge, Sally B. *Details: The Architect's Art.* San Francisco: Chronicle Books, 1991.